THE BEST OF
BROCHURE
DESIGN

Art Director: Lynne Havighurst
Designer: **PandaMonium Designs, Boston**
Additional photography by: Douglas Cannon

First published in the United States of America by:
Rockport Publishers, Inc.
33 Commercial Street
GLoucester, Massachusetts 01930
Telephone: (978) 282-9590
Fax: (978) 283-2742

Distributed to the book trade and art trade in the
United States by:
North Light, an imprint of
F & W Publications
1507 Dana Avenue
Cincinnati, Ohio 45207
Telephone: (513) 531-2222

Other Distribution by:
Rockport Publishers
Gloucester, Massachusetts 01930

ISBN 1-56496-556-2

10 9 8 7 6 5 4 3

Printed in China

THE BEST OF
BROCHURE
DESIGN

ROCKPORT
PUBLISHERS

ROCKPORT PUBLISHERS

ROCKPORT, MASSACHUSETTS

Distributed by
NORTH LIGHT BOOKS, CINCINNATI, OHIO

TABLE OF CONTENTS

introduction

With so much design emphasis being focused these days on URLs, hyper links, and HTML, with our children glued to CRTs and MTV, and with the general public losing interest in the printed word, it s nothing short of a miracle that traditional print graphic designers still exist...or is it?

Somehow, amid the media hype about how technology impacts our world, I often find the maxim the more things change, the more things stay the same, is only too true. Case in point—the focus of this book. The brochure is now, and probably will remain, the cornerstone of modern graphic design. Designers love to discuss corporate identity, posters, packaging, etc... but the fact stands that the brochure is probably the first thing that comes to mind when your relatives ask so, what does a graphic designer do anyway?

Brochures are the very definition of graphic design. The marriage of word and visuals to not just selling a product, but creating an image as well. Often it s the only link between the customer and the product. It s no wonder that clients tend to be very involved in brochure production. If handled improperly, a brochure can be a company's wet handshake from a cheesy-grinned, seersucker salesman, screwing up a good opportunity. If handled well, it can be a powerful tool in developing the next big venture. The point is this: It's not enough to be a great company or to have a great product if that information cannot effectively be conveyed to the proper audience. A successful brochure sits with the target market long after direct contact is over, resonating its message.

In concept, this seems simple enough. In practice, creating an engaging brochure on time, on target and within budget is difficult at best. If it carries any element of artistic merit, then you've not only satisfied your personal goals but you have actually done your job. Like everything in life there are no ready-made solutions to the myriad of problems facing the designer at least for the designer who is doing his or her job well. When faced with comments like the CEO's wife doesn't like green..., or I heard that sans serif type is harder to read..., or why can't we make it look like their brochure...? it's all the designer can do not to throw in the towel and take a long walk. The best designers find a way to make it all happen. They ease tensions, focus on problems, take opportunities to educate their clients, and search for imaginative solutions that make everyone stand up and take notice, or sit down and think, or pick up the phone, or buy a new product, or enroll in a program, or make a donation, etc... That's what it is to design. It beats flipping burgers.

PAUL MONTIE
*Montie is a principal at Fahrenheit, a Boston,
Massachusetts graphic design studio.*

promotional

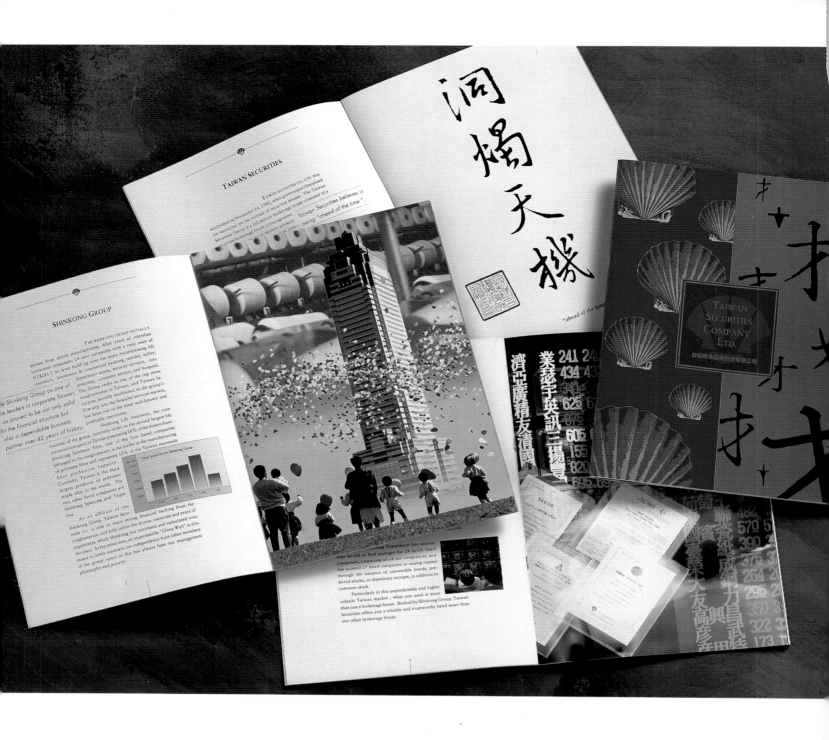

Design Firm **Artailor Design House**
Art Director **Raymond Lam**
Designers **Shirley Wu, Vivian Yao**
Photographer **Dynasty Commercial Photography**
Client **Taiwan Securities Co. Ltd.**
Printer **Zanders**
Tools **Adobe Illustrator and Adobe Photoshop**

The illustration and calligraphy play on both the company's logo and the meaning within Chinese characters. The Chinese character for "money" combines the character for "shell" with the character for "talent." Therefore, this combined graphic of shells (on the left side of the cover) with the Chinese characters for various talents (on the right) presents a subtle but clear visual message to this brochure's predominantly Chinese audience.

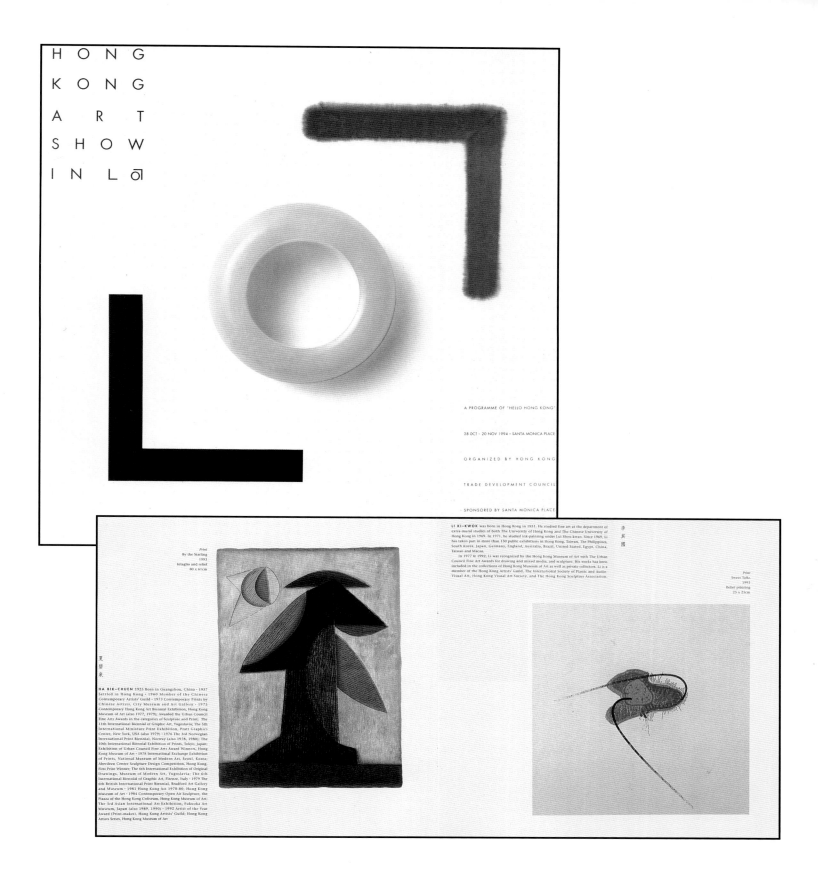

HONG
KONG
ART
SHOW
IN LA

A PROGRAMME OF "HELLO HONG KONG"

28 OCT - 20 NOV 1994 • SANTA MONICA PLACE

ORGANIZED BY HONG KONG

TRADE DEVELOPMENT COUNCIL

- SPONSORED BY SANTA MONICA PLACE

Design Firm **Kan Tai-keung Design & Associates Ltd.**
Art Director **Kan Tai-keung**
Designers **Kan Tai-keung, Eddy Yu Chi Kong**
Photographer **C.K. Wong**
Client **Hong Kong Trade Development Council**
Paper/Printer **Coated Art-Paper, Reliance Production**
Tool **Macromedia FreeHand**

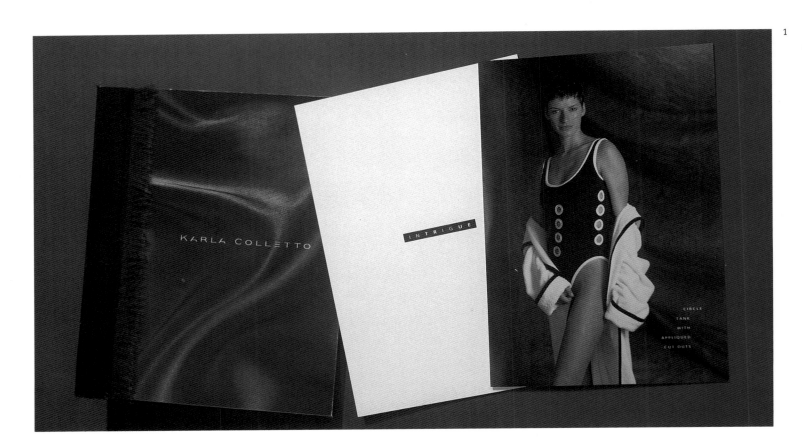

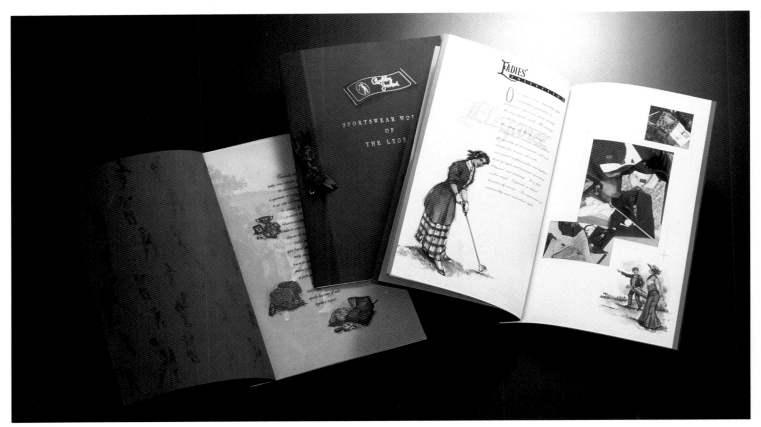

1
Design Firm **Grafik Communications, Ltd.**
Designers **Melanie Bass, David Collins, Judy Kirpich**
Photographers **Steve Biver, Heidi Neimala**
Copywriter **Jake Pollard**
Client **Karla Colletto Swimwear**
Paper/Printer **Quintescence, Virginia Lithograph**

1➤ *This brochure is hand collated and machine sewn in order to save costs. The use of fabric gives the binding a handmade appearance, and relates it to the cover photography, which features pieces of translucent fabric with colored lights.*

2➤ *This piece uses ribbon, embossing and hot-gold stamping to communicate an elite corporate image.*

2
Design Firm **Masterline Communications Ltd.**
Art Director **Grand So, Kwong Chi Man**
Designer **Kwong Chi Man, Grand So**
Illustrator **James Fong**
Photographer **David Lo**
Client **Ryoden Sports Trading Co., Ltd.**
Printer **Yiu Wah Offset Printing Co.**

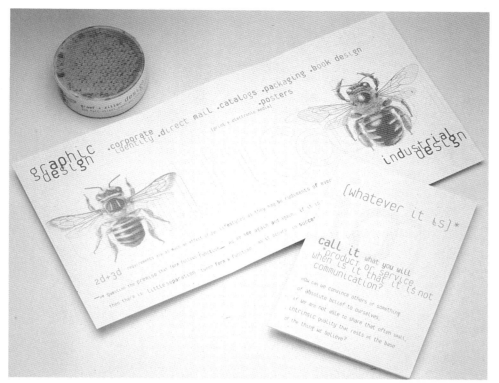

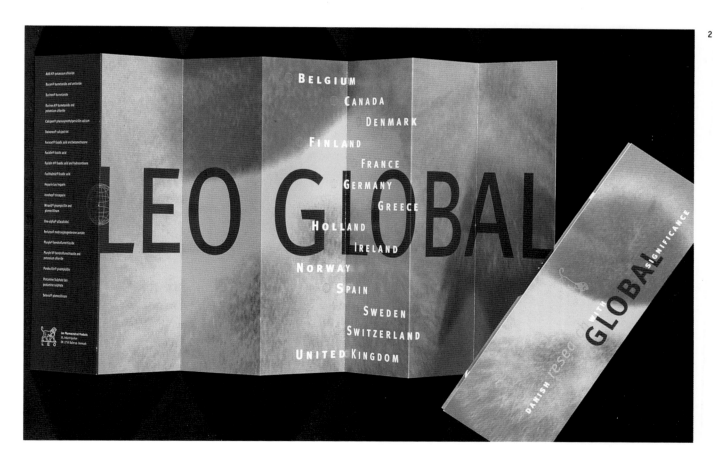

1
Design Firm **Graef & Ziller Design**
Art Directors **Barbara Ziller, Andrew Graef**
Designers **Barbara Ziller, Andrew Graef**
Illustrator **Elaine Hodges**
Copywriter **Andrew Graef**
Client **Graef & Ziller Design**
Paper/Printer **Evergreen, Linotext GTO**
 (Heidelberg Digital Press)
Tools **QuarkXPress, Adobe Illustrator,**
 Adobe Photoshop

1► *The honeycomb used in this piece is an inexpensive addition that supports the graphic and makes the brochure memorable.*

2
Design Firm **Leo in House**
Art Director **Karsten Lentge**
Copywriters **Karsten Lentge, Preben Schroder**
Client **Leo Pharmaceutical**
Paper **Royal Consort, Silk**
Tool **QuarkXPress**

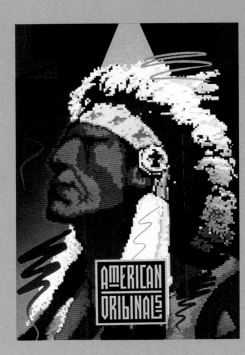

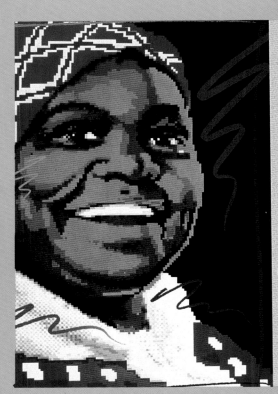

Design Firm **Sackett Design Associates**
Art Director **Mark Sackett**
Designers **Mark Sackett, Wayne Sakamoto**
Illustrator **Dave Willardson**
Copywriters **Brian Belefant, Deborah Benedict,
Jim Comparos, Jack Kinney**
Client **Lax Magazine**
Paper/Printer **Sterling Litho Satin 80 lb.,
Text Miller Graphics**

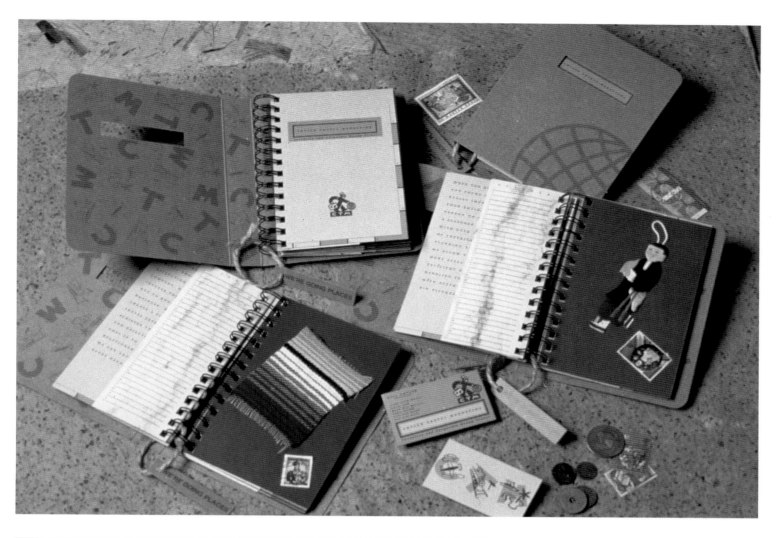

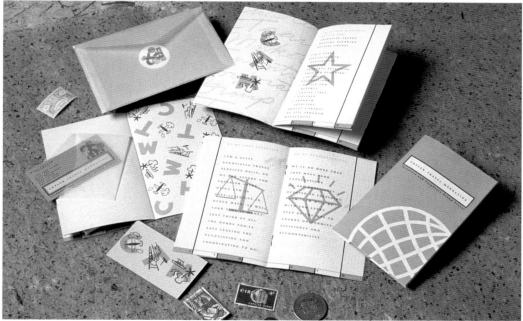

Design Firm **Sayles Graphic Design**
Art Director **John Sayles**
Designer **John Sayles**
Illustrator **John Sayles**
Copywriter **Wendy Lyons**
Client **Cutler Travel Marketing**
Paper/Printer **Curtis Paper, Artcraft Printing,
 The Printing Station**

*Printed on text weight paper to save costs, the intro-
ductory brochure mails in a glassine envelope. The cor-
porate brochure is a three-dimensional encounter—with
foreign coins and stamps, postcards, maps, and travel
memorabilia from around the globe, attached by hand
to its multi-colored pages.*

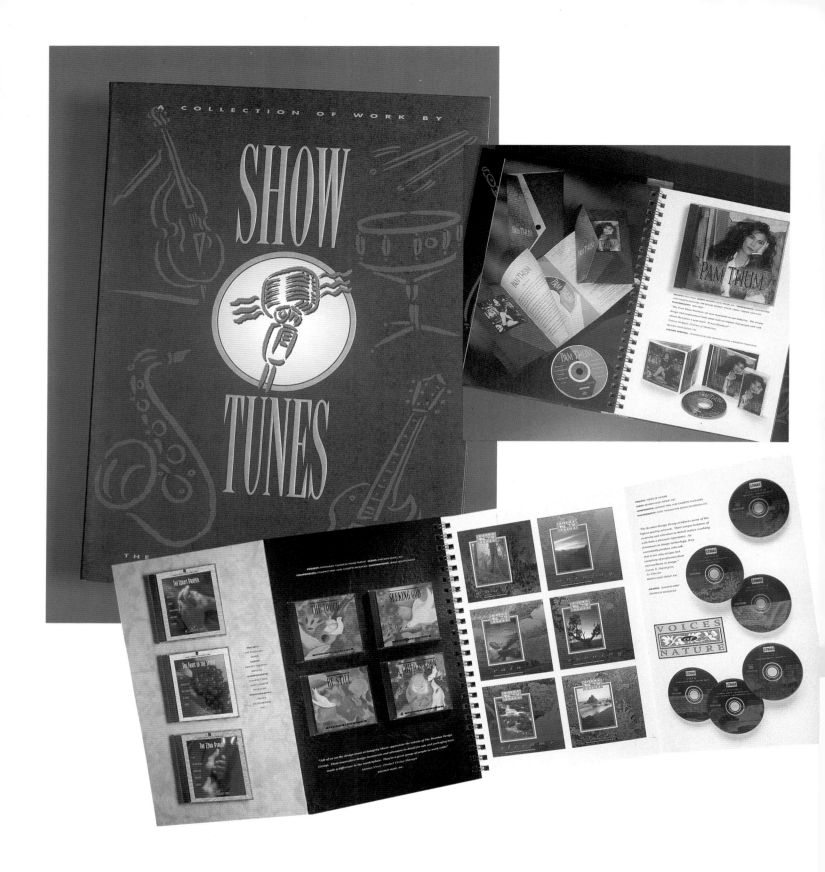

Design Firm **The Riordon Design Group Inc.**
Art Director **Ric Riordon**
Designers **Dan Wheaton, Ric Riordon**
Illustrator **Andrew Lewis**
Photographers **Stephen Grimes, David Graham White**
Client **The Riordon Design Group Inc.**
Paper/Printer **Couger, Royal Impression, CJ Graphics**
Tools **QuarkXPress, Adobe Illustrator, and Adobe Photoshop**

This piece is offset printed, embossed, and wire-o bound. The designers found choosing the work to be featured in this self-promotional brochure was one of the greatest challenges in creating it.

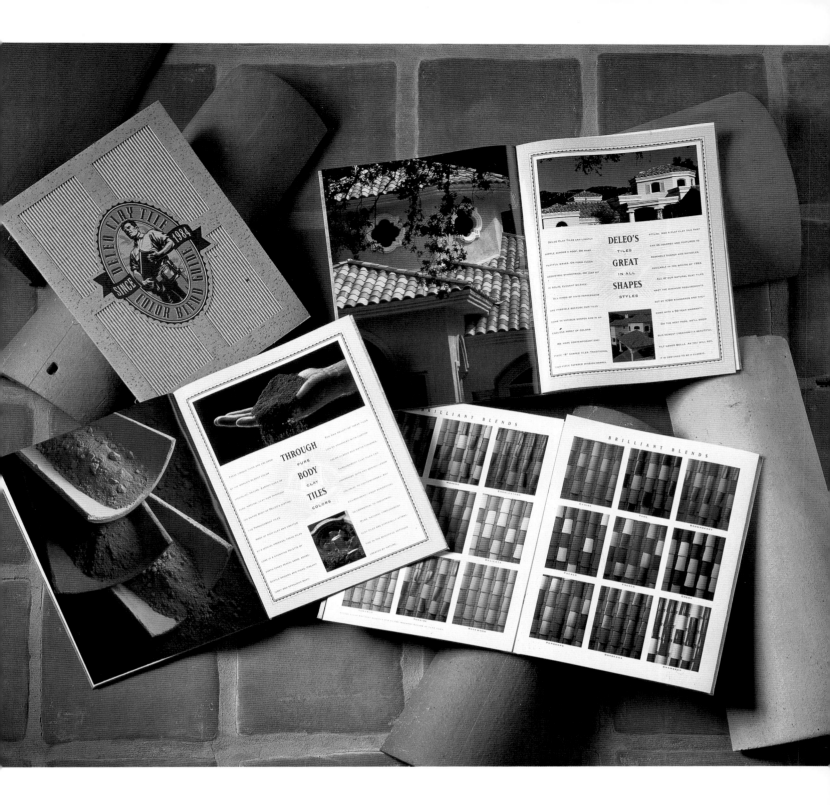

Design Firm **Mires Design, Inc.**
Art Director **José Serrano**
Designer **José Serrano**
Illustrators **Nancy Stahl, Tracy Sabin**
Client **Deleo Clay Tile Co.**

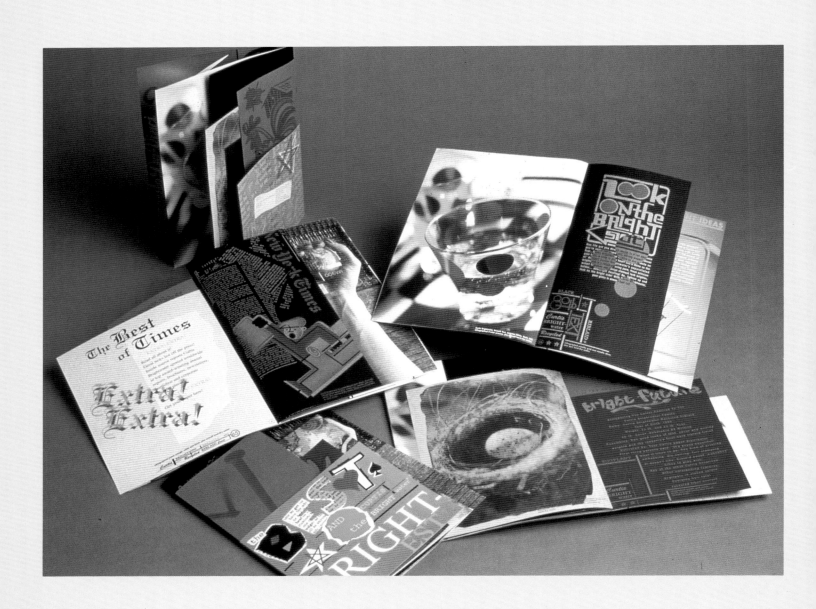

Design Firm **Sayles Graphic Design**
Art Director **John Sayles**
Designer **John Sayles**
Illustrator **John Sayles**
Photographer **Bill Nellans**
Copywriter **Wendy Lyons**
Client **James River, Curtis Fine Papers**

This twenty-page brochure is printed on a combination of six different Brightwater weights and finishes. The designer hand-rendered type on some pages and created original illustrations for others; some pages are designed around double-exposed photographs, while other spreads feature duotones, halftones and 4-color photos. An interesting mix of ink colors and typefaces gives each page personality.

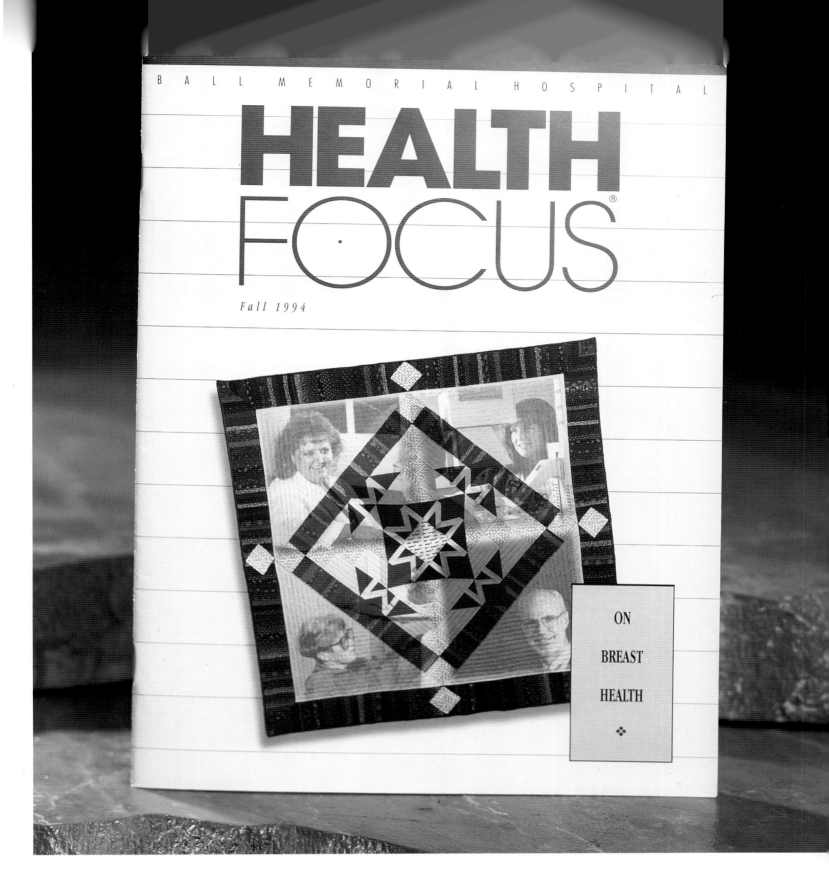

Design Firm **Held Diedrich**
Art Director **Dick Held, Tim Grant, Doug Diedrich**
Designer **David Snedigar**
Photographer **Rick DeCroes**
Copywriter **Jenny Hawke**
Client **Ball Memorial Hospital**
Paper/Printer **Productolith**

Directed at civic leaders, hospital staff, referring physi-cians and former patients, this hospital services brochure employs a contemporary design without being flashy. Printed in 2-color, each quarter of the piece focuses on a particular specialty area.

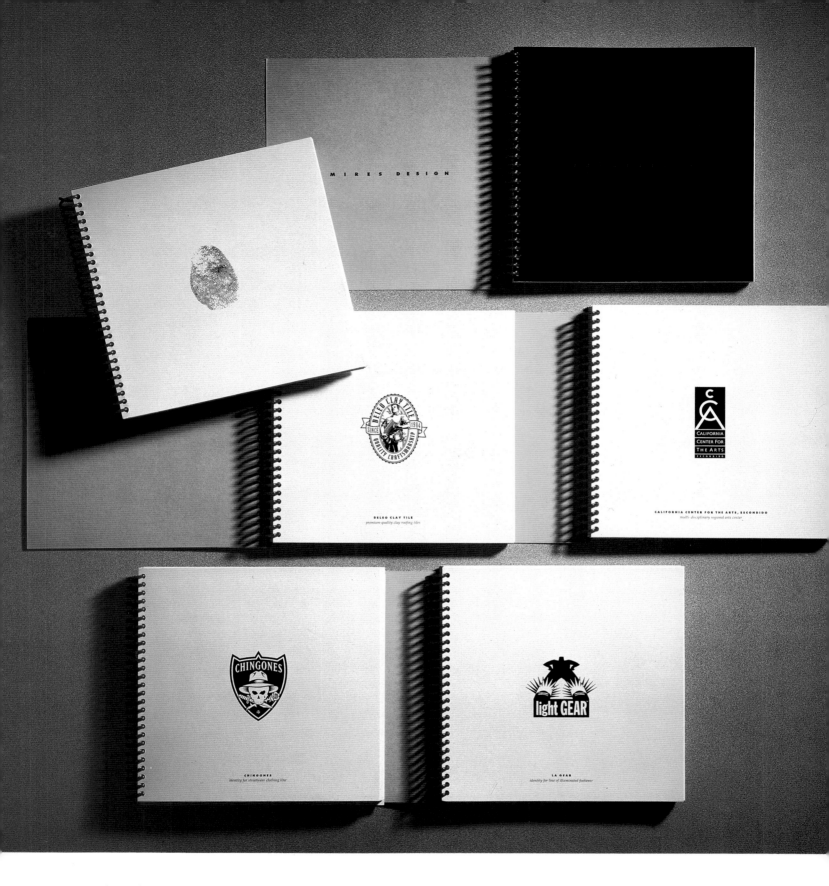

Design Firm **Mires Design, Inc.**
Art Director **José Serrano**
Designers **José Serrano, Deborah Fukushima**
Client **Mires Design, Inc.**

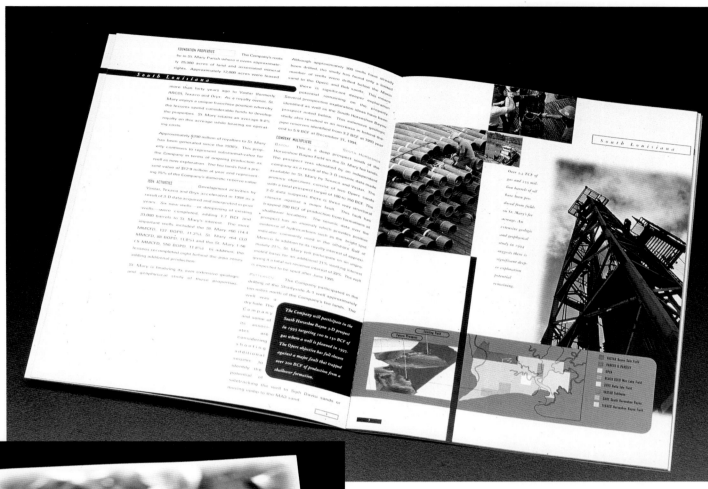

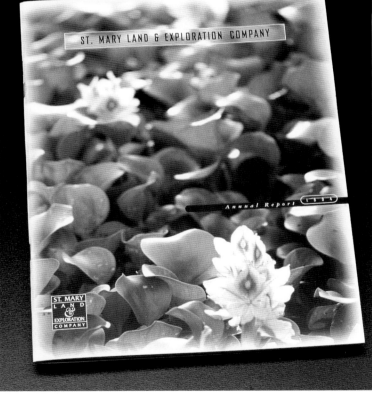

Design Firm **Lee Reedy Design**
Art Director **Lee Reedy**
Designer **Karey Christ-Janer**
Illustrator **Karey Christ-Janer**
Photographer **Ron Coppock**
Copywriter **Mark Hellerstein**
Client **St. Mary Land & Exploration Co.**
Paper/Printer **Centura Dull, L & M Printing**

1
Design Firm **Segura Inc.**
Art Director **Carlos Segura**
Designer **Carlos Segura**
Client **Segura Inc.**
Printer **Argus Press**
Tools **Adobe Illustrator, QuarkXPress,
and Adobe Photoshop**

2
Design Firm **Grand Design Co.**
Art Directors **Grand So, Kwong Chi Man**
Designer **Kwong Chi Man**
Illustrator **Kwong Chi Man**
Photographer **David Lo**
Client **Hop Shing Loong Lighting Ltd.**
Printer **Reliance Production**

2➤ *This piece was created entirely by hand.*

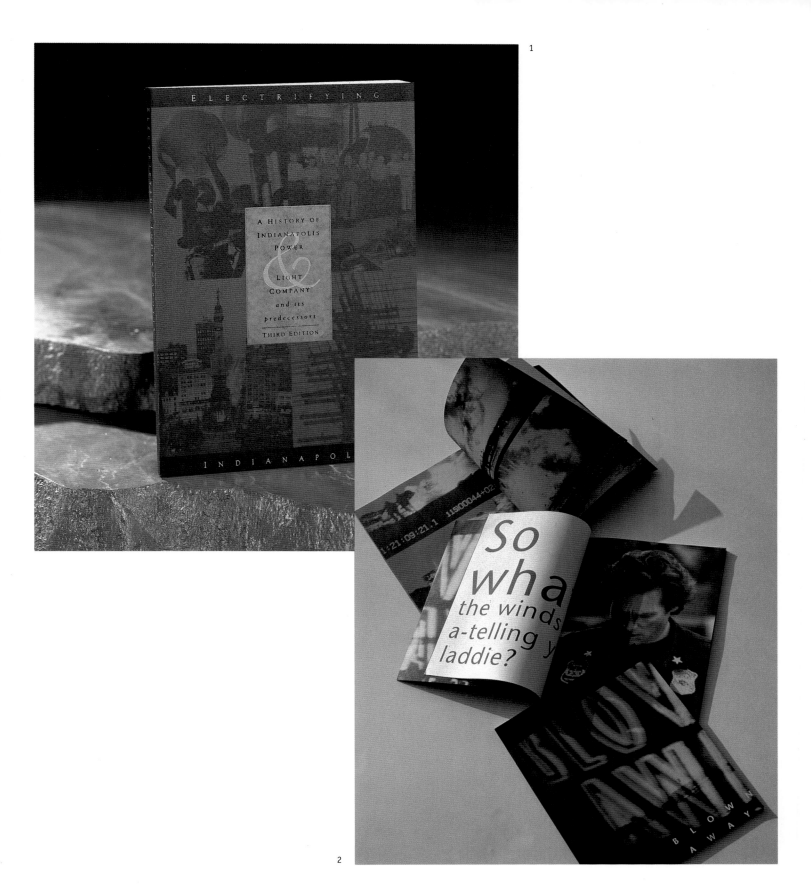

1

Design Firm **Held Diedrich**
Art Director **Doug Diedrich, Tim Gant**
Designer **Tim Gant, David Snedigar**
Copywriter **William Lutholtz**
Client **Indianapolis Power & Light Company**
Paper/Printer **Cover - Curtis Flannel Burgundy, Cover,
 Cougar Opaque, Text Pages. Metropolitan Printing**
Tools **QuarkXPress, Adobe Photoshop**

1➤ *For this third edition of their company brochure,
Indianapolis Power & Light focused on the compa-
ny's history and growth. The heavy paper and silver
foil stamping on the cover were chosen to convey a
tactile richness that also has visual punch. Inside,
the booklet is printed in 2-colors on paper chosen
to give it a historic look and feel.*

2

Design Firm **Mike Salisbury Communications, Inc.**
Art Director **Mike Salisbury**
Designers **Mike Salisbury, Patrick O'Neal**
Illustrators **Joel D. Warren, Bruce Birmeliw**
Client **MGM**
Tools **QuarkXPress, Adobe Photoshop**

1

Design Firm **Grafik Communications**
 David Collins, Judy Kirpich
Photographer **Pierre-Yves Goavec**
Copywriters **David Collins, Judy Kirpich**
Client **Pierre-Yves Goavec**
Paper/Printer **Vintage Velvet, Photographic Filter,
 Broomall**
Tools **QuarkXPress, Adobe Photoshop,
 and Adobe Illustrator**

1➤ *The typography in this piece is designed to reflect
the client's contradictory style.*

2

Design Firm **Mires Design**
Art Director **José Serrano**
Designer **José Serrano**
Illustrator **Dan Thoner**
Client **Sylvan**

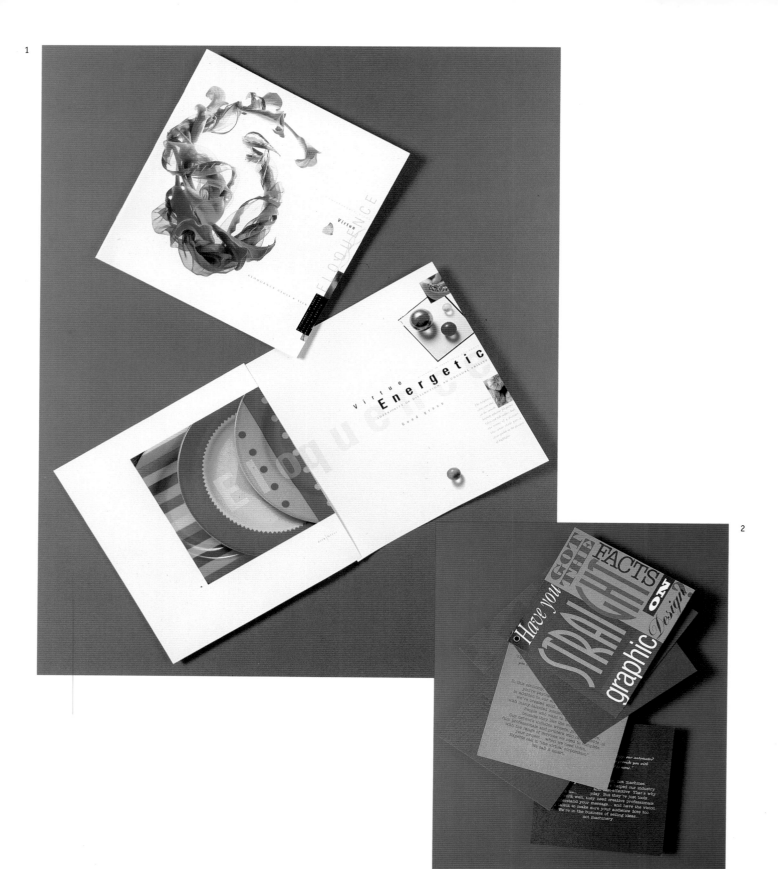

1
Design Firm **The Kuester Group**
Art Director **Kevin B. Kuester**
Designer **Bob Goebel**
Copywriter **David Forney**
Client **Potlatch Corporation, NW Paper Division**
Paper/Printer **Eloquence Silk, Diversified Graphics**
Tools **QuarkXPress, Macromedia FreeHand, and Adobe Photoshop**

2
Design Firm **246 Fifth Design**
Art Director **Terry Laurenzio**
Designer **Sid Lee**
Copywriter **Joy Parks**
Client **246 Fifth Design**
Paper/Printer **Fox River Confetti, Custom Printers of Renfrew**

2➤ *Using only white paper, this piece is printed in 4-color to mimic the different hues of confetti paper. The brochure is rivet-bound.*

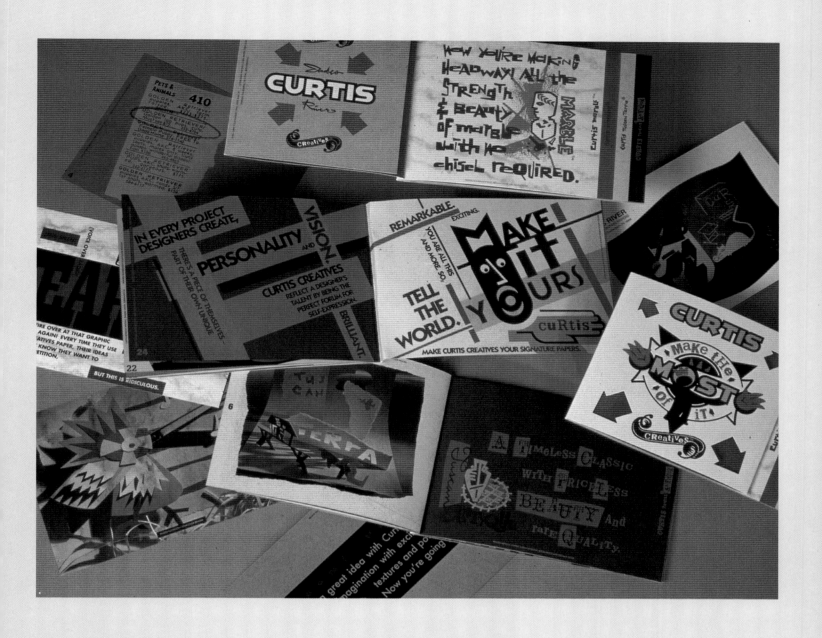

Design Firm **Sayles Graphic Design**
Art Director **John Sayles**
Designer **John Sayles**
Illustrator **John Sayles**
Copywriter **Wendy Lyons**
Client **James River, Curtis Fine Papers**
Paper/Printer **Curtis Papers, Columbia Graphics**

This unique brochure promotes Curtis Creatives line; catchy sub-themes such as "Make it Snappy," "Make it Up," and "Make it Yours" echo the brochure's fun theme. For example, inside the brochure, a colorful paper bird with a scissor beak illustrates how Curtis Creatives "make it sing."

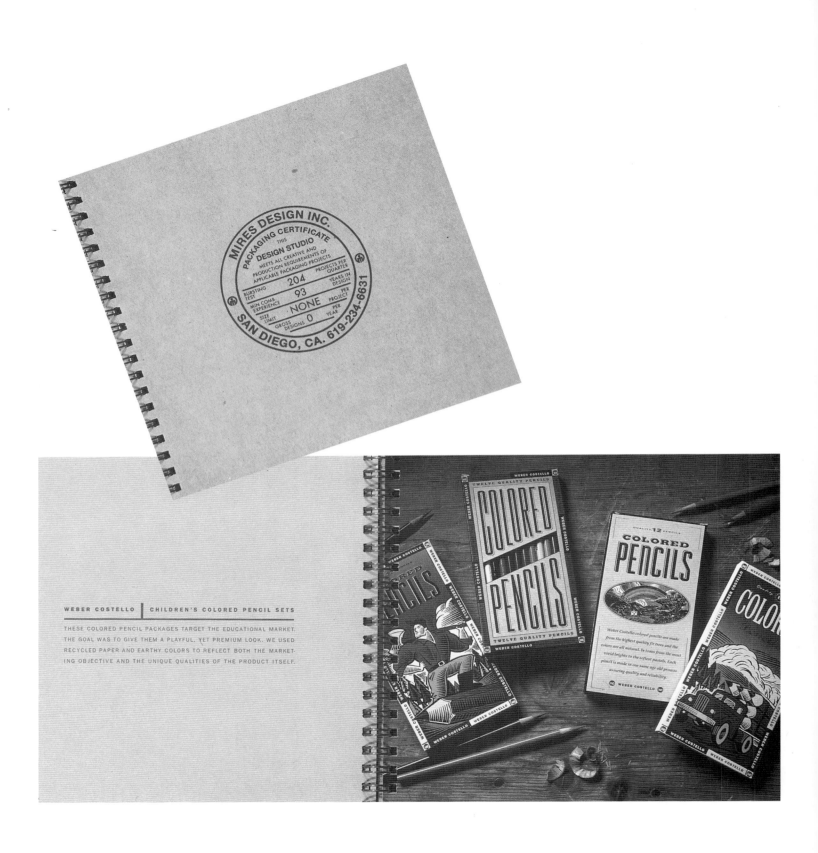

WEBER COSTELLO | CHILDREN'S COLORED PENCIL SETS

THESE COLORED PENCIL PACKAGES TARGET THE EDUCATIONAL MARKET.
THE GOAL WAS TO GIVE THEM A PLAYFUL, YET PREMIUM LOOK. WE USED
RECYCLED PAPER AND EARTHY COLORS TO REFLECT BOTH THE MARKET-
ING OBJECTIVE AND THE UNIQUE QUALITIES OF THE PRODUCT ITSELF.

Design Firm **Mires Design**
Art Director **José Serrano**
Designer **José Serrano**
Client **Mires Design, Inc.**
Tool **QuarkXPress**

*This piece uses E Flute cardboard, 4-color offset print-
ing and wire-o binding.*

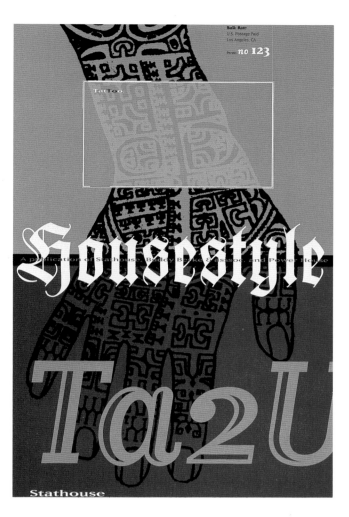

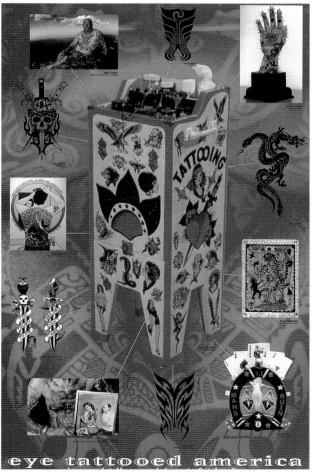

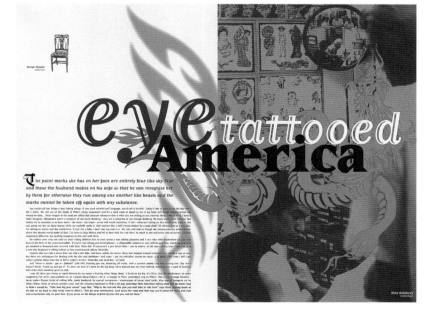

Design Firm **Mike Salisbury Communications**
Art Director **Mike Salisbury**
Designers **Mary Evelyn McGough, Sander Van Baalen, Saunder Egging**
Client **Stathouse**
Tools **QuarkXPress, Adobe Photoshop, Adobe Illustrator**

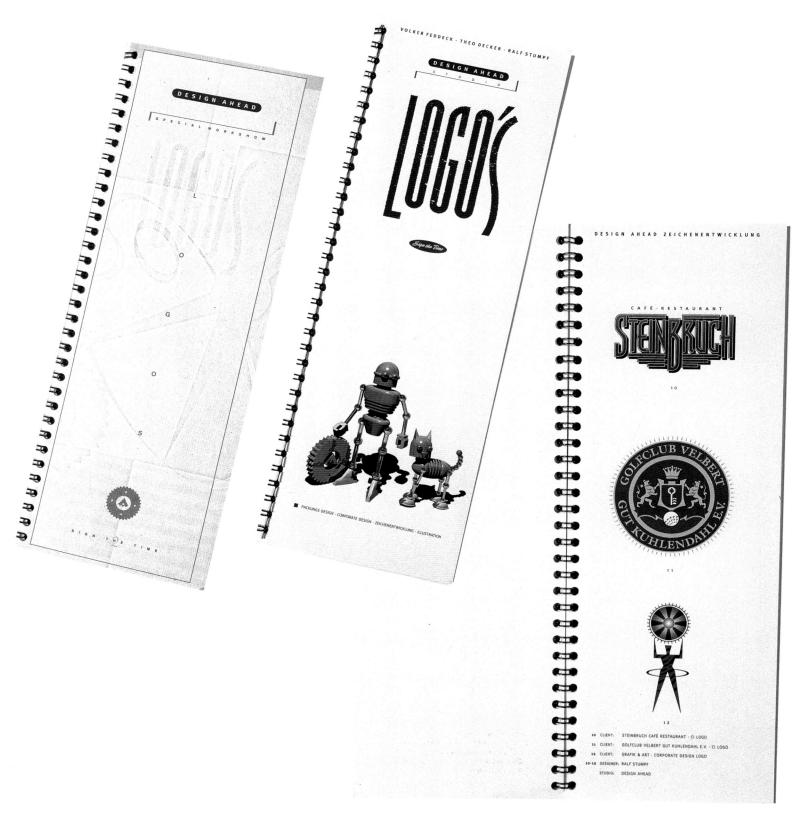

1
Design Firm **Design Ahead**
Art Director **Ralf Stumpf**
Designers **Stumpf, Decker, Feddeck**
Illustrator **Ralf Stumpf**
Client **Design Ahead**
Paper **Canabis, Ikonofix**
Tools **Macromedia FreeHand, Adobe Photoshop,**
 and Specular International Infini-D

2
Design Firm **Held Diedrich**
Art Director **Dick Held**
Designer **Megan Snow**
Photographer **Partners Photography**
Copywriter **Andie Marshall**
Client **Fairbanks Hospital - Annual Report**
Paper/Printer **Strathmore Elements**

2➤ *Fairbanks Hospital is nationally recognized, non-profit, chemical-dependency treatment provider. The theme "Opening Doors to Recovery" is visually carried through this brochure with photographs of actual doors. Since the clients are a not-for-profit entity, wise budget management dictated the use of three spot colors throughout the piece.*

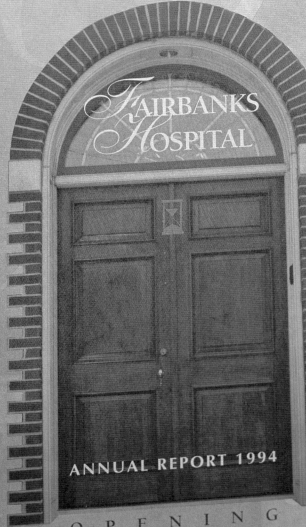

FAIRBANKS
HOSPITAL

ANNUAL REPORT 1994

OPENING

DOORS TO

RECOVERY

1

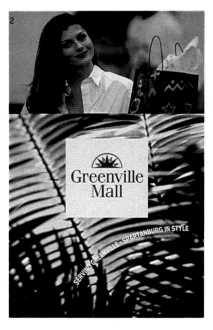

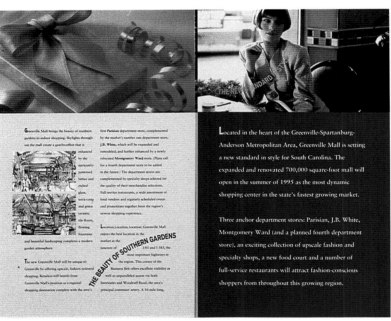

1
Design Firm **Segura Inc.**
Art Director **Carlos Segura**
Designer **Carlos Segura**
Photographer **Geof Kern**
Copywriter **John Cleland**
Client **John Cleland**
Printer **Argus Press**
Tools **Adobe Illustrator, QuarkXPress,**
 and Adobe Photoshop

2
Design Firm **Gregory Group**
Art Director **Jon Gregory**
Client **Intershop Real Estate**
Paper/Printer **Loe 100 lb. Cover Gloss, Colormark**
Tools **QuarkXPress**

2➤ *Created for a large regional mall undergoing a major renovation, this leasing brochure had to be upscale and vibrant, to motivate tenant interest. A blend of fashion-forward photos and detail photos of gifts and food sets the tone for the mall's new direction.*

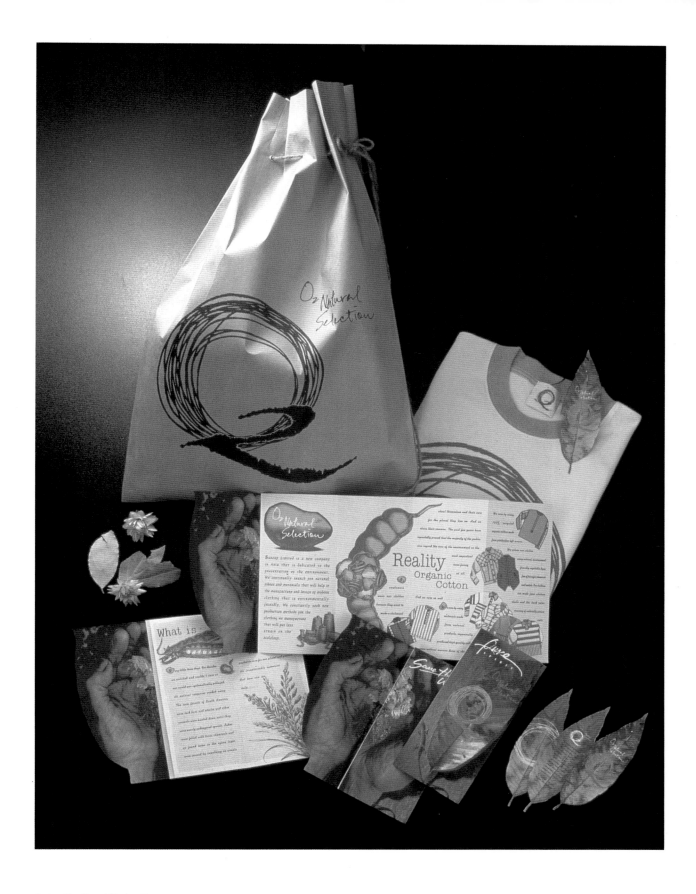

Design Firm **Grand Design Co.**
Art Directors **Grand So, Kwong Chi Man**
Designers **Kwong Chi Man, Grand So**
Illustrator **Martin Ng**
Photographer **Almond Chu**
Copywriter **Finny Maddess Consultants Ltd.**
Client **Sureap Ltd.**
Printer **Reliance Production**

Design Firm **Shari Flack**
Art Director **Shari Flack**
Designer **Shari Flack**
Copywriter **Shari Flack**
Client **Shari Flack**
Paper **Arvey**
Tool **QuarkXPress**

Used as a follow-up piece for résumés, this brochure was photocopied in-house to save costs, then assembled by hand.

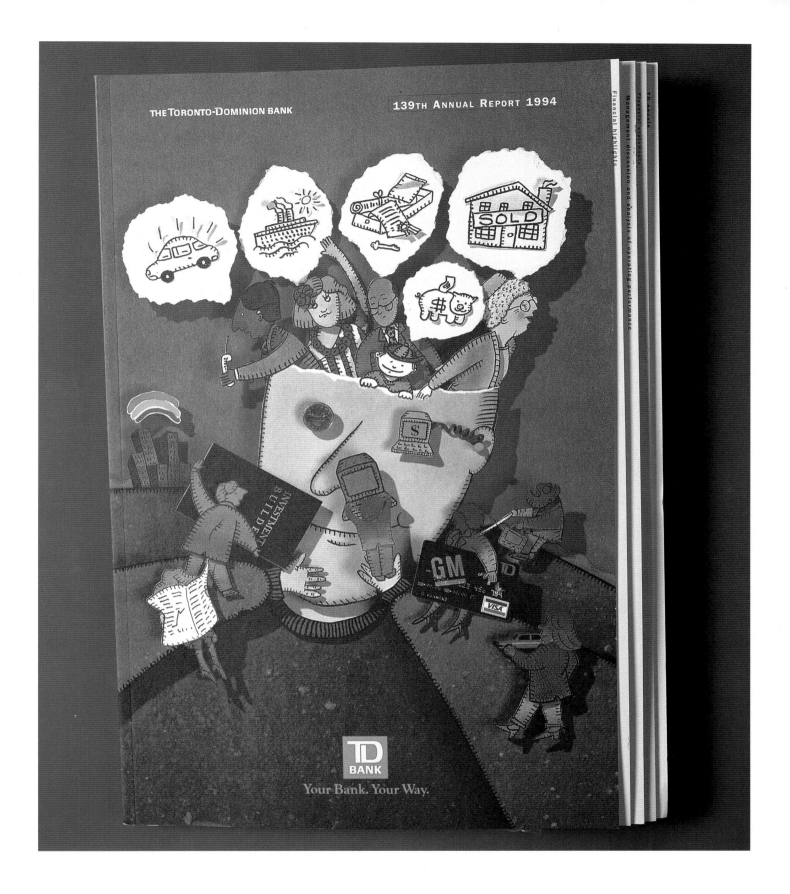

Design Firm **Eskind Waddell**
Art Director **Roslyn Eskind**
Designers **Roslyn Eskind and Nicola Lyon**
Illustrator **Franklin Hammond**
Copywriter **Toronto Dominion Bank**
Client **Toronto Dominion Bank**
Printer **Arthurs - Jones Lithographing Ltd.**
Tools **Adobe Illustrator, QuarkXPress,
 and Adobe Photoshop**

*The report is organized in tiered, manageable sections,
with varying amounts of detail and complexity—so it
appeals to a variety of audiences.*

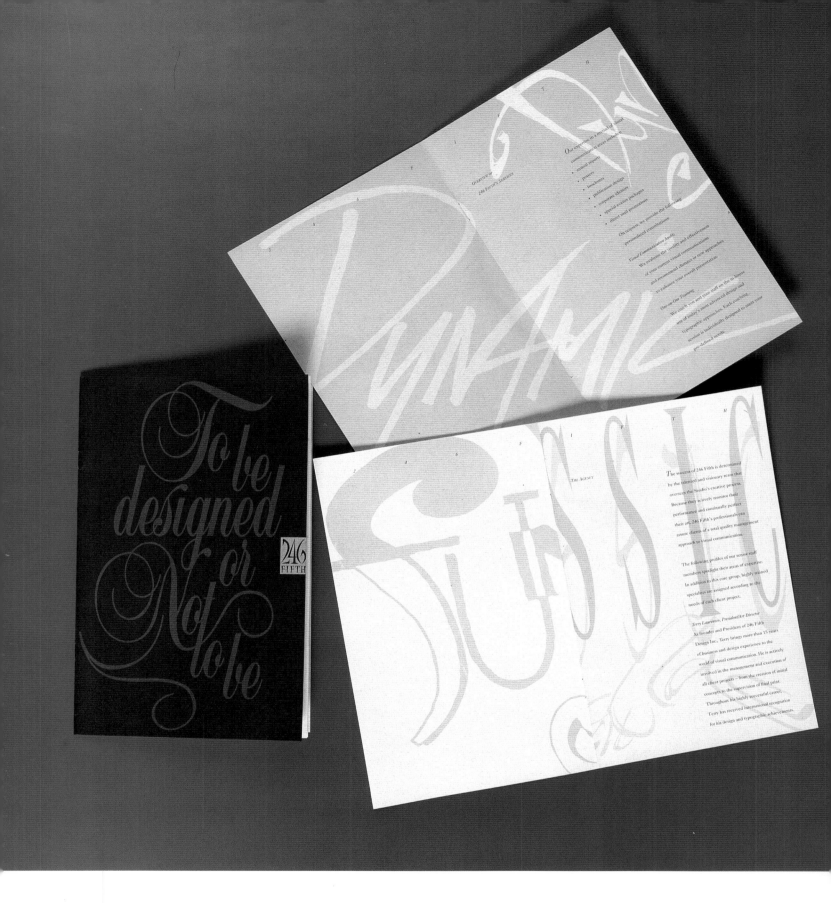

Design Firm **246 Fifth Design**
Art Director **Terry Laurenzio**
Designer **Sid Lee**
Copywriter **Joy Parks**
Client **246 Fifth Design**
Paper/Printer **Neenah, Custom Printers of Renfrew**
Tool **Adobe Illustrator**

This piece features 5-color metallic ink on black linen paper, with a 2-color interior. Some of the type is hand drawn.

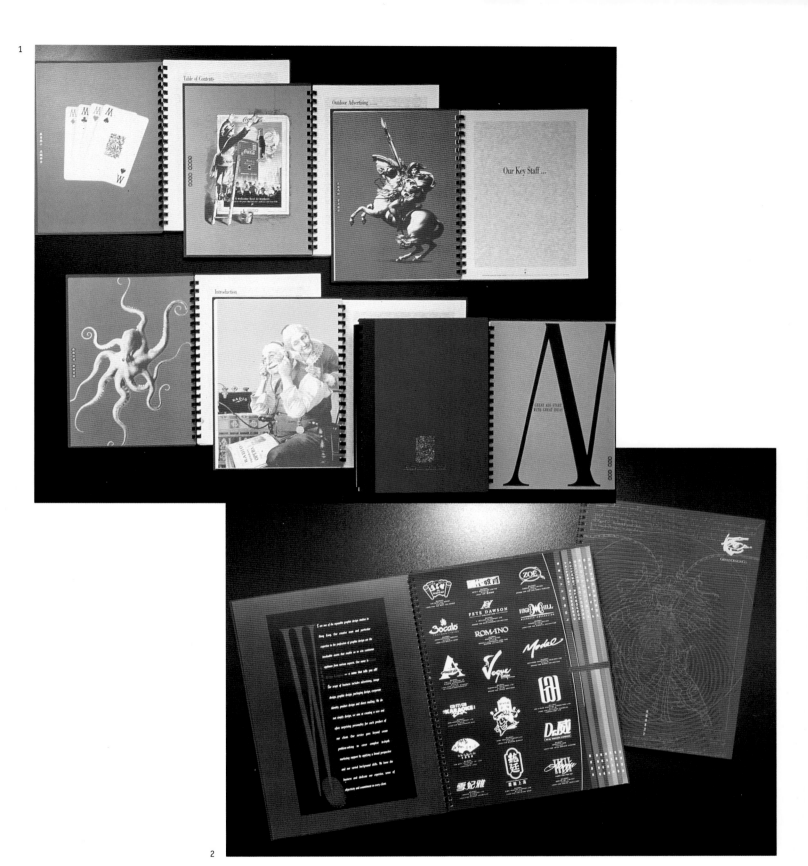

1
Design Firm **Masterline Communications Ltd.**
Art Directors **Grand So, Raymond Au,**
 Kwong Chi Man, Candy Chan
Designers **Grand So, Raymond Au, Kwong Chi Man**
Illustrators **Grand So, Kwong Chi Man**
Photographer **David Lo**
Copywriters **Grand So, Johnson Cheng**
Client **Masterline Communications Ltd.**

2➤ *The portraits on the front and inside covers are
designed to reflect the intelligence and energy
of the client.*

2
Design Firm **Grand Design Co.**
Art Directors **Grand So, C.M. Kwong, Raymond Au,**
 Candy Chan
Designers **Grand So, C.M. Kwong, Raymond Au**
Illustrators **Grand So, C.M. Kwong**
Photographer **David Lo**
Copywriters **Grand So, Mimi Lee**
Client **Grand Design Co.**

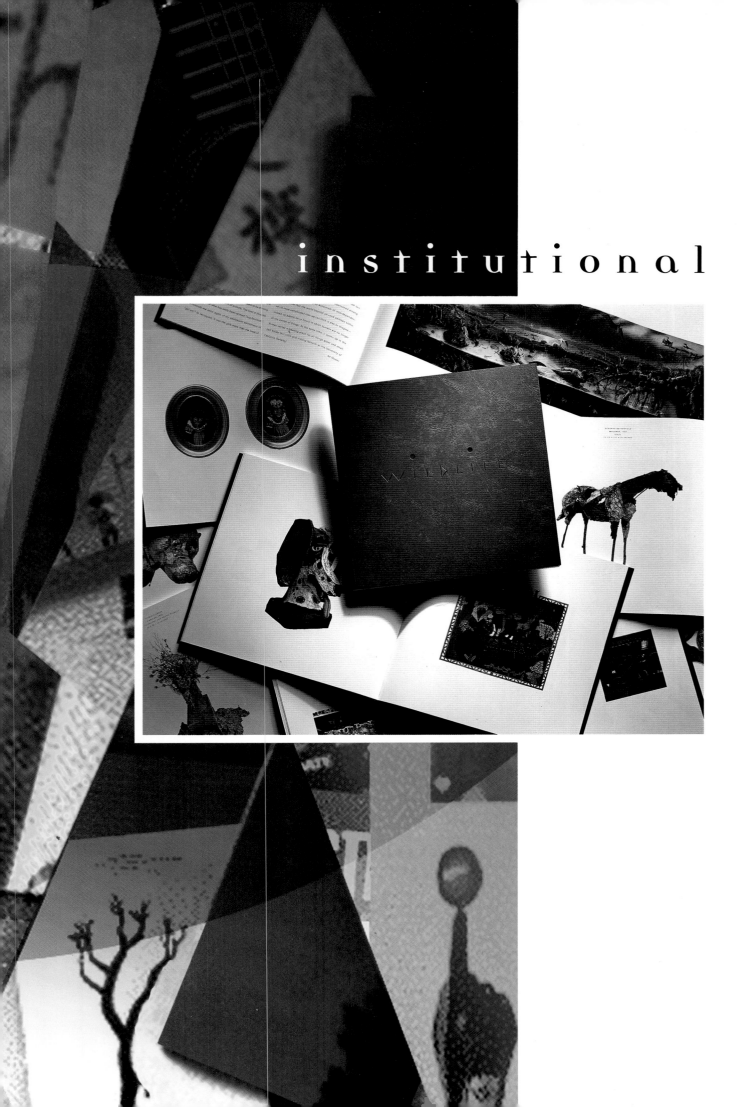

institutional

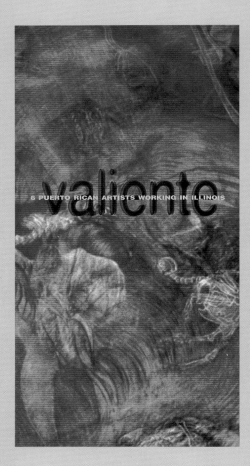

José Andreu

A graduate of the University of Wisconsin, José has exhibited widely including Barat College, Oskar Friedl Gallery, Klein Art Works, World Tatoo Gallery and Ruiz Belvis Cultural Center. José teaches at Columbia College, Roosevelt University and the School of the Art Institute and directs programs for the Mexican Fine Arts Center/ Museum, and the Department of Cultural Affairs. José curated exhibits for Gallery 37, is board member of the Chicago Artists Coalition and juried the Hispanic Art Exhibit for the Museum of Science and Industry. His paintings represent an investigation on the aesthetics of identity, ethnicity and universality.

The six artists selected for this exhibition have been brought together for their contributions to the visual arts as well as for their cultural heritage. Puerto Rican by birth, all six now live in Chicago and share in the experience of leaving their place of origin and reconstructing new lives in the Midwest. Today they follow professional careers in the visual arts. Three of the artists presented here arrived in Illinois at a young age, (José Andreu, Oscar Luis Martínez and Gamaliel Ramírez) while the others came as adults (Antonio Navia, Raúl Ortiz Bonilla and Bibiana Suárez).

The idea of emigrating, beginning new lives, and making professional choices to live and work in the United States has always been a complicated affair for Puerto Ricans. The culture of Puerto Rico has provided a strong identity for individuals living in and away from the Island. As their work has evolved in the United States, and while still keeping in mind the important aspects of their homeland, these artists have found distinct ways to contribute to the language and dialogue of art. Puerto Ricans come from a much older culture than that of the United States. It is a society whose people are deeply rooted in the Spanish and African traditions of language and religion, as well as being strongly influenced by the indigenous heritage of its first inhabitants, the Taino Indians. This mixture of races and cultures existed before the colonization of North America

Bibiana Suárez

Seen together in this exhibition, the artists and their work provide the viewer with six distinct voices. All the artists are participants in visual arts, as well as members of the midwestern community. Their work not only presents the opulent vocabulary of visual styles present within this group of artists, but also suggests how these artists and their work still reflect and build upon the heritage of Puerto Rico.

Edward M. Maldonado, Curator

Edward M. Maldonado is the Associate Curator for the City of Chicago, Department of Cultural Affairs and has been a member of its staff since 1989. He has worked as a teaching assistant in the Department of Art History and as an instructor in the Painting Department at the School of the Art Institute. As an independent curator he curated five major exhibitions in Chicago at the Randolph Street Gallery and WPA gallery. His professional activities include Board Member at the New Art Examiner and Randolph Street Gallery. Mr. Maldonado's formal education includes: MA, School of the Art Institute of Chicago, 1992; BFA The School of the Art Institute of Chicago, 1978; Academy Fine Arts, Chicago, 1975.

A native of Mayagüez, Puerto Rico, Bibiana Suárez studied at the School of the Art Institute and as Associate Professor, currently teaches at DePaul University. Bibiana exhibits widely in one person and group exhibitions most recently at Painted Bride Art Center in Philadelphia, Kohler Arts Center in Sheboygan, WI and with the Inter/American Gallery of Miami Dade Community College. Recent grants and awards include the Illinois Arts Council Fellowship Award, Community Arts Assistance Grant, Arts Midwest/NEA Regional Visual Arts Fellowship.

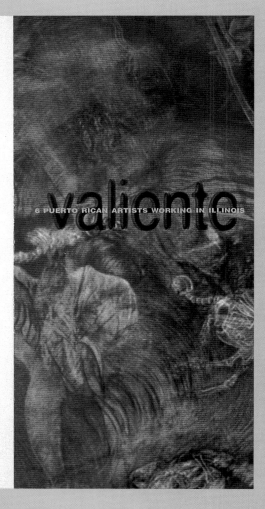

valiente
6 PUERTO RICAN ARTISTS WORKING IN ILLINOIS

José Andreu, Raúl Ortiz Bonilla, Oscar Luis Martínez, Antonio Navia, Gamaliel Ramírez and Bibiana Suárez

Curated by Edward Maldonado of the Chicago Cultural Center

Northern Illinois University Art Museum
Altgeld Hall
DeKalb, Illinois

April 20 - May 13, 1995

Near Northwest Arts Council
1579 North Milwaukee Avenue
Chicago, Illinois

July 7 - August 12, 1995

South Shore Cultural Center
7059 South South Shore Drive
Chicago, Illinois

September 15 - October 14, 1995

This exhibition has been co-sponsored by the Northern Illinois University Art Museum and the Near Northwest Arts Council with partial support from the Illinois Arts Council, a state agency.

Credits:
Front Panel: Detail of "Una Question de Honor", Bibiana Suárez.
Design: Carol Benthal-Bingley

Design Firm **Northern Illinois University Office of Publications**
Art Director **Carlos J. Granados**
Designer **Carol M. Benthal-Bingley**
Illustrator **Carol M. Benthal-Bingley**
Client **Northern Illinois University Art Museum**
Paper/Printer **10 pt. Carolina C2S, River Street Press**
Tools **Adobe Illustrator, Adobe PageMaker, and Adobe Photoshop**

The designer created the fonts for the head and subhead in Illustrator and then brought them into Photoshop to create the feathered and transparent look.

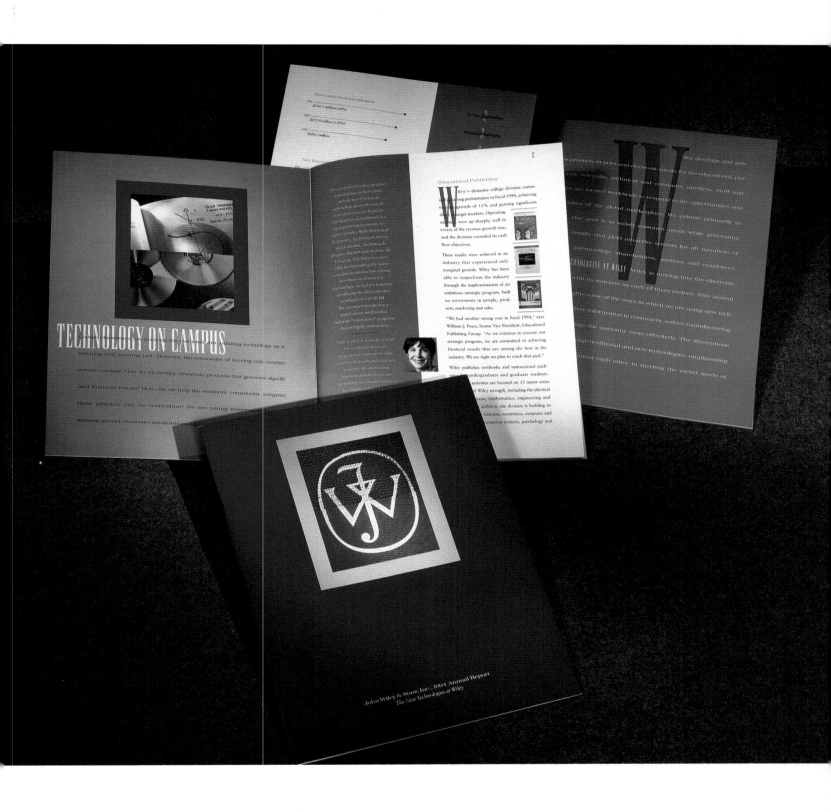

Design Firm **Bernhardt Fudyma Design Group**
Art Director **Janice Fudyma and Iris Brown**
Designer **Iris Brown**
Photographer **David Arkey**
Copywriter **Dick Blodgett**
Client **John Wiley & Sons, Publisher**
Paper/Printer **Lustro Offset Dull Recycled, Lebanon
 Valley Offset**
Tool **QuarkXPress**

*Bernhardt Fudyma Design produced this project entirely
by electronic means. They never generated any physi-
cal, paper art. They used black-and-white photographs
and scanned negatives, adding color with Photoshop.
They then gave the image files to the printer, who pro-
duced the final product.*

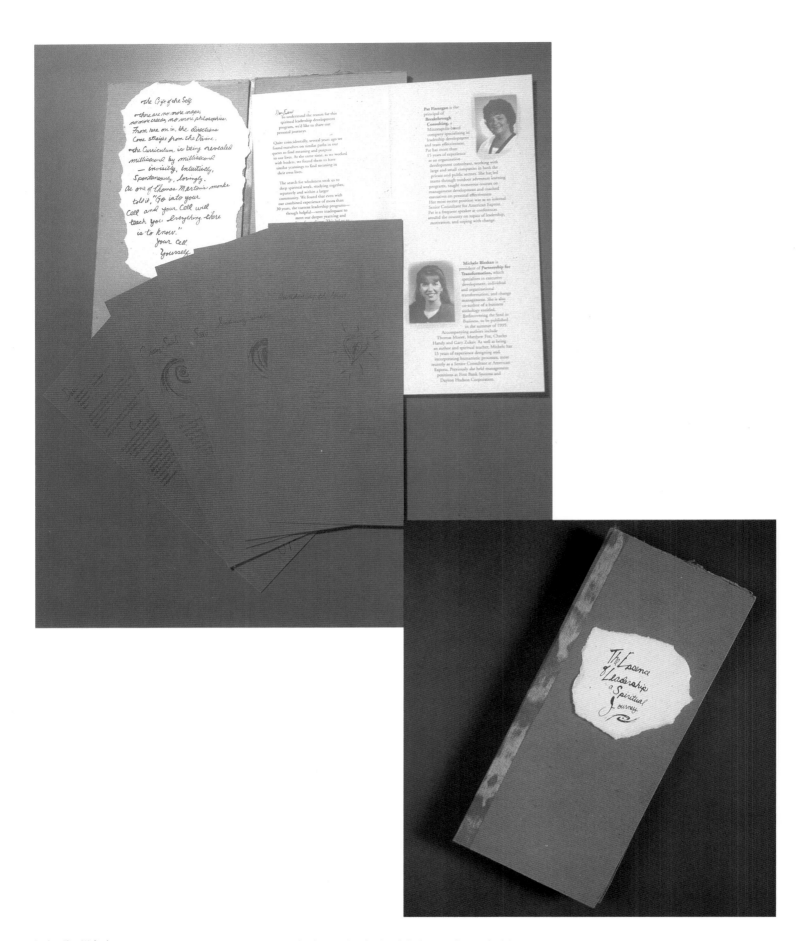

The designer hand-painted the icons and created original typefaces. The brochure was assembled by hand.

Design Firm **W design**
Art Director **Alan Wallner**
Designer **Alan Wallner**
Client **Breakthrough Consulting**
Printer **Tandem Printing**
Tool **QuarkXPress**

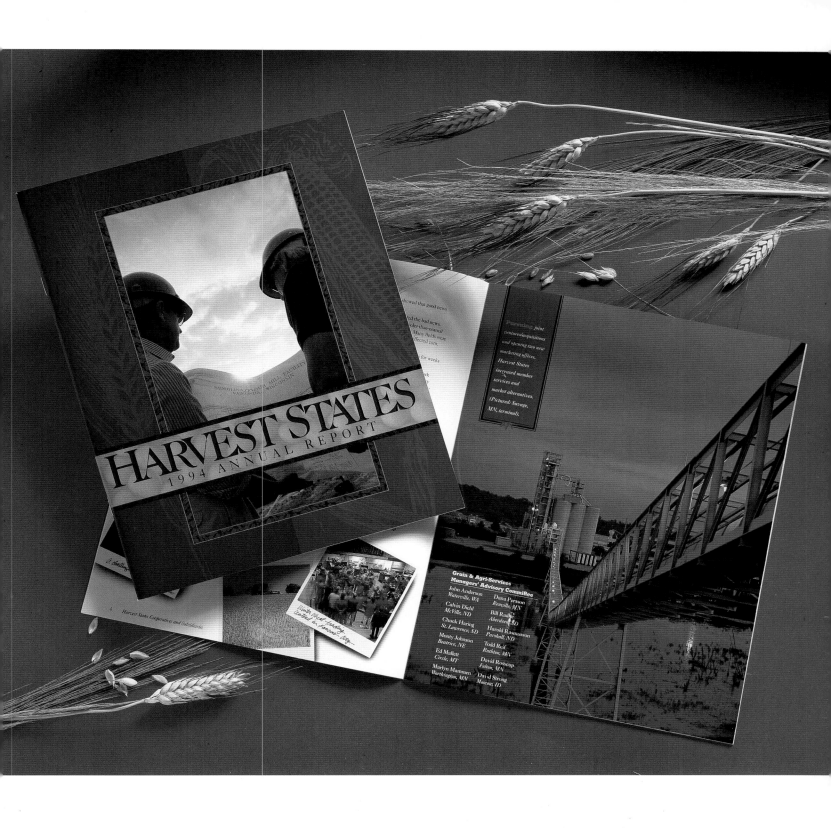

Design Firm **Wehrman & Company, Inc.**
Art Director **Ken Wehrman**
Designers **Greg Jager, Pat Majewski,**
 and Karen Williams
Photographer **Jim Erickson**
Copywriter **Harvest States**
Client **Harvest States**
Paper/Printer **Glen Eagle, Marlo Graphics, Inc.**

Wehrman & Company created this high-impact financial report using Polaroid images and hand-written cut lines.

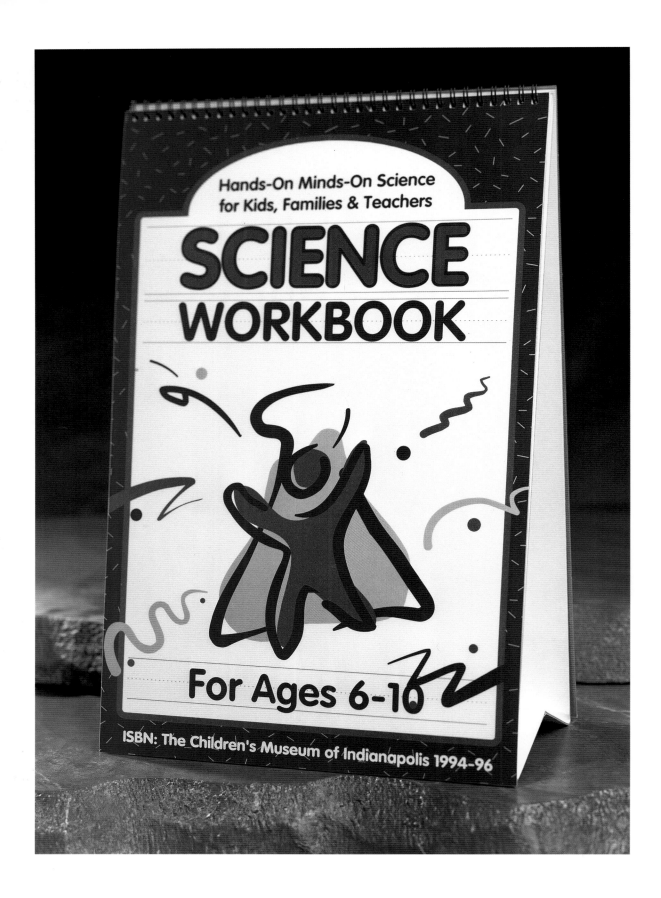

Design Firm **Held Diedrich**
Art Director **David Snedigar**
Designers **David Snedigar and Linda Lazier**
Illustrator **David Snedigar**
Copywriter **Linda Lazier**
Client **Indianapolis Children's Museum**
Tools **QuarkXPress, Adobe Illustrator, and a Wacom tablet**

The Children's Museum of Indianapolis created this piece as a fund-raising sales flip chart. They wanted to show what the donations could fund. The piece emulates the old style school writing tablets—a natural tie-in to the museum.

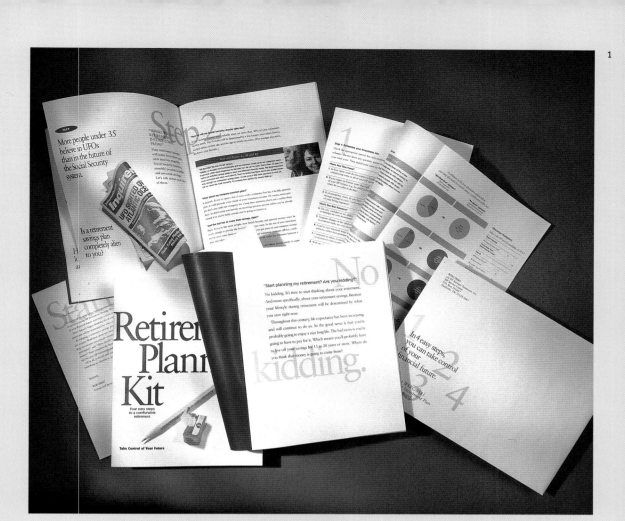

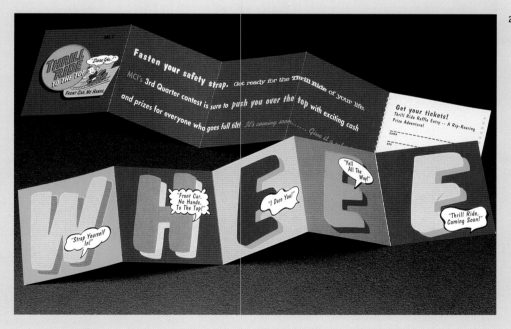

1
Design Firm **Bernhardt Fudyma Design Group**
Art Directors **Craig Bernhardt and Janice Fudyma**
Designer **Janice Fudyma**
Illustrator **Matt Foster**
Photographers **David Ackey and Jeanne Strognin**
Client **Bankers Trust**
Paper/Printer **Mohawk Opaque, Tanagraphics**
Tools **QuarkXPress**

2
Design Firm **Lee Reedy Design**
Art Director **Lee Reedy**
Designer **Lee Reedy**
Illustrator **Mathew McFarren**
Copywriter **Shawn Allegrezza**
Client **MCI**
Paper/Printer **Lithofect, Frederic**
Tool **QuarkXPress**

2➤ *This piece is teaser for an employee incentive program.*

Why

invest or rent in

London?

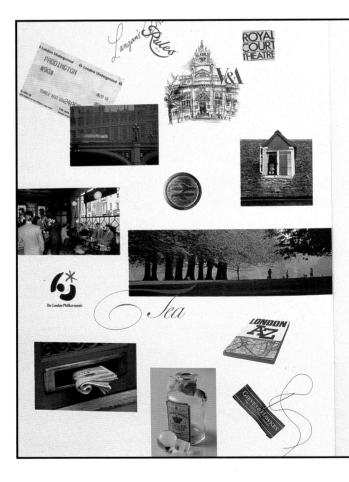

...because

London is one of the truly great cities of the world with green parklands, wide open spaces, palaces, elegant houses, museums, theatres and attractive shops. It is also safe in the broadest sense of personal security and offers comprehensive facilities for recreation and educational pursuits. London is one of the leading business centres of the world and is an important centre of communications between Asia and America.

Historically, it has made good financial sense for Britons living abroad as expatriates to maintain a stake in the UK property market through a residential property investment in London. For residents of the United Kingdom, the inclusion of a well-managed property investment in the Capital can be financially rewarding and, for non-British individuals, a combination of the soundness of the British constitutional system and a stable market provides a safe environment in which to

invest with confidence.

Design Firm **George Tscherny**
Art Director **George Tscherny**
Designers **George Tscherny and Lynne Buchman**
Copywriter **Chris Dick**
Client **PKL Limited**
Paper/Printer **Parilux, Matte White, 127 lb. Balding and Mansell (England)**

PKL Limited sells and rents real estate in London. The designers' premise in creating the brochure was that they had to sell London before selling the company. The result was a cover that teased the reader into turning the page for an answer to the question.

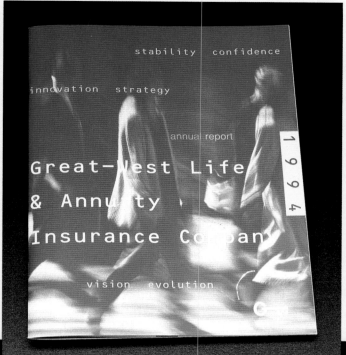

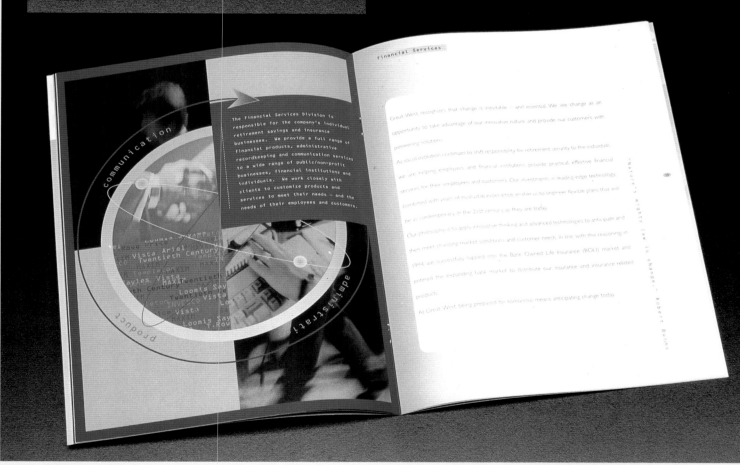

Design Firm **Lee Reedy Design**
Art Director **Lee Reedy**
Designer **Heather Haworth**
Illustrator **Heather Haworth**
Photographer **Ron Coppock and stock**
Copywriter **Great West**
Client **Great West**
Paper/Printer **Productolith, L & M Printing**
Tools **QuarkXPress, Adobe Illustrator, Macromedia
 FreeHand, and Adobe Photoshop**

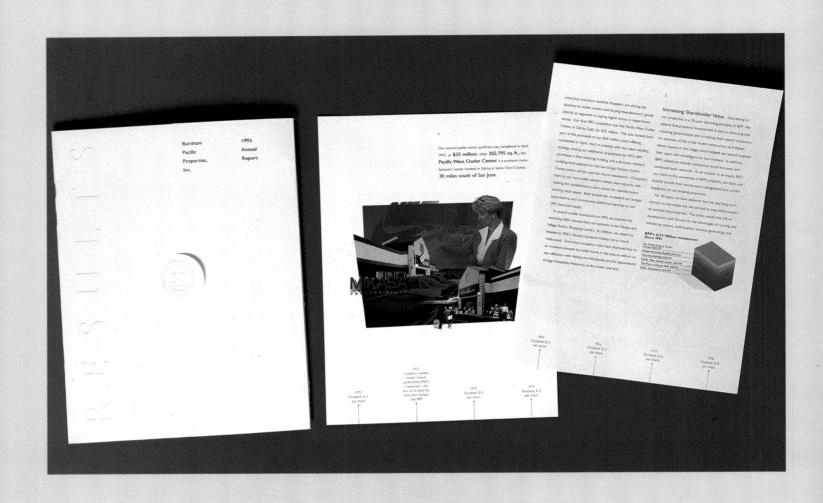

Design Firm **Mires Design, Inc.**
Art Director **John Ball**
Designer **John Ball**
Illustrator **Mark Lyon**
Client **Burnham Pacific Properties, Inc.**

The designer used embossing to dress up the annual report for Burnham Pacific Properties.

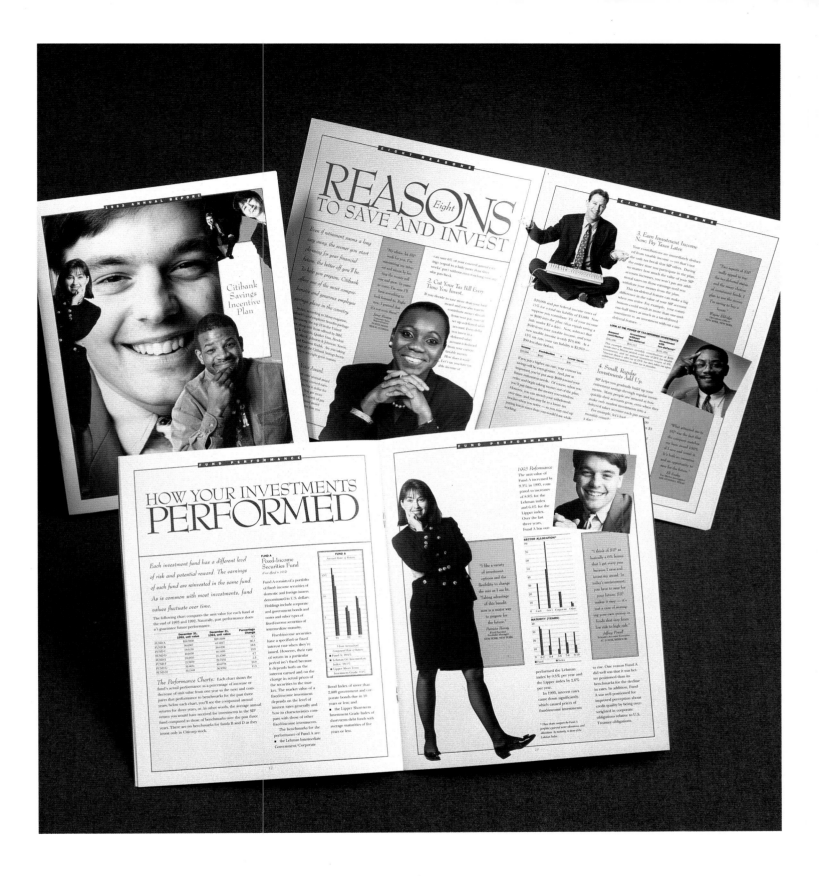

Design Firm **Bernhardt Fudyma Design Group**
Art Director **Iris Brown**
Designer **Iris Brown**
Client **Citibank**
Paper/Printer **Consolidated Centura,**
 Lebanon Valley Offset
Tools **QuarkXPress**

The logistics for this project were difficult: design had to coordinate and direct photographers in 14 different cities to photograph more than 20 people in such way that the final product appeared to be the work of a single photographer.

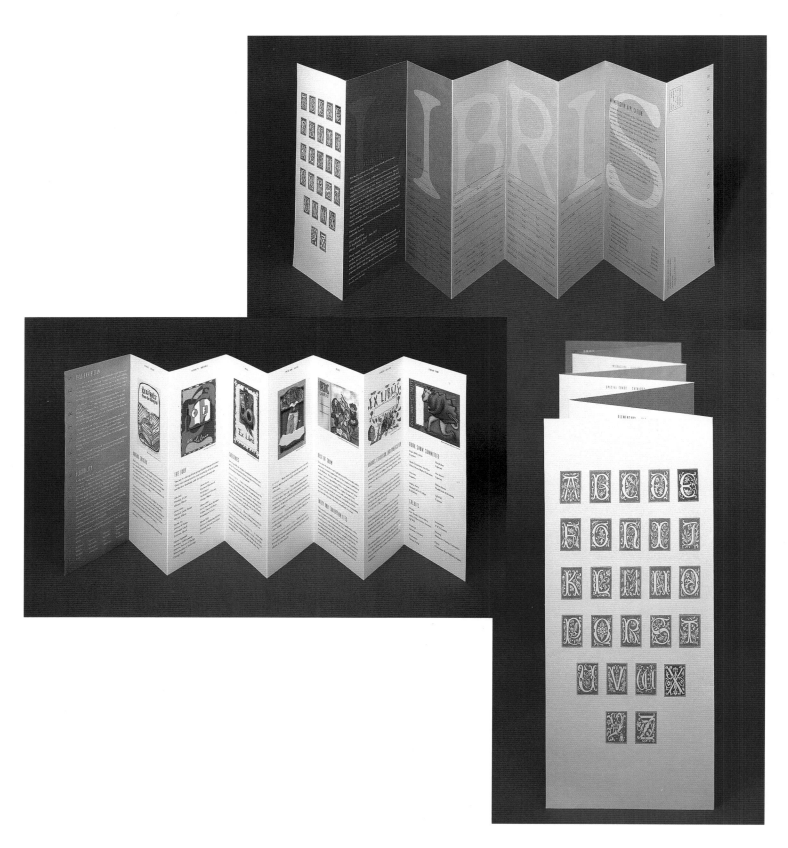

Design Firm **Ligature, Inc.**
Art Director **Jeff Wills**
Designers **John Menefee, Tamra Nelson,
 Jundine O'Shea, and Kristen Perantoni**
Illustrators **Chuck Gonzales, Jose Ortega,
 Victoria Raymond, Susan Swan, Latjana Krizmanic,
 Leslie Cober-Gentry, and Marie Lafrance**
Copywriter **Adrienne Lieberman**
Client **The Chicago Book Clinic**
Paper/Printer **Scott Vellum Opaque Cover, 65 lb,
 Cream, Wicklander Printing Corporation**
Tools **QuarkXPress and Adobe Photoshop**

*The Chicago Book Clinic is a nonprofit organization.
The artists and suppliers who worked on this project
donated their time, services, and goods. The designers
chose the Ex Libris, or bookplate theme, in the tradi-
tion of fine book making. Each illustration is a book-
plate which represents a different entry category.*

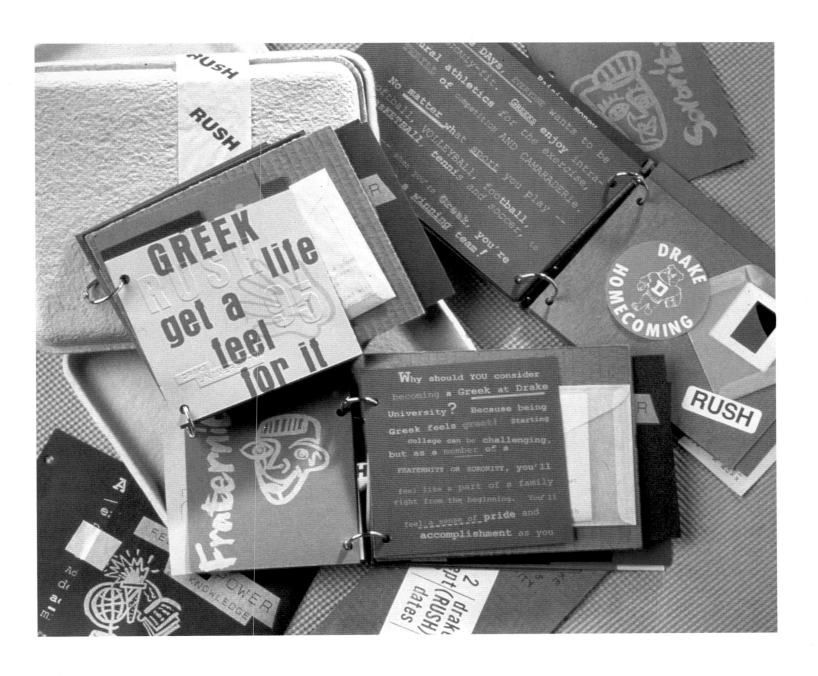

Design Firm **Sayles Graphic Design**
Art Director **John Sayles**
Designer **John Sayles**
Illustrator **John Sayles**
Copywriter **Wendy Lyons**
Client **Drake University**
Paper/Printer **Curtis Tuscan Antique, Action Print,
 Acme Printing**

For this fraternity/sorority "rush" recruitment mailing,
the designer used found objects, including paper rem-
nants from a recently completed corporate project,
scrap corrugated cardboard, and industrial office sup-
ply materials. Perhaps the most innovative material
found is the front cover of the piece; it is an actual
metal printing plate. Although they were never actually
used in the printing process, the plates have been
burned with the project title "Greek Life: Get A
Feel For It."

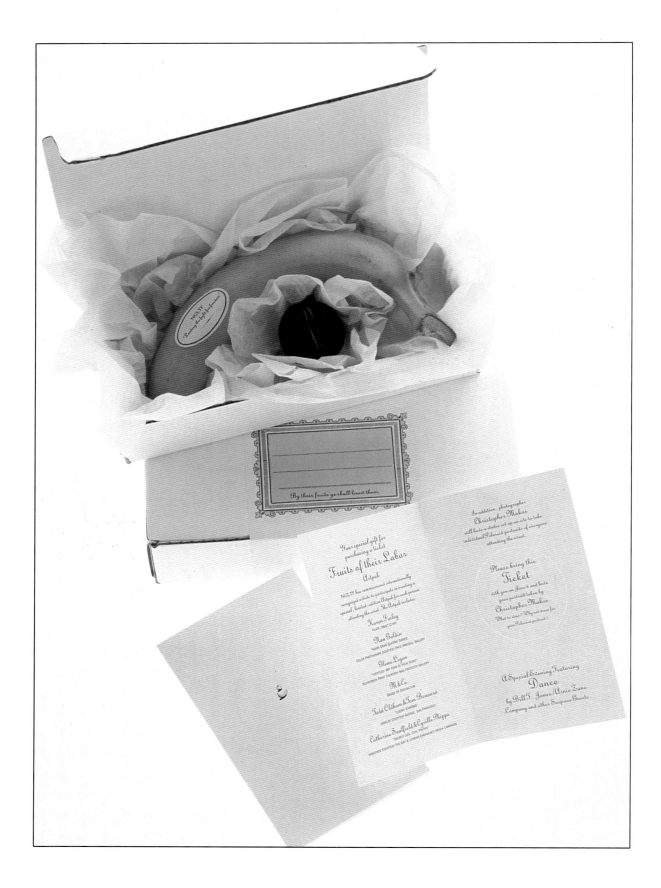

Design Firm **M & Company**
Art Director **Stefan Sagmeister**
Designer **Stefan Sagmeister and Tom Walker**
Illustrator **Tom Walker**
Copywriters **Lee Brown and Stefan Sagmeister**
Client **Gay and Lesbian Task Force**
Paper/Printer **80 lb. uncoated corrugated box, tissue paper**

This brochure comes in a box with a real banana and plum. Two thousand pieces were sent out during a summer heat wave, making production a nightmare. The bananas were rotten by the time the plums arrived, but in the end, the project was a success. Most of the packages were hand-delivered.

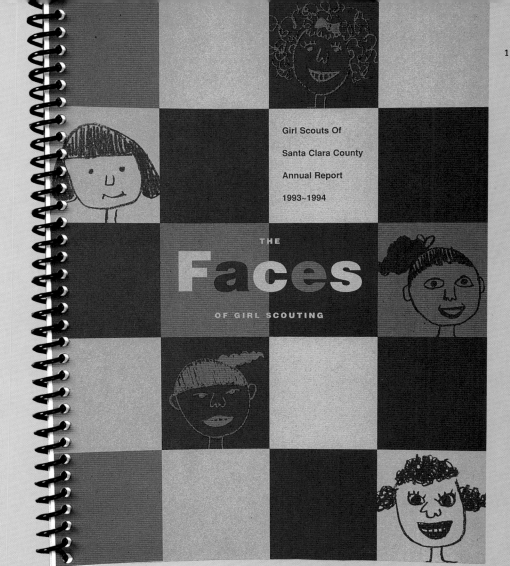

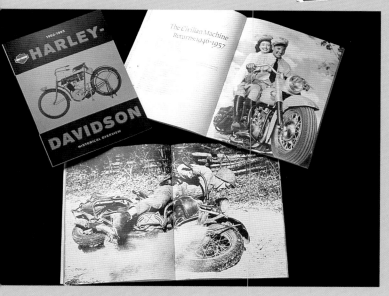

2

1
Design Firm **Melissa Passehl Design**
Art Director **Melissa Passehl**
Designers **Melissa Passehl and Jill Steinfeld**
Illustrator **Betty Bates**
Photographer **Franklin Avery**
Copywriter **Susan Sharpe**
Client **Girl Scouts of Santa Clara County**
Paper/Printer **Simpson Quest Auburn 80 lb. cover,**
 Karma 100 lb.text, Meitzler Printing

1➤ *With "The Faces Of Girl Scouting" in mind, this
annual report represents the multi-cultural diversity
and empowering programs that are characteristic
of the Girl Scouts. The illustrations and pho-
tographs create a playful solution within this
small, spiral-bound format.*

2
Design Firm **Segura Inc, USA Partners**
Art Directors **Carlos Segura, Dana Arnett, and Ken Fox**
Designer **Carlos Segura**
Copywriter **USA Partners**
Client **Harley-Davidson**
Tools **Adobe Illustrator, QuarkXPress,**
 Adobe Photoshop

1

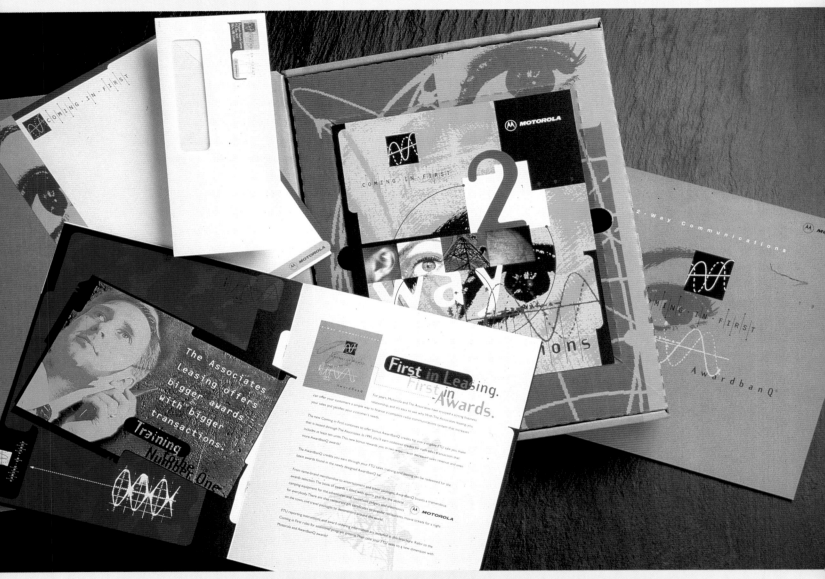

1
Design Firm **Richard Endly Design, Inc.**
Art Director **Bob Berken**
Designer **Keith Wolf**
Client **Business Incentives, Motorola**
Tools **Adobe Illustrator, Adobe Photoshop,
 and QuarkXPress**

2
Design Firm **Caldera Design**
Art Director **Paul Caldera**
Designers **Tim Fisher and Paul Caldera**
Illustrator **Jacques Barbey**
Client **Phelps Dodge**
Tools **QuarkXPress and Adobe Photoshop**

2➤ *Caldera Design used a combination of electronic
and live photos to create the composite of images
on the inside of the brochure.*

PHELPS DODGE CORPORATION

CANDELARIA

1994 ANNUAL REPORT

PHELPS DODGE INDUSTRIES

Phelps Dodge Industries

will use strategic acquisitions,

modernization, expansion,

new product development

and technological leadership

to strive to double its 1992

operating cash flow by the end

of the century. The companies of

Phelps Dodge Industries possess

significant market shares,

internationally competitive costs,

and the commitment of their

9,000 employees to quality

and customer partnerships.

Phelps Dodge Industries consists of leading companies and their associate companies that produce wheels and rims for medium and heavy trucks, trailers and buses; carbon blacks and synthetic iron oxides; magnet wire, electrical and telecommunications cables; and specialty high performance conductors. The core companies of Phelps Dodge Industries are Accuride Corporation, Columbian Chemicals Company, Phelps Dodge International Corporation, Phelps Dodge Magnet Wire Company and Hudson International Conductors.

1994 RESULTS

In 1994, Phelps Dodge Industries recorded operating income of $150.7 million, which was reduced to $106.1 million by $44.6 million of non-recurring pre-tax charges applicable to its operations. Phelps Dodge Industries reported record revenues of $1.47 billion with increased annual earnings reflecting higher 1994 sales volumes in the wheel and rim business, the magnet wire business and the carbon black business. Phelps Dodge Industries made $55.1 million in capital expenditures in 1994. Recent modernizations, expansions and acquisitions enabled these businesses to capitalize on the strong North American economy.

In 1994, eight operating facilities and a research laboratory of Phelps Dodge Industries received ISO certification in recognition of the quality systems standards formulated for manufacturing companies worldwide by the prestigious International Organization of Standardization. This brings the total number of ISO quality certifications obtained by Phelps Dodge Industries to 19.

For the second consecutive year, three associate companies of Phelps Dodge International Corporation received the 1994 *Phelps Dodge Corporation Chairman's International Safety Awards.*

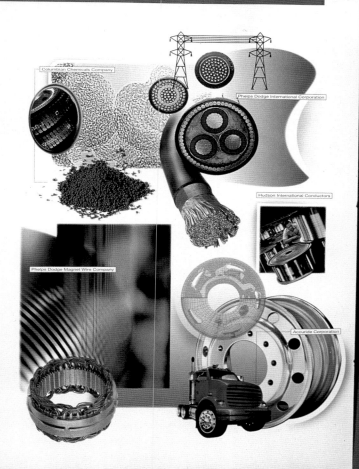

Columbian Chemicals Company

Phelps Dodge International Corporation

Hudson International Conductors

Phelps Dodge Magnet Wire Company

Accuride Corporation

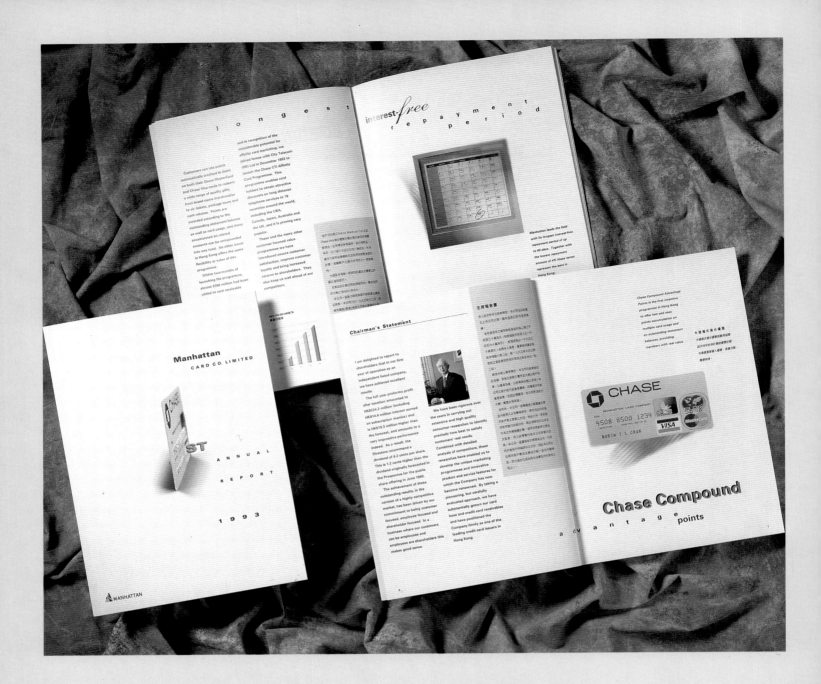

Design Firm **Kan Tai-keung Design & Associates Ltd.**
Art Directors **Kan Tai-keung, Freeman Lau Siu Hong,**
 and Clement Yick Tat Wa
Designers **Clement Yick Tat Wa**
 and Joyce Ho Ngai Sing
Photographer **C K Wong**
Client **Manhattan Card Co. Ltd.**
Paper/Printer **Coated Art Paper,**
 Elegance Printing Co. Ltd.
Tools **Adobe Photoshop and Macromedia FreeHand**

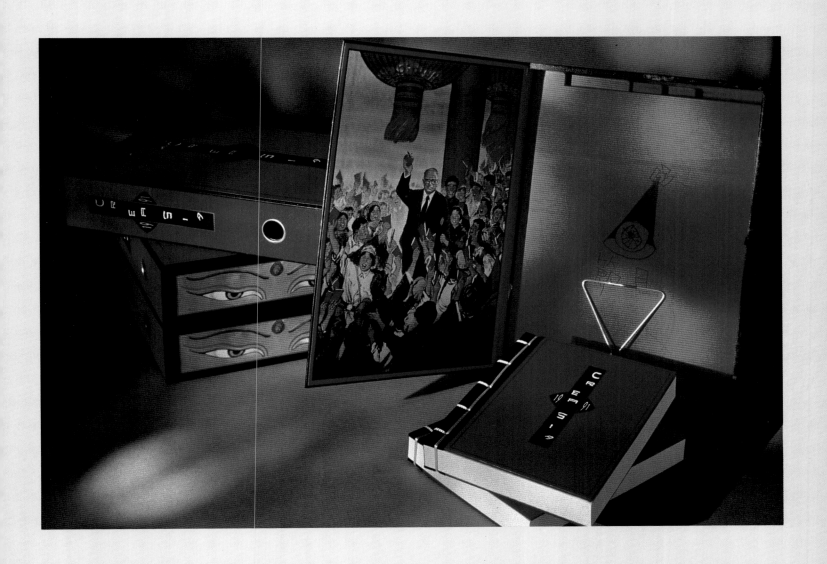

Design Firm **The Design Group**
Art Director **Stefan Sagmeister**
Designers **Stefan Sagmeister, Peter Rae,
and Patrick Daily**
Copywriter **Stefan Sagmeister**
Client **Leo Burnett Hong Kong**

*The Design Group created this piece for a creative con-
ference. To make it interesting, they found out the eye
color of every participant, had glass eyes manufactured
to spec and placed them in a die cut in the notebook.
Then they bound the notebooks by hand.*

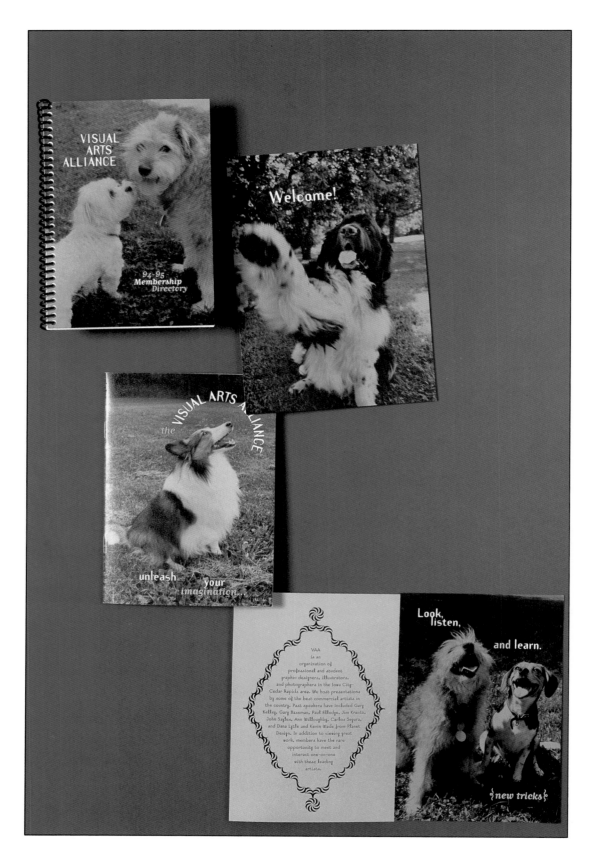

Designers **Kimberly Cooke and Ann Freerks**
Photographer **Jon Van Allen**
Copywriter **Kimberly Cooke**
Client **The Visual Arts Alliance**
Paper/Printer **Simpson Kashmir,**
 Goodfellow Printing, Inc.
Tools **Adobe PageMaker**

The Visual Arts Alliance is a non-profit organization.
All services that went into creating their recruitment
brochure were donated.

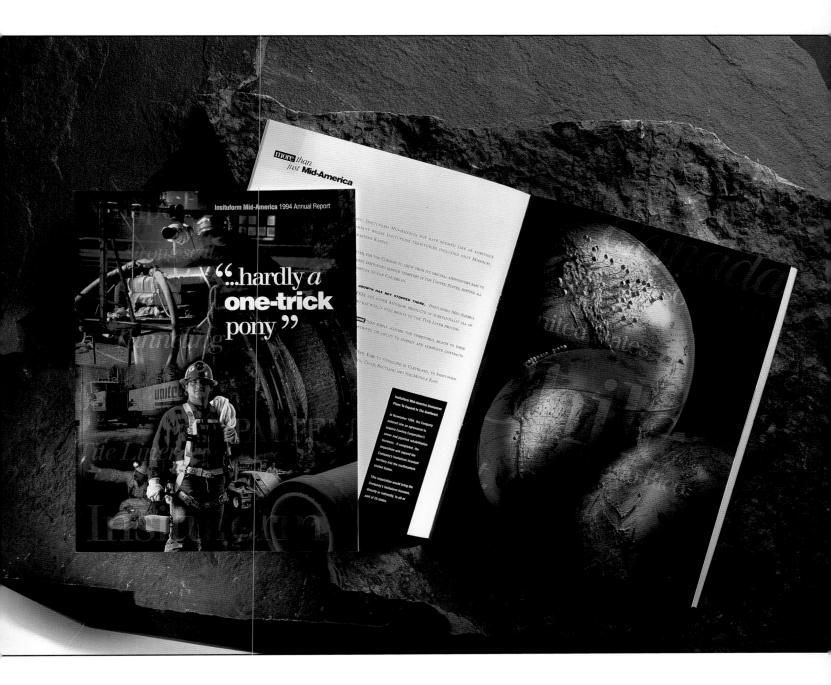

Design Firm **Wehrman & Company, Inc.**
Art Director **Ken Wehrman**
Designer **Greg Jager**
Illustrator **Greg Jager**
Photographer **Gretchen Poag**
Copywriter **Mary Bufe**
Client **Insituform Mid-America**
Paper/Printer **Glen Eagle Dull,**
 Reprox Commercial Printing
Tool **Adobe Photoshop**

*High-resolution Photoshop montages show the diversity
of Insituform Mid-America technologies.*

DEL WEBB CORPORATION 1994 ANNUAL REPORT

Building

Value.

A Way of

Business,

A Way

of Life.

Design Firm **Caldera Design**
Art Directors **Doreen Caldera and Paul Caldera**
Designers **Bart Welch and Doreen Caldera**
Photographer **Rodney Rascona Studios**
Copywriter **Jon Ward**
Client **Del Webb**
Tools **QuarkXPress**

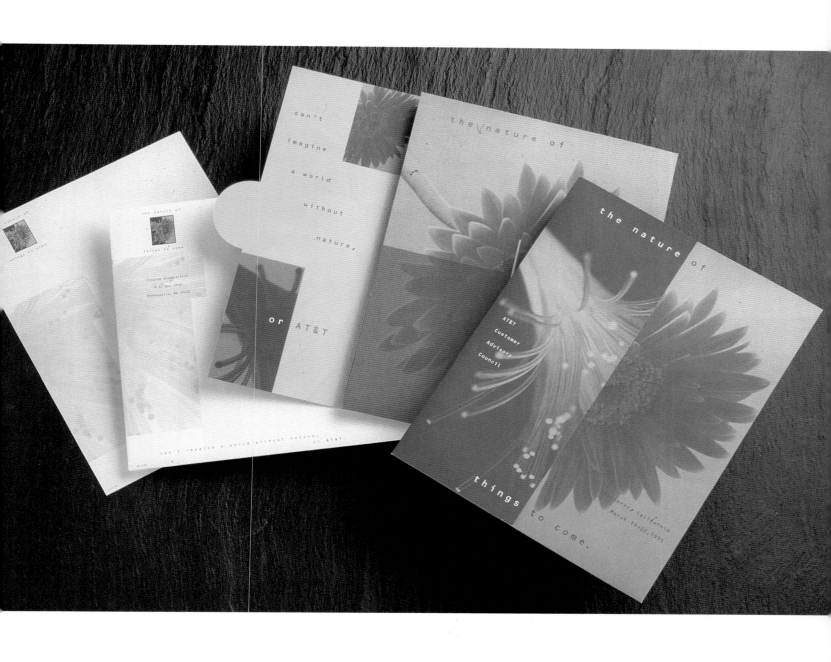

Designer **Richard Endly Design, Inc.**
Art Director **Lydia Anderson**
Designers **Richard Endly and Keith Wolf**
Illustrator **Keith Wolf**
Client **Business Incentives, AT&T**
Tools **QuarkXPress, Adobe Illustrator,**
 and Adobe Photoshop

The designers merged nature with technology, flowers
with fiber optics to create this piece.

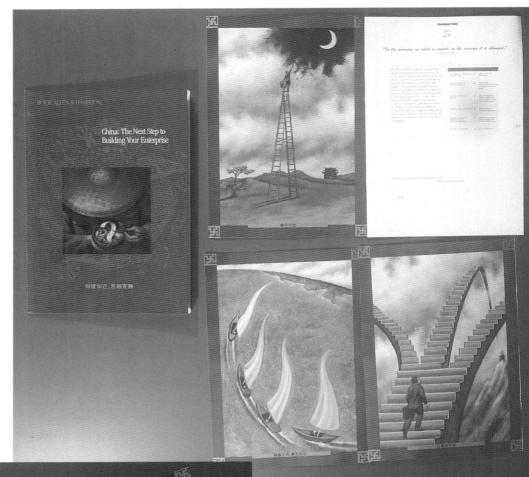

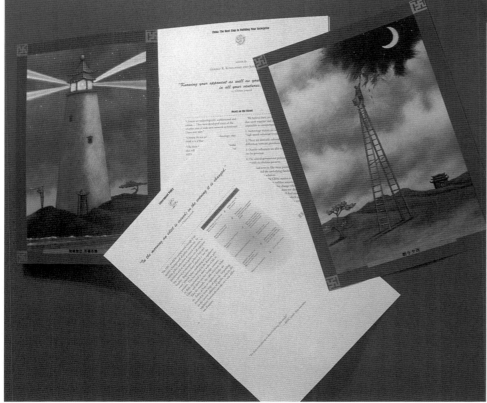

Design Firm **Metropolis Corporation**
Art Director **Denise Mendelsohn**
Designer **Lisa Deseno**
Illustrator **Warren Gerbert**
Client **Booz, Allen & Hamilton**
Printer **W. Mac Printing**

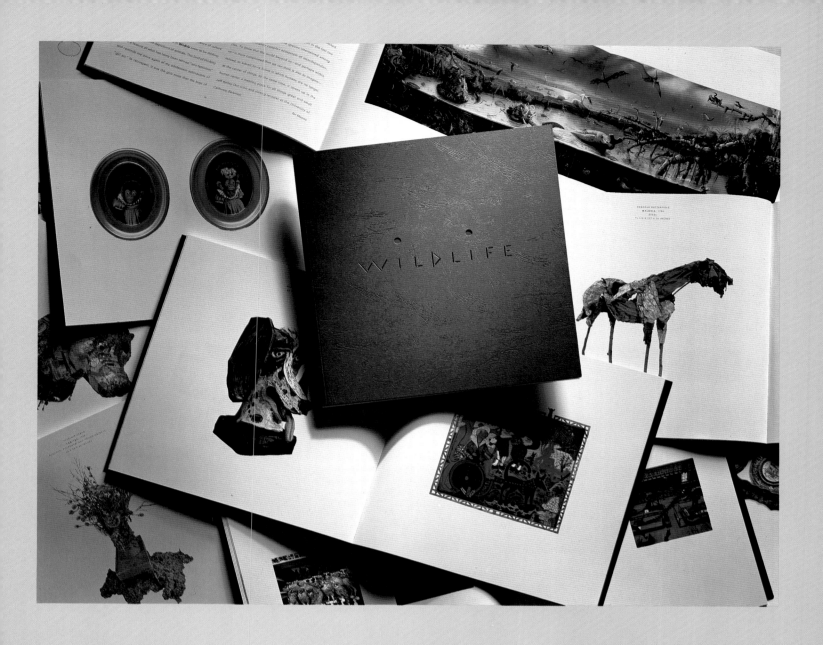

Design Firm **Mires Design**
Art Director **John Ball**
Designers **John Ball and Gale Spitzley**
Client **California Center For The Arts Museum**
Tools **QuarkXPress and Adobe Illustrator**

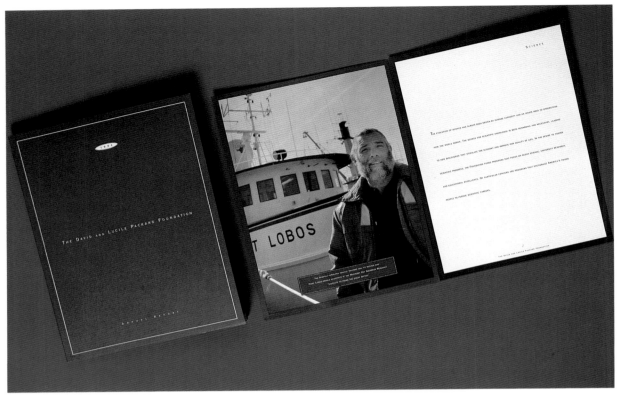

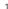

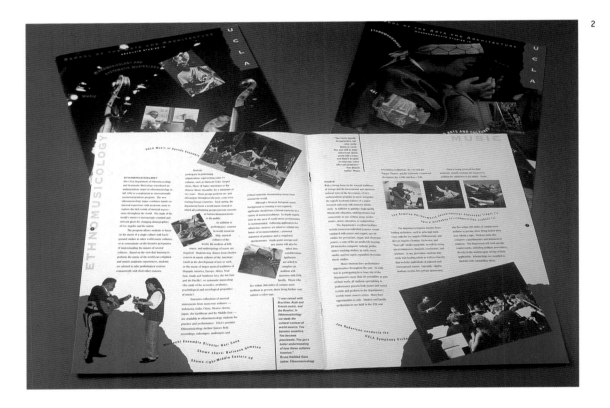

1
Design Firm **Melissa Passehl Design**
Art Director **Melissa Passehl**
Designers **Melissa Passehl and Jill Steinfeld**
Photographer **Franklin Avery**
Copywriter **Susan Sharpe**
Client **The David And Lucile Packard Foundation**
Paper/Printer **Proterra Recycled Paper,
Lithocraft Printers**

2
Design Firm **Julia Tam Design**
Art Director **Julia Chong Tam**
Designer **Julia Chong Tam**
Copywriter **Dale Applebaum**
Client **UCLA School of Arts and Architecture**
Printer **Donahue Printing**

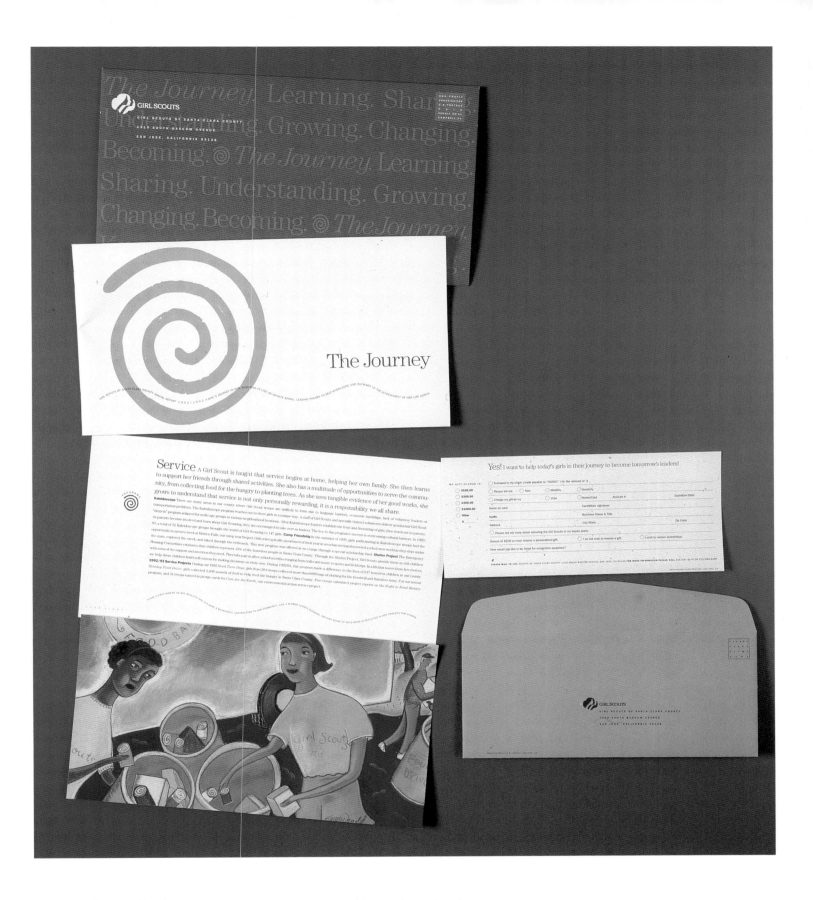

Design Firm **Melissa Passehl Design**
Art Director **Melissa Passehl**
Designer **Melissa Passehl**
Illustrator **Mercedes McDonald**
Copywriter **Susan Sharpe**
Client **Girl Scouts of Santa Clara County**
Paper/Printer **Simpson, Potlatch, Kirk, Hatcher Trade Press, Meitzler Printing**

The objective of this annual report is to elevate awareness of the Girl Scouts and their philosophies. The overall design, unique size, and mailing sleeve emphasize the ongoing message "The Journey". In essence, the theme becomes the package.

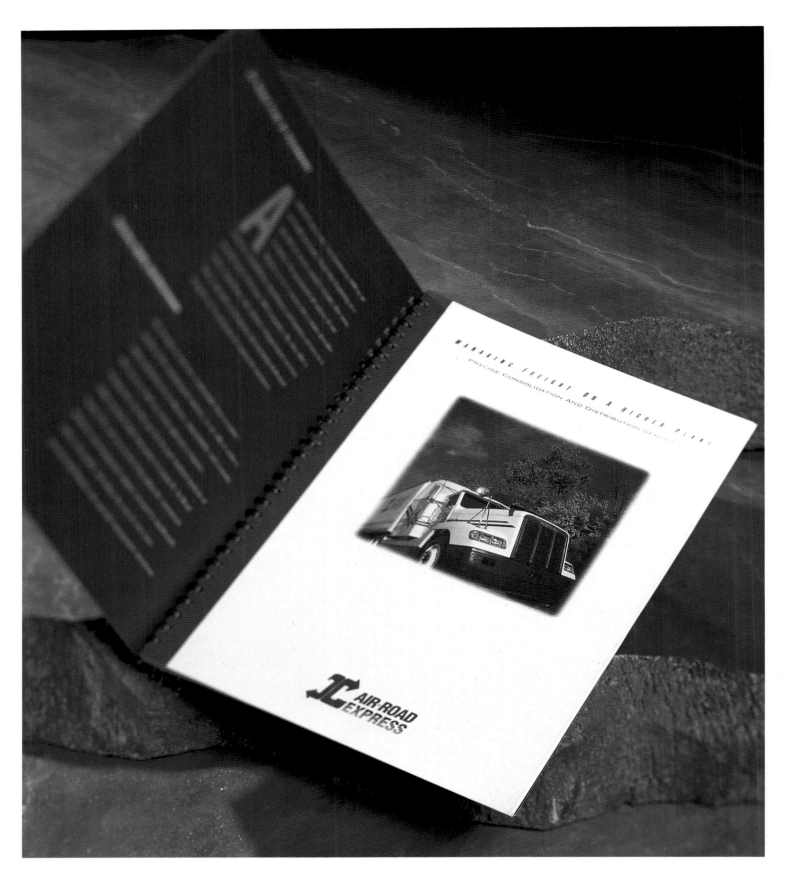

Design Firm **Held Diedrich**
Art Director **Dick Held**
Designer **Dick Held**
Copywriter **Drew Endicott**
Client **Air Road Express**
Paper/Printer **Strathmore Elements**
Tools **QuarkXPress, Adobe Photoshop**

This sales piece presented a challenge: it had to be designed so it could be bound as one document or separated into booklets for specific areas of service. Thus, if a sales prospect were interested in only one segment of the business, then the correct part of the four-page signature could be sent in response.

Design Firm **Yellow M**
Art Director **Craig Falconer**
Designer **Craig Falconer**
Photographer **Tony Stone Images**
Client **New Castle Protection Indemnity Association**
Paper **Keaycolour, Matte Art**
Tools **Macromedia FreeHand, QuarkXPress,
and Adobe Photoshop**

This annual report focuses on three areas—direction, support, and finance—and illustrates each with a photograph. The front cover uses foil blocking on colored card. The foil is applied full strength and a thirty percent tint creates a two-tone foil effect.

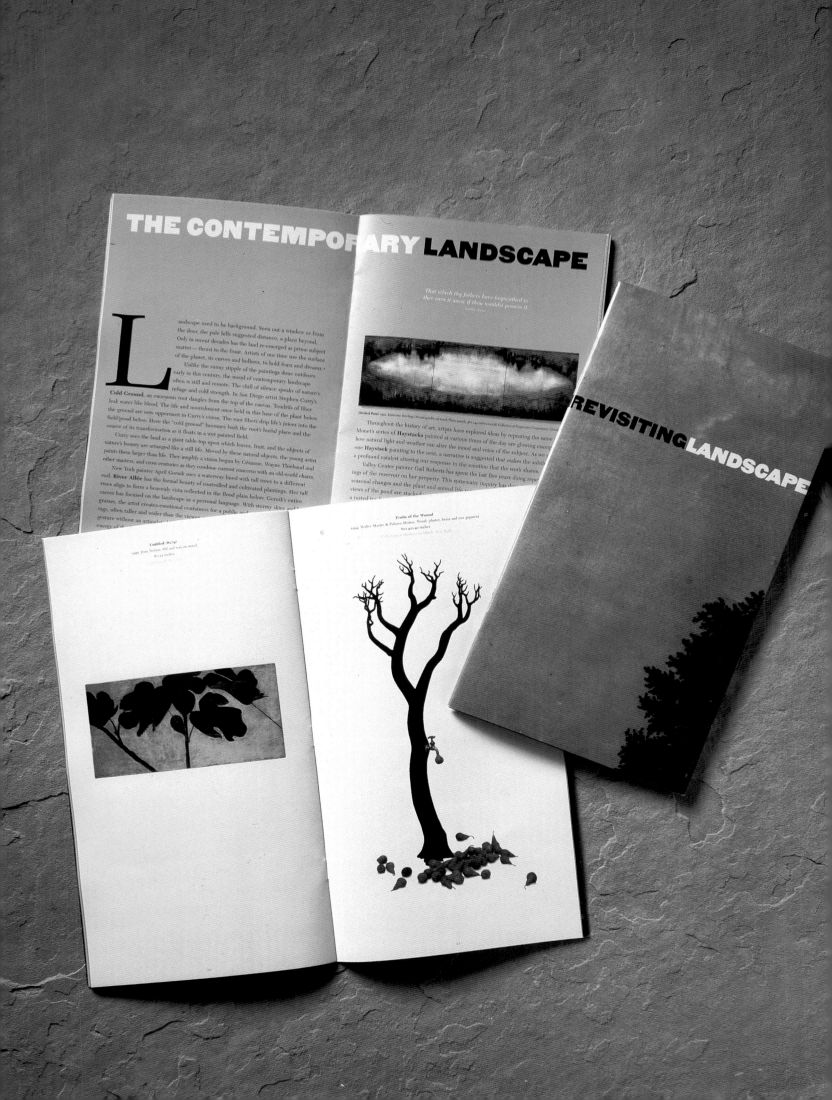

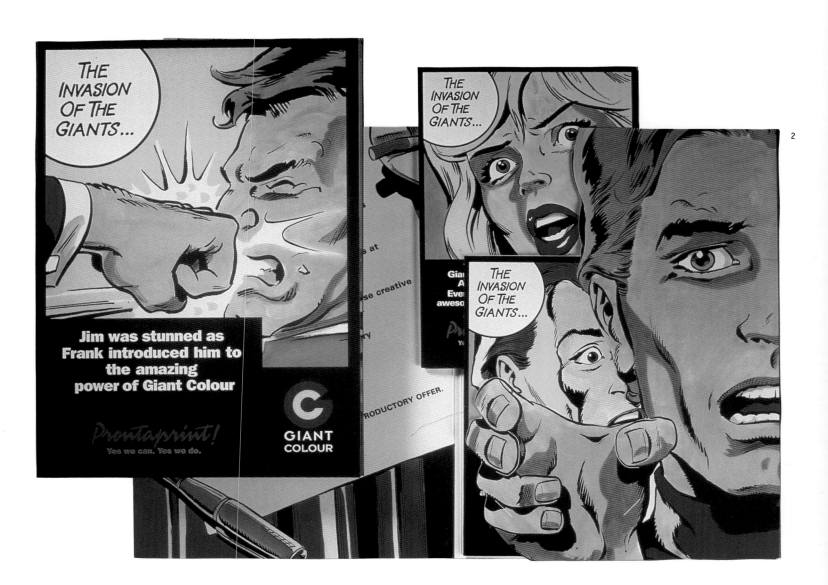

1
Design Firm **Mires Design**
Art Director **John Ball**
Designers **John Ball and Deborah Fukushima**
Copywriters **Reesey Shaw and Catherine Whalen**
Client **California Center For The Arts Museum**
Tool **QuarkXPress**

2
Design Firm **Yellow M**
Art Director **Mark Martin**
Designer **Mark Martin**
Illustrator **Richardson Studio**
Copywriter **Chris Rickaby**
Client **ProntaPrint**
Paper/Printer **Matte 200 lb. Cover, Matte 116 lb. Text Pages**
Tools **QuarkXpress, Macromedia FreeHand, and Adobe Photoshop**

2➤ *The project launches a new print service offered by Prontaprint, emphasizing the intensity in color and scale of print.*

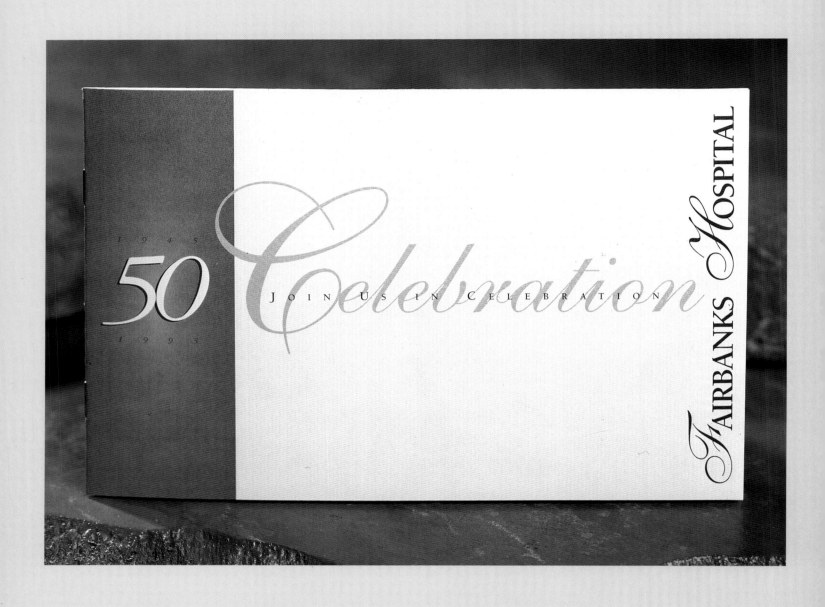

Design Firm **Held Diedrich**
Art Director **Dick Held**
Designer **Megan Umbanhower**
Copywriter **Andie Marshall**
Client **Fairbanks Hospital**
Paper **Strathmore Elements Natural Line**

This invitation was created for a Fairbanks Hospital 50th anniversary party honoring contributors, patrons, patients, and staff.

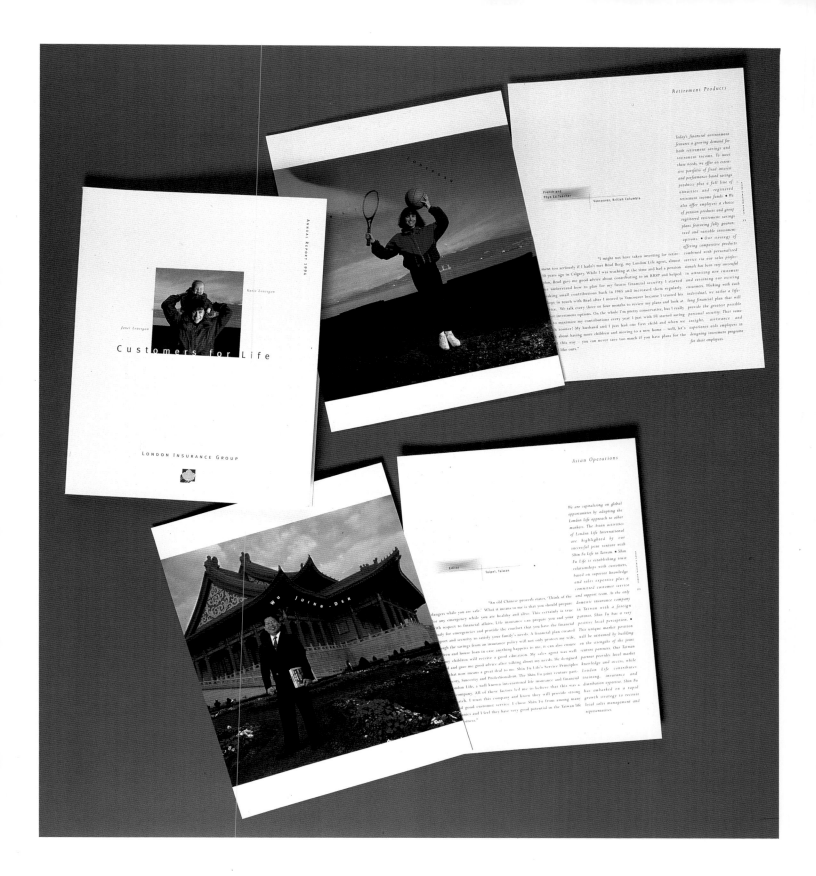

Design Firm **Eskind Waddell**
Art Director **Roslyn Eskind**
Designer **Donna Gedeon**
Photographers **Jim Allen and Ming Feng Chen**
Copywriter **London Insurance Group**
Client **London Insurance Group**
Printer **Bonne of Toronto**
Tools **Adobe Photoshop, Adobe Illustrator,
 and QuarkXPress**

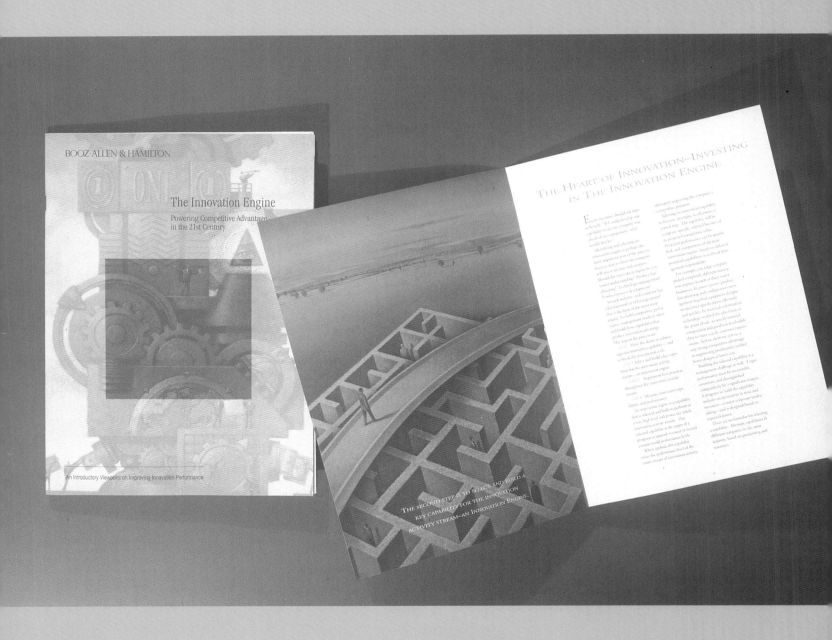

Design Firm **Metropolis Corporation**
Art Director **Denise Mendelsohn**
Designers **Andy Wessels and Richard Uccello**
Client **Booz, Allen & Hamilton**
Printer **W. Andrews Printing**

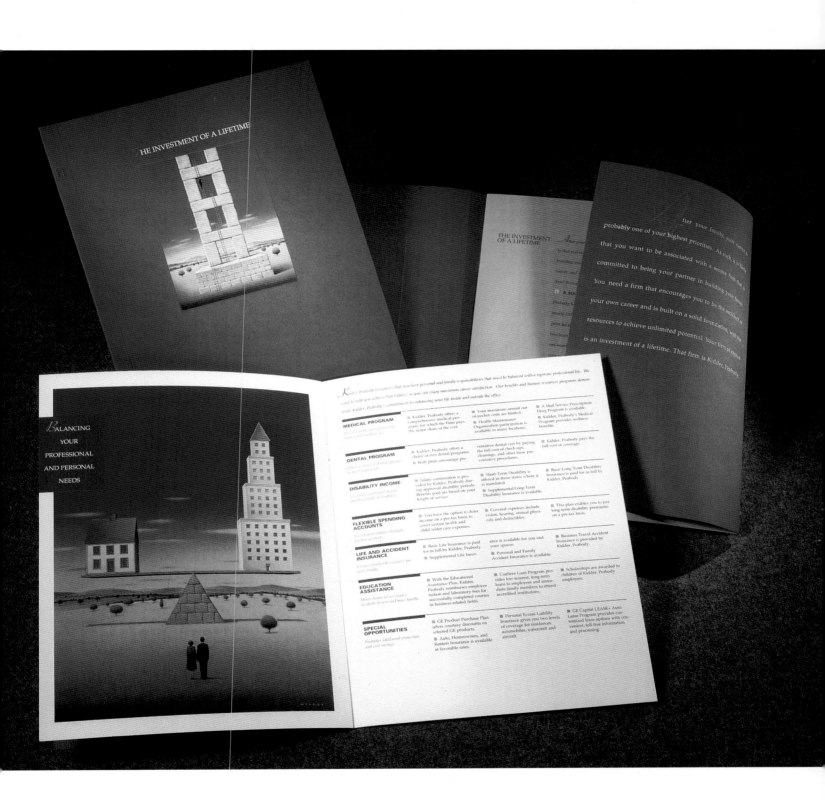

Design Firm **Bernhardt Fudyma Design Group**
Art Director **Iris Brown**
Designer **Iris Brown**
Illustrator **David Wilcox**
Client **Kidder Peabody & Co.**
Paper/Printer **Simpson Gainsborough**
Tool **QuarkXPress**

*This piece has a high level of visual sophistication
aimed at upper level management and "star traders".*

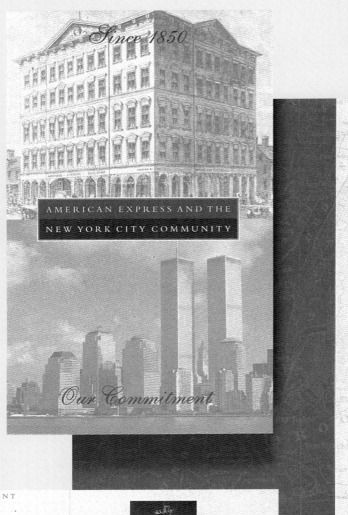

CIVIC INVOLVEMENT

American Express is an active member of numerous New York City civic organizations.

American Express is an active member of numerous New York City civic organizations. Our goal is to contribute in a meaningful way to the improvement of the city's quality of life. These organizations include:

- The Association for a Better New York
- The Better Business Bureau of Metropolitan New York
- The Citizens Budget Commission
- The Downtown – Lower Manhattan Association
- The New York Chamber of Commerce and Industry
- The New York City Partnership
- The New York Convention and Visitors Bureau
- The Regional Plan Association

Design Firm **Creative Media**
Art Director **Jayne Hertko**
Designer **J. Graham Hanson**
Copywriter **Stephen D. Lemson**
Client **American Express**
Paper/Printer **Mohawk Satin, Brodock Press, Inc.**
Tool **QuarkXPress**

The images used in the booklet were obtained from a wide variety of antique and contemporary sources, then reproduced as duotones to achieve consistency.

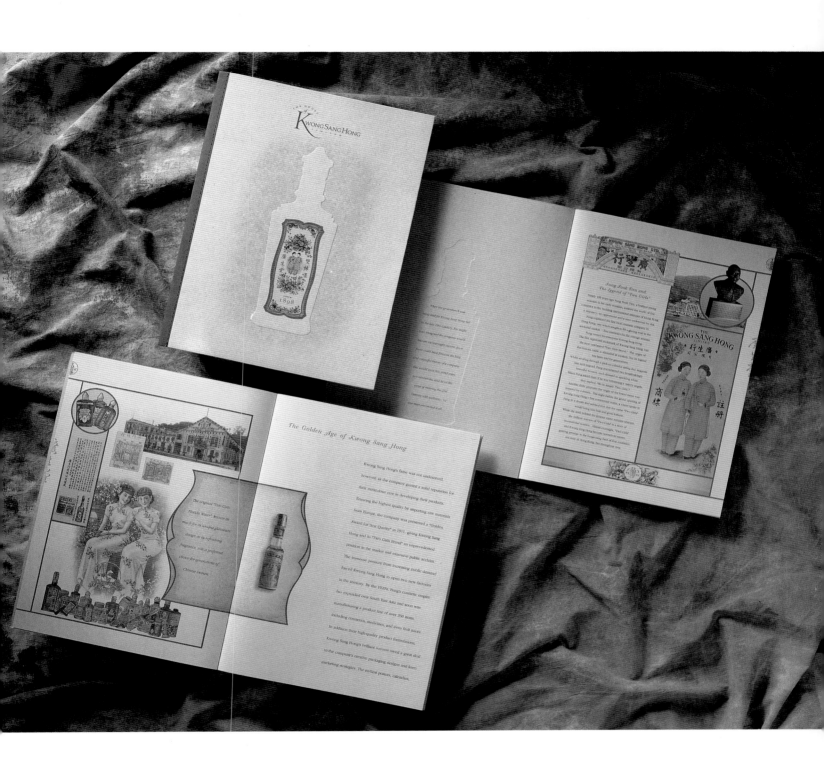

Design Firm **Kan Tai-keung Design & Associates Ltd.**
Art Directors **Kan Tai-keung, Freeman Lau Siu Hong,**
 and Eddy Yu, Chi Kong
Designer **Joyce Ho Ngai Sing**
Copywriter **The House of Kwong Sang Hong Ltd.**
Client **The House of Kwong Sang Hong Ltd.**
Paper/Printer **Graphika, Woodfree Paper, Yu Luen**
 Offset Printing Fty. Ltd.
Tools **Adobe Photoshop, Macromedia FreeHand**

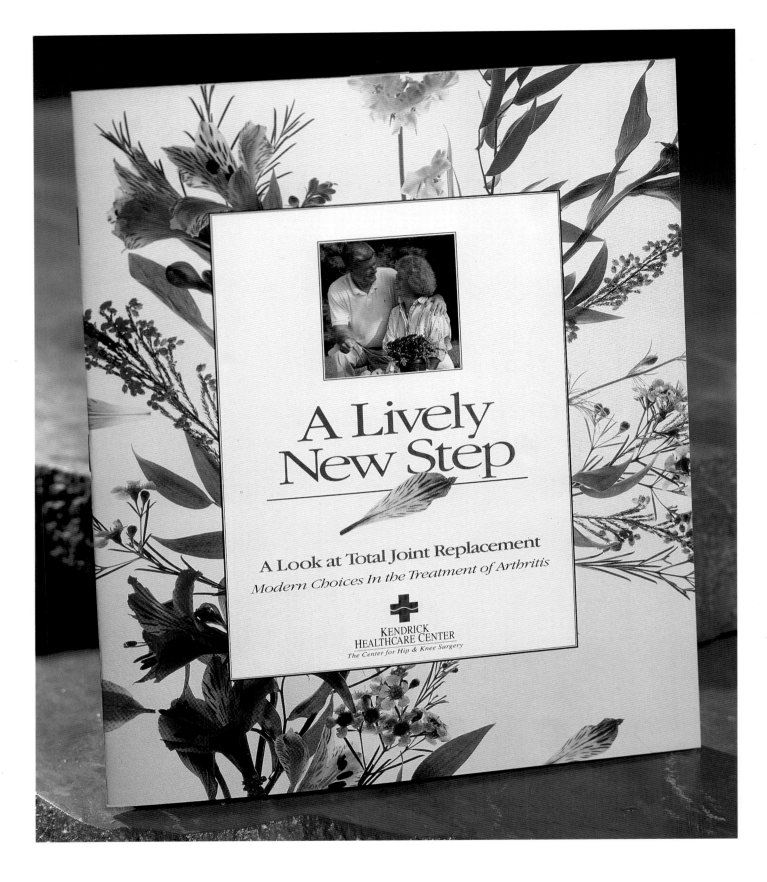

Design Firm **Held Diedrich**
Art Director **Tim Gant**
Photographer **Partners Photography**
Copywriter **Kelli Searles**
Client **Kendrick Hospitals**
Paper **Karma Natural**
Tools **QuarkXPress and Adobe Photoshop**

This piece communicates the benefits of undergoing a total joint replacement. The target audience is typically the elderly patient who is experiencing arthritic joint pain. The brochure uses floral imagery to communicate that patients can resume their previous activities, such as gardening, without experiencing any joint pain.

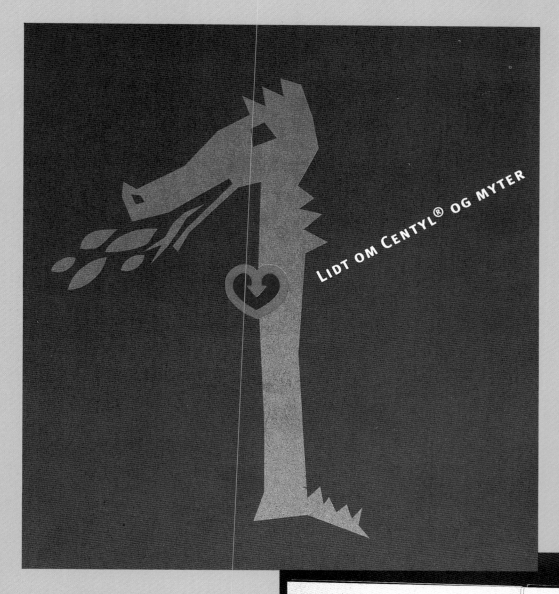

LIDT OM CENTYL® OG MYTER

6

sværgede, at han ikke ville sige noget til andre, for, hvad ville der ikke ske, hvis det rygte bredte sig, at Tor havde mistet sin hammer Mjølner.

Den kloge Loke foreslog straks, at de skulle spørge Freja, om de måtte låne hendes fugleham, og så vil-le Loke selv flyve til Jotunheim for at finde ud af, hvem af jætterne, der havde den frækhed at stjæle Tors hammer. Freja var straks parat til at hjælpe dem, om så vingerne på fuglehammen havde været af guld og fjerene af sølv.

Så fløj Loke afsted, og da han var kommet fra Asgård et stykke ind i Jotunheim, kom han til jæt-ten Trym. Loke kunne straks se at Trym måtte være meget rig, for hundene havde guldhalsbånd

og køernes horn var belagt med guld.

Trym selv stod ved leddet og strøg manken på sine heste, og da han så Loke komme flyvende, spurgte han drillende, hvordan det stod til hos aserne, og om der var noget galt siden Loke kom helt alene på besøg.

Så var Loke klar over, at han på rette spor og han spurgte ligeud, om det var Trym der havde stjålet Tors hammer. Det indrømmede Trym med det samme, men han sagde også, at den var gemt otte mil under jorden, og at han ikke ville hente den op, før guderne havde bragt ham Freja til brud.

Vibeke Nódskov created the illustration with cut paper, greasy and non-greasy crayons, and ballpoint pen.

Design **Leo Pharmaceuticals**
Art Director **Vibeke Nódskov**
Designer **Vibeke Nódskov**
Illustrator **Vibeke Nódskov**
Copywriter **Mogens Norn**
Client **Leo Pharmaceuticals**
Paper/Printer **Brown Recycled and Cyllus Offset, Saloprint**
Tool **QuarkXPress**

1

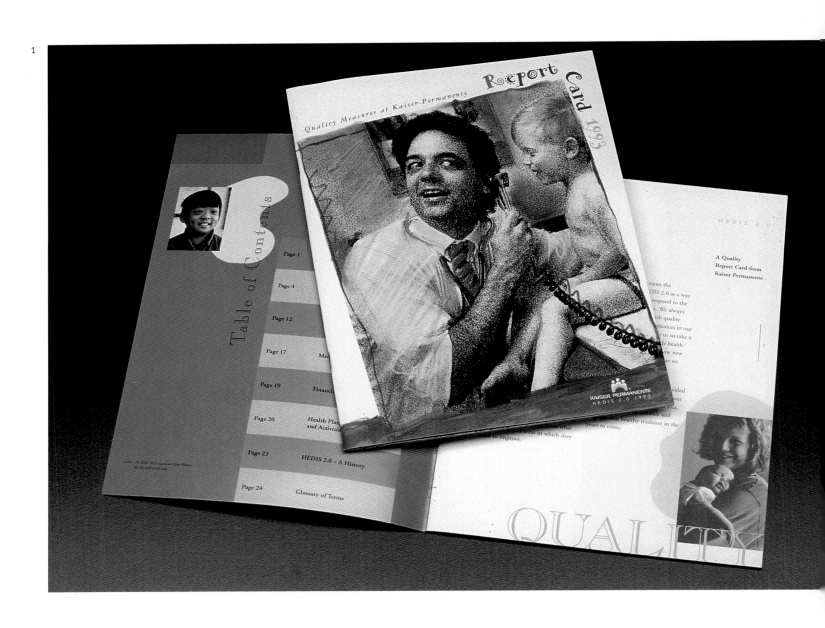

1
Design Firm **Lee Reedy Design**
Art Director **Lee Reedy**
Designers **Lee Reedy and Heather Haworth**
Illustrator **Heather Haworth**
Photographer **Ken Bisio**
Copywriter **Marilyn Starrett**
Client **Kaiser Permanente**
Paper/Printer **Lithofect, Frederic Printing**
Tool **QuarkXPress**

2
Design Firm **Mires Design**
Art Director **John Ball**
Designers **John Ball and Miguel Perez**
Illustrator **Tracy Sabin**
Photographer **Carl Vanderschult**
Client **California Center For The Arts, Escondido**
Tools **QuarkXPress and Adobe Illustrator**

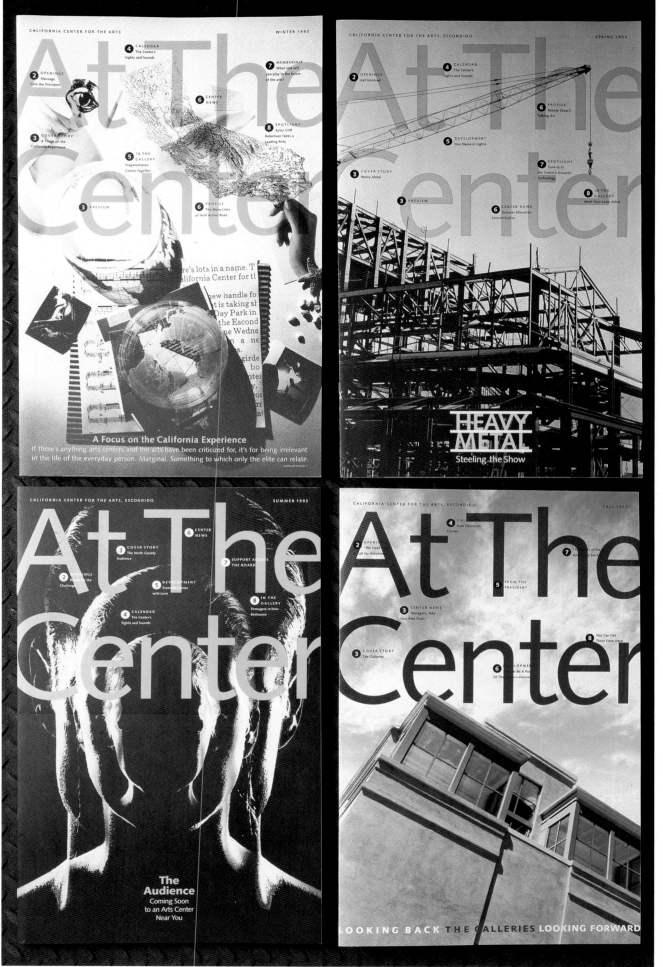

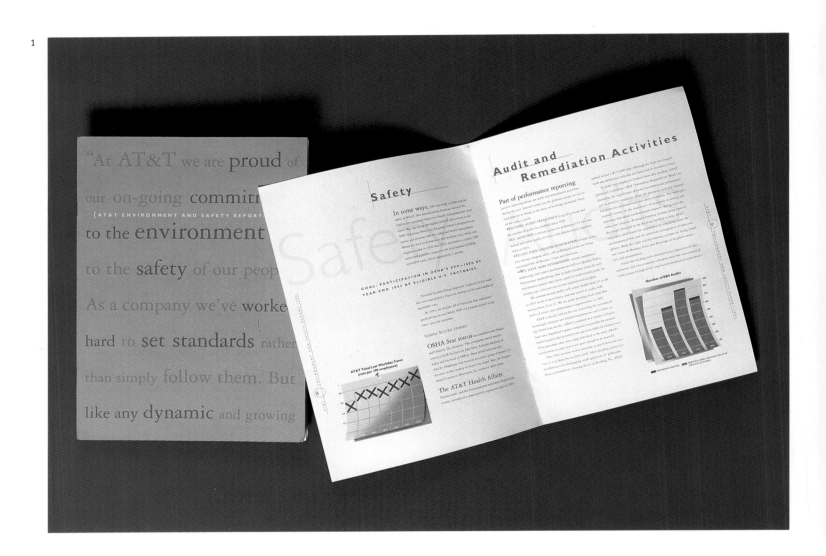

1
Design Firm **Studio W. Inc.**
Art Director **Fo Wilson**
Designer **Julie Metz**
Illustrator **Julia Gorton**
Photographer **Brian Smale**
Copywriter **Joe Horine**
Client **AT&T**
Paper/Printer **Champion Benefit, Enterprise Press**
Tool **QuarkXPress**

2
Design Firm **Belyea Design Alliance**
Art Director **Patricia Belyea**
Designer **Samantha Hunt**
Illustrator **Jere Smith, Brian O'Neill**
Calligrapher **Christian Salas**
Copywriters **Peggy Willcats and Luann Columbo**
Client **Snohomish County Public Utility District**
Paper/Printer **Springhill 12 pt, Allied Printers**
Tools **QuarkXPress and Macromedia FreeHand**

2➤ *The illustrations are acrylic on canvas. Belyea Design Alliance produced the lettering by hand and completed the final piece in QuarkXPress and Macromedia FreeHand. The built-in sundial has a perforation and a score for the three-dimensional shadow maker.*

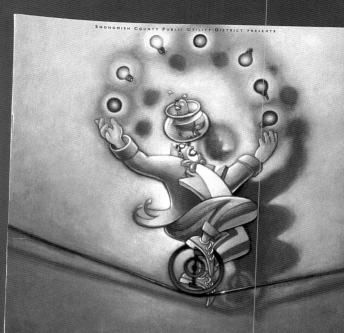

The Electric Circus

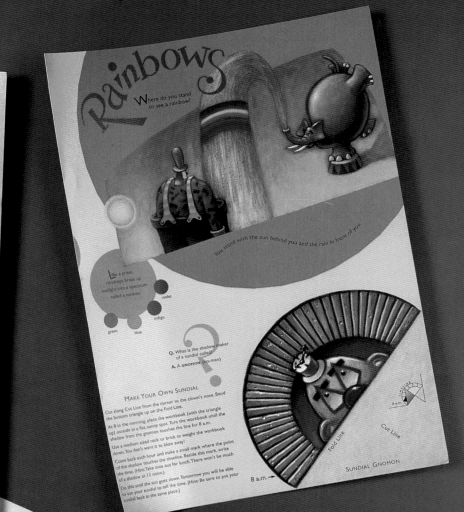

Rainbows

Where do you stand to see a rainbow?

You stand with the sun behind you and the rain in front of you.

Like a prism, raindrops break up sunlight into a spectrum called a rainbow.

green blue indigo violet

Q. What is the shadow maker of a sundial called?
A. A GNOMON. (no-men)

MAKE YOUR OWN SUNDIAL

Cut along Cut Line from the corner to the clown's nose. Bend the bottom triangle up on the Fold Line.

At 8 in the morning, place the workbook (with the triangle up) outside in a flat, sunny spot. Turn the workbook until the shadow from the gnomon touches the line for 8 a.m.

Use a medium sized rock or brick to weight the workbook down. You don't want it to blow away!

Come back each hour and make a small mark where the point of the shadow touches the timeline. Beside this mark, write the time. (Hint: Take time out for lunch. There won't be much of a shadow at 12 noon.)

Do this until the sun goes down. Tomorrow you will be able to use your sundial to tell the time. (Hint: Be sure to put your sundial back in the same place.)

8 a.m. →

Fold Line Cut Line

SUNDIAL GNOMON

Mirrors
Mirrors reflect light best because they are very shiny and smooth.

Every thing reflects light. Mirrors reflect light best because they are very shiny and smooth.

Refraction

Light travels at 186,000 miles per second. Light slows down when it travels through water. This is called refraction.

White light is the combination of all colors in the spectrum. The spectrum is made up of an infinite number of colors.

red orange yellow

Put a straw in a glass of water and walk around it. Depending on the position of the straw and where you stand, the straw appears bigger, broken or not there.

8

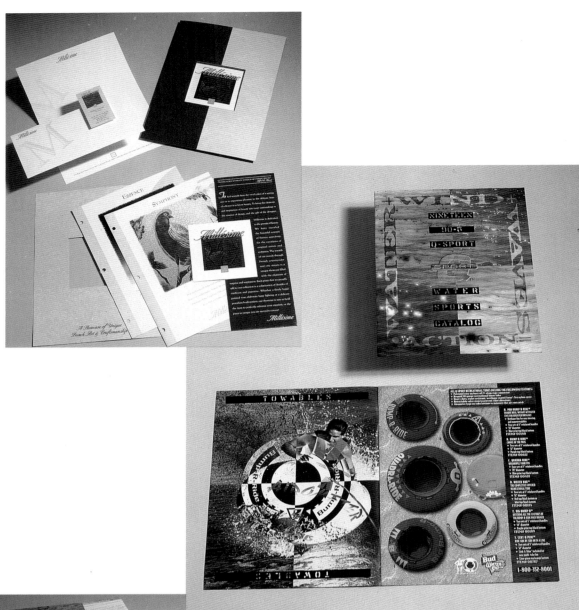

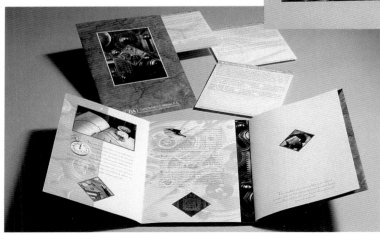

Design Firm **Chameleon Graphics, Inc.**
Art Director **Leslie Brown**
Designer **David Sloan, Leslie Brown**
Copywriter **Leslie Brown**
Client **Carter, Belcourt & Atkinson, P.A.**
Paper/Printer **Enhance Cover Gloss**
Tools **QuarkXPress, Adobe Photoshop**

*It took more than a year to create this piece because
the client could not finalize the copy. After seven sets
of revisions, the final product almost exactly matches
the first proof.*

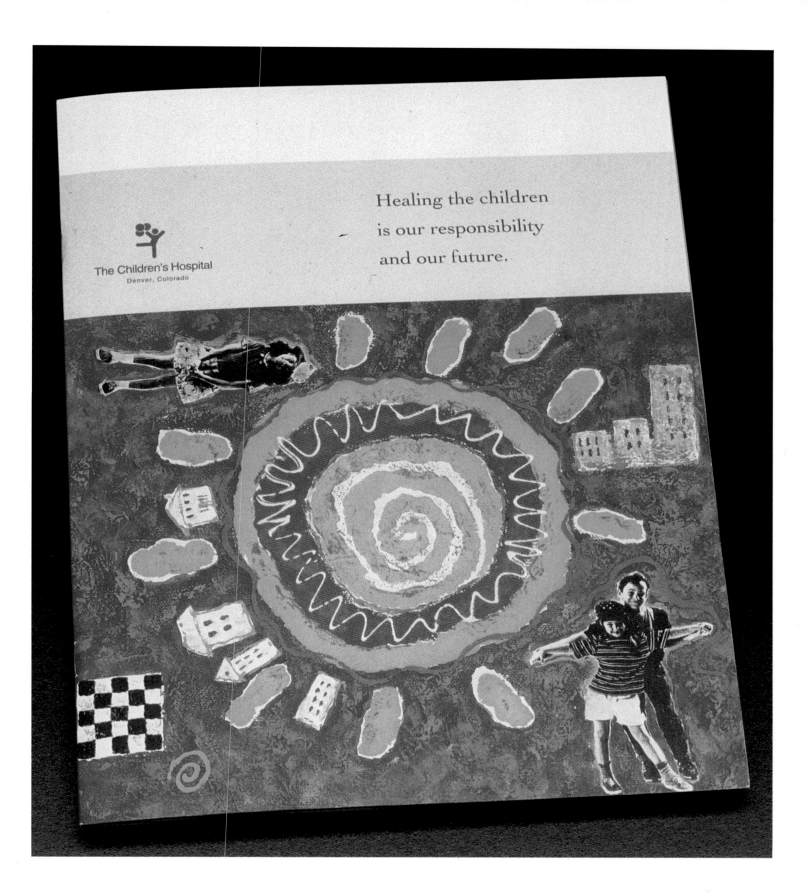

This design combines illustration acrylic on canvas with a collage of xeroxed images.

Design Firm **Lee Reedy Design**
Art Director **Lee Reedy**
Designer **Lee Reedy, Heather Haworth**
Illustrator **Heather Haworth**
Photographer **Ron Coppock**
Copywriter **Jordis Ruhl**
Client **Children's Hospital**
Paper/Printer **Speckletone, National Printing**
Tools **QuarkXPress**

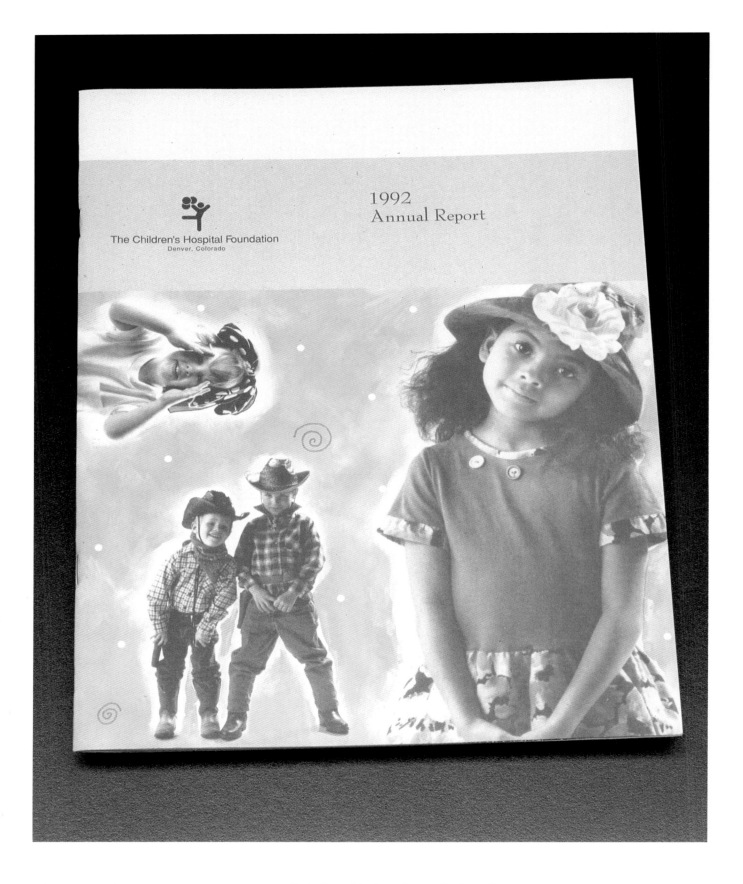

The background for the brochure was handpainted,
then scanned-in around the photos.

Design Firm **Lee Reedy Design**
Art Director **Lee Reedy**
Designer **Heather Haworth**
Illustrator **Heather Haworth**
Photographer **Ron Coppock**
Copywriter **Jordis Ruhl**
Client **Children's Hospital**
Paper/Printer **Speckletone, National Printing**
Tools **QuarkXPress**

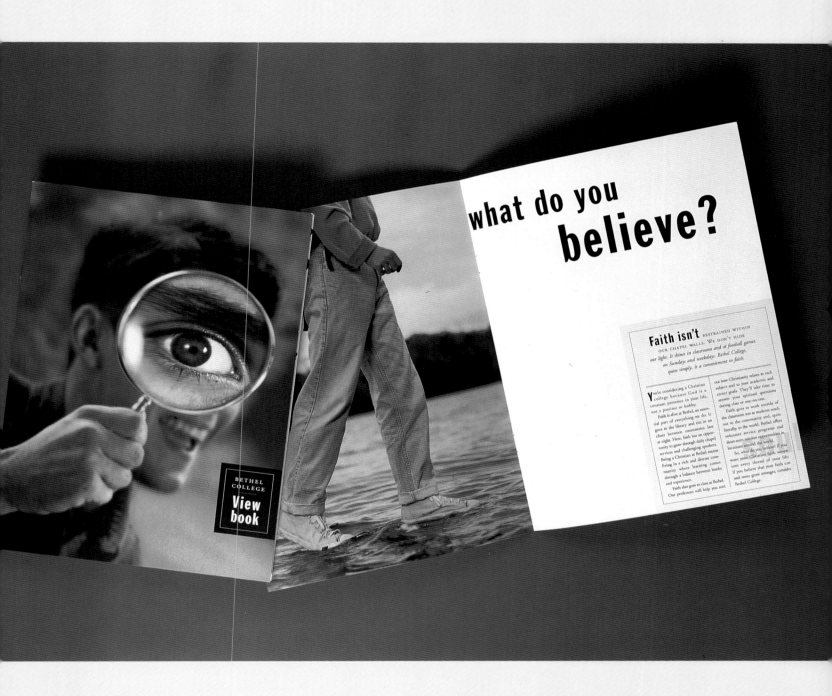

Design Firm **The Kuester Group**
Art Director **Kevin B. Kuester**
Designer **Bob Goebel**
Photographer **July Olausen**
Copywriter **David Forney**
Client **Bethel College**
Paper/Printer **Potlatch Mountie Matte,**
 Heartland Graphics
Tool **QuarkXPress**

This brochure seeks to differentiate Bethel College's
literature from other college literature, without using
standard campus shots. The brochure communicates
the unique qualities of the College by portraying actual
students in all the photographs.

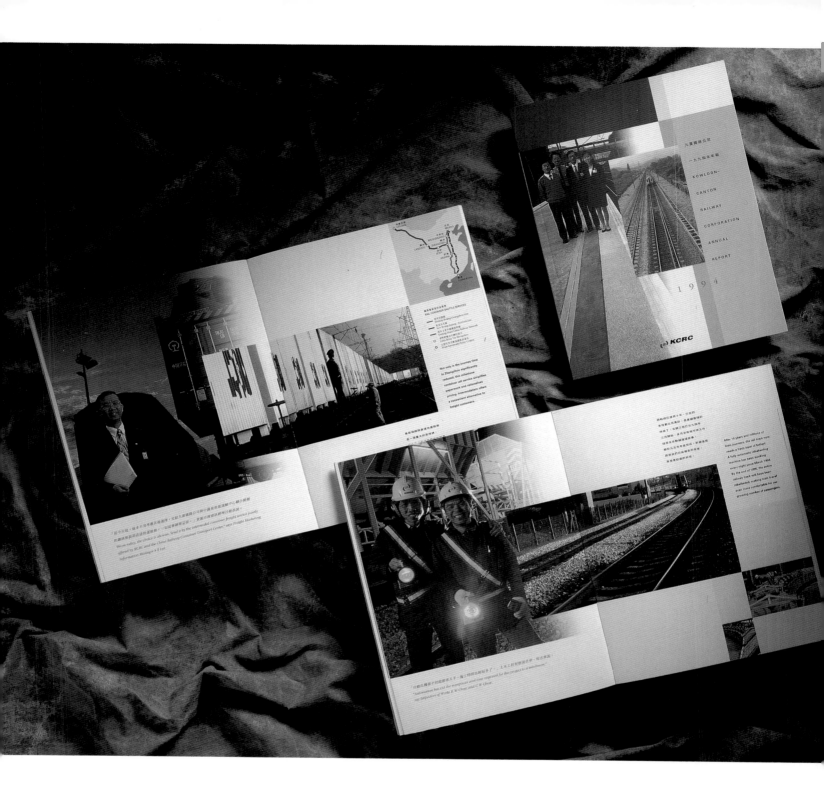

Design Firm **Kan Tai-keung Design & Associates Ltd.**
Art Directors **Kan Tai-keung and Eddy Yu Chi Kong**
Designer **Eddy Yu Chi Kong**
Photographers **Leong Ka-tai and C.K. Wong**
Client **Kowloon-Canton Railway Corporate**
Paper **Coated Art Paper for cover and non-accounts
 section, Graphika Lineal for accounts section**
Tools **Adobe Photoshop and Macromedia FreeHand**

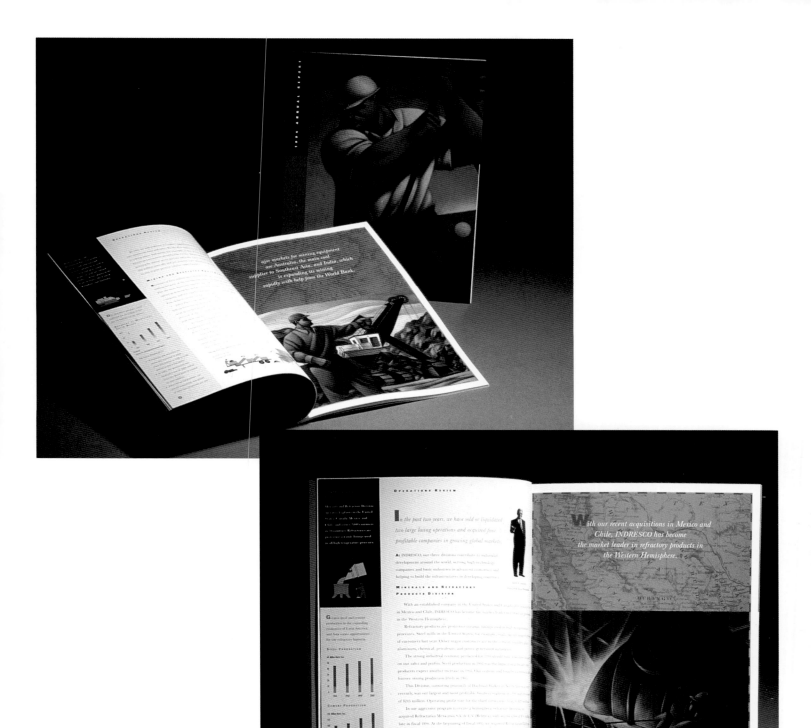

Design Firm **Sibley/Peteet**
Art Director **Don Sibley**
Designer **Don Sibley**
Illustrator **Mike Benny**
Photographer **Neal Whitlock**
Copywriter **Wolford McCue**
Client **Indresco**
Paper/Printer **SD Warren and Heritage Press**

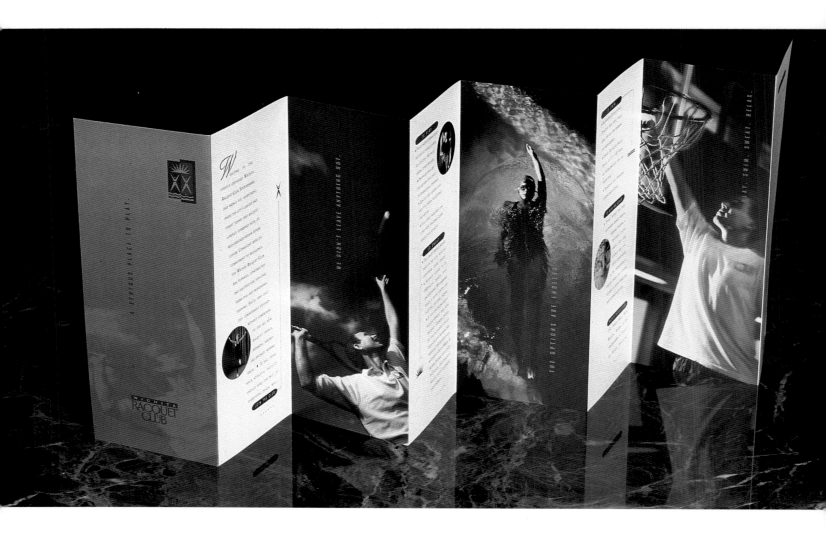

Design Firm **Greteman Group**
Art Director **Sonia Greteman**
Designer **Sonia Greteman, James Strange**
Photographer **Ron Berg**
Copywriter **Bart Wilcox**
Client **Racquet Club**
Paper/Printer **Productolith, Donlevy**
Tools **Macromedia FreeHand**

The piece was created using metallic ink with a ghosted photo, plus various duotones.

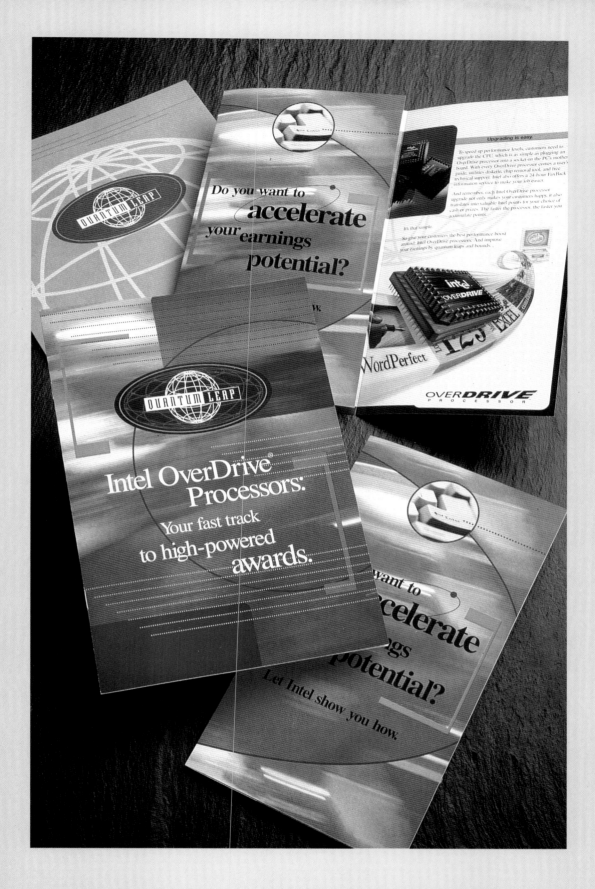

Design Firm **Richard Endly Design, Inc.**
Art Director **Mark Geis**
Designers **Todd Paulson and Keith Wolf**
Client **Business Incentives, Intel**
Tools **Adobe Photoshop, Adobe Illustrator, and QuarkXPress**

The designers manipulated photos to create a sense of speed and the high tech world in which Intel operates

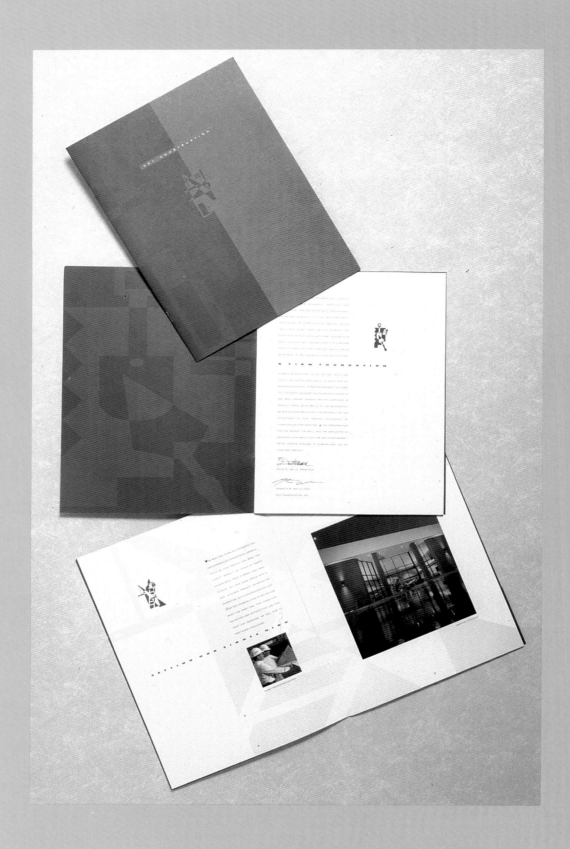

Design Firm **Greteman Group**
Art Director **Sonia Gretman**
Designer **Sonia Gretman, James Strarge**
Photographer **Paul Bowen**
Client **Key Construction**
Paper/Printer **Classic Crest, Domevy Litho**

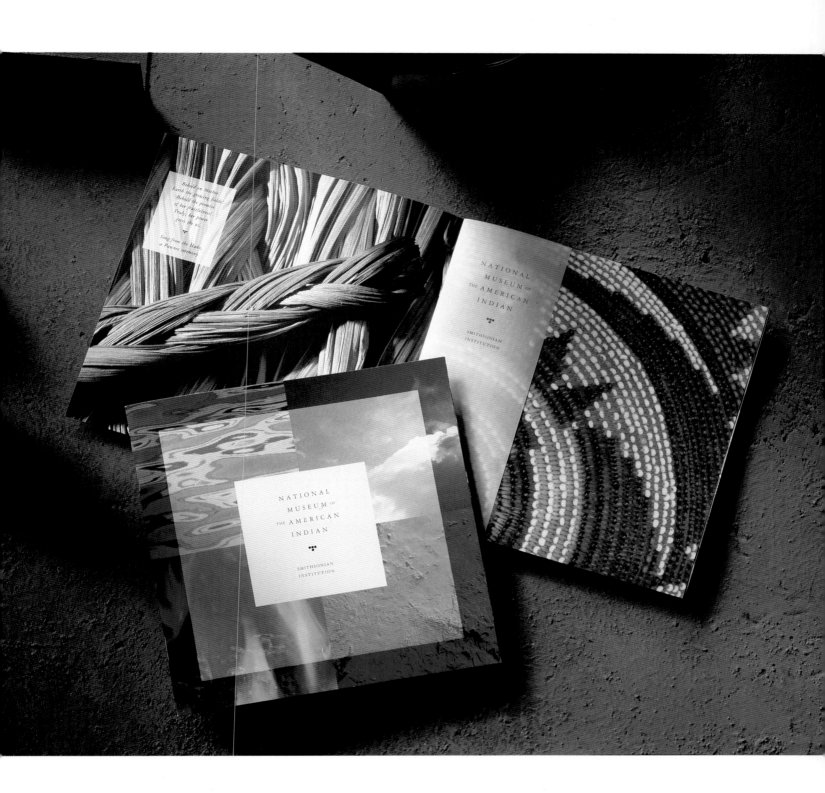

Design Firm **Grafik Communications, Ltd.**
Designers **Lynn Umemoto and Judy Kirpich**
Photographer **David Heald**
Client **National Museum of the American Indian**
Printer **Virginia Lithograph**
Tool **QuarkXPress**

Keystone Communications Corporation

1

1
Design Firm **Ad Dimension II, Inc.**
Art Director **Robert Bynder**
Designer **Robert Bynder**
Copywriter **Brad Mouberry**
Client **Keystone Communications Corp.**
Paper/Printer **Direct Color, Vintage Velvet**

1➤ *Created as a new corporate identity piece for a company providing satellite services to the broadcasting community, this twelve-page corporate brochure features a new logo, spot varnish, and high-impact, full-page, 4-color bleeds.*

2
Design Firm **Greteman Group**
Art Directors **Sonia Greteman and James Strange**
Designers **Sonia Greteman and James Strange**
Photographer **Linda K. Robinson**
Copywriter **John Brown**
Client **Kansas Elks Training Center**
Paper/Printer **Speckletone Kraft, Classic Crest White Donlevey**
Tool **Macromedia FreeHand**

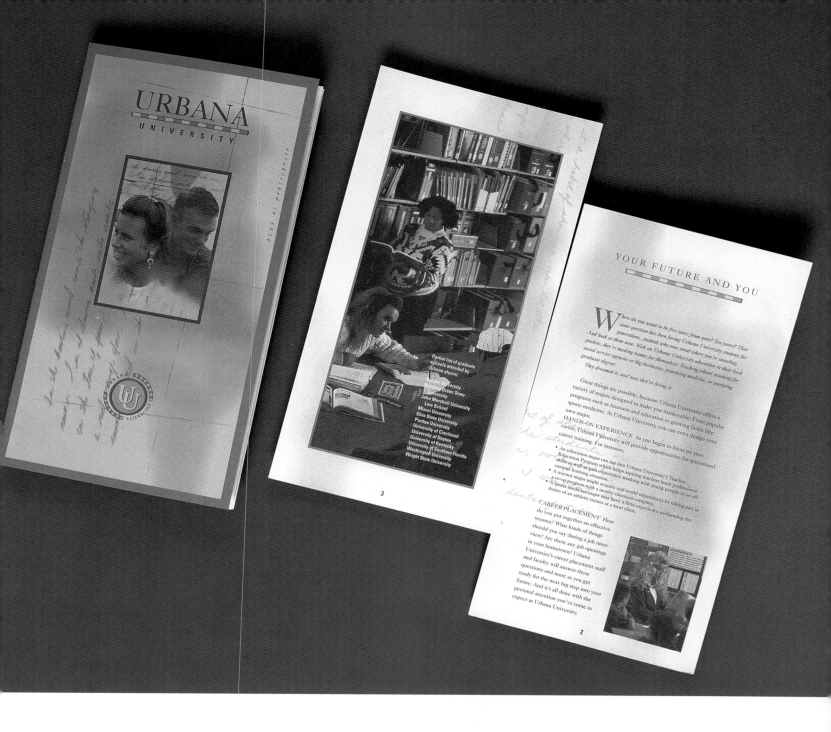

Design Firm **Stamats Communications**
Art Director **Tim Greenzweig**
Illustrator **Tim Greenzweig**
Photographer **Steve Jordan**
Copywriter **Dave Rebeck**
Client **Urbana University**
Paper/Printing **Hammermill/Cedar Graphics**
Tools **Adobe Photoshop, QuarkXPress,
 and Macromedia FreeHand**

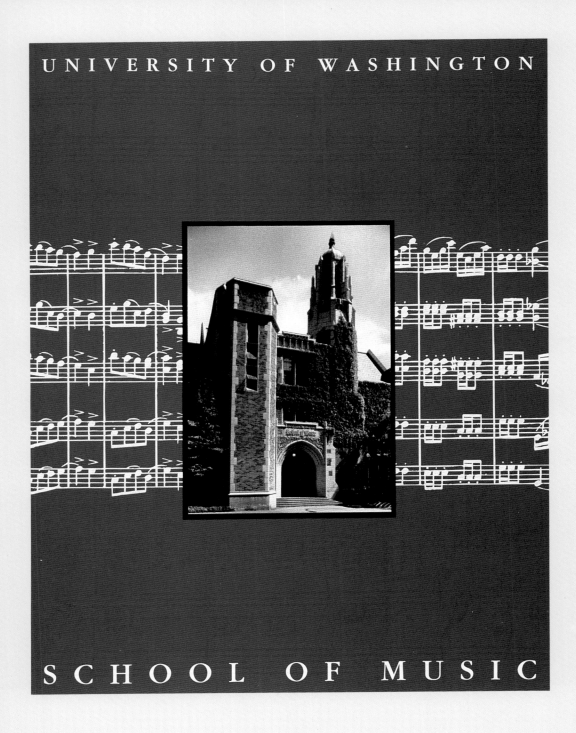

UNIVERSITY OF WASHINGTON

SCHOOL OF MUSIC

Design Firm **David Balzer**
Art Director **David Balzer**
Designer **David Balzer**
Copywriter **Margot Smith**
Client **University of Washington, School of Music**
Paper/Printer **Signature 70 lb., Spring Printing, Inc.**
Tools **QuarkXPress, Adobe Photoshop, and Adobe Illustrator**

To save money, this piece uses only 2-color printing on its inside pages.

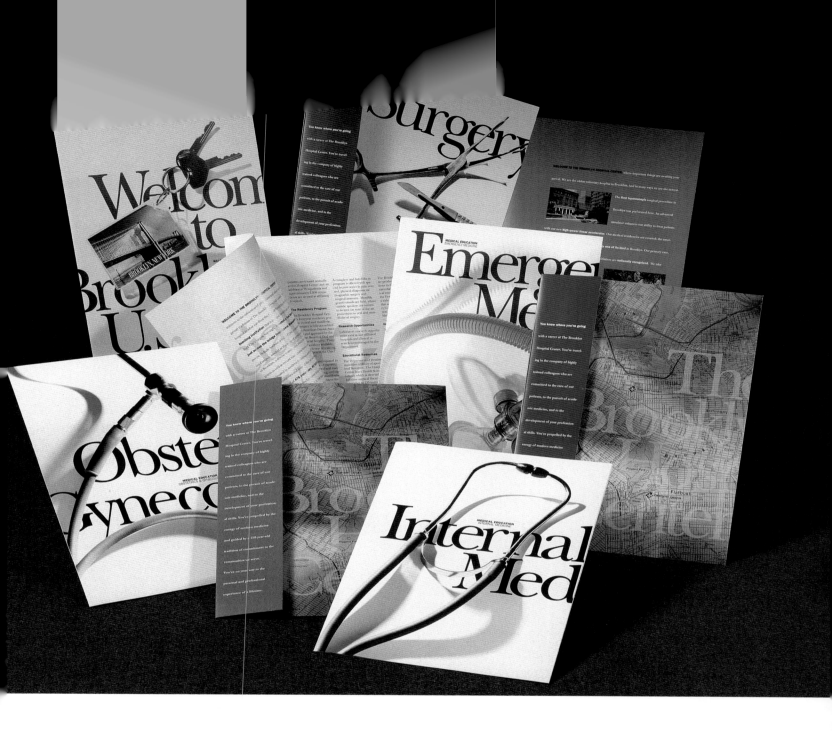

Design Firm **Bernhardt Fudyma Design Group**
Art Directors **Janice Fudyma and Iris Brown**
Designer **Iris Brown**
Photographer **David Arkey**
Client **The Brooklyn Hospital Center**
Printer **Tanagraphics**
Tool **QuarkXPress**

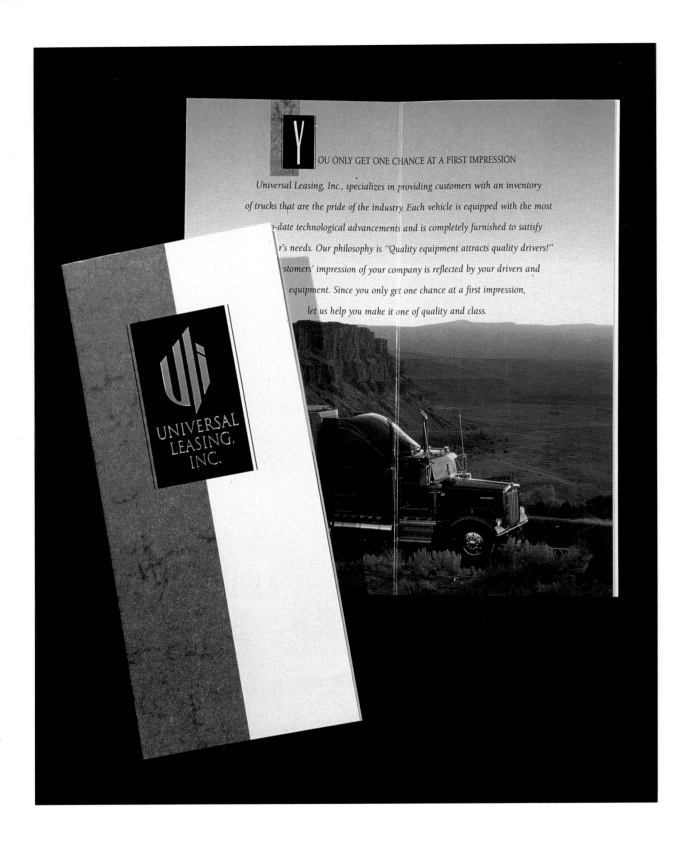

YOU ONLY GET ONE CHANCE AT A FIRST IMPRESSION

Universal Leasing, Inc., specializes in providing customers with an inventory
of trucks that are the pride of the industry. Each vehicle is equipped with the most
up-to-date technological advancements and is completely furnished to satisfy
your's needs. Our philosophy is "Quality equipment attracts quality drivers!"
Your customers' impression of your company is reflected by your drivers and
your equipment. Since you only get one chance at a first impression,
let us help you make it one of quality and class.

Design Firm **TAB Graphics Design, Inc.**
Art Director **Tanis Bull**
Copywriter **Sal Pizzoferrato**
Client **Universal Leasing, Inc.**
Paper/Printer **Lustro Offset Enamel Dull Cream 80 lb.,**
 Cover: Spectrographics

Inspired by the client's favorite saying, "You only get
one chance at a first impression", designers chose a
"marble" texture, gold foil, and a formal presentation
format for this brochure, to create a memorable first
impression.

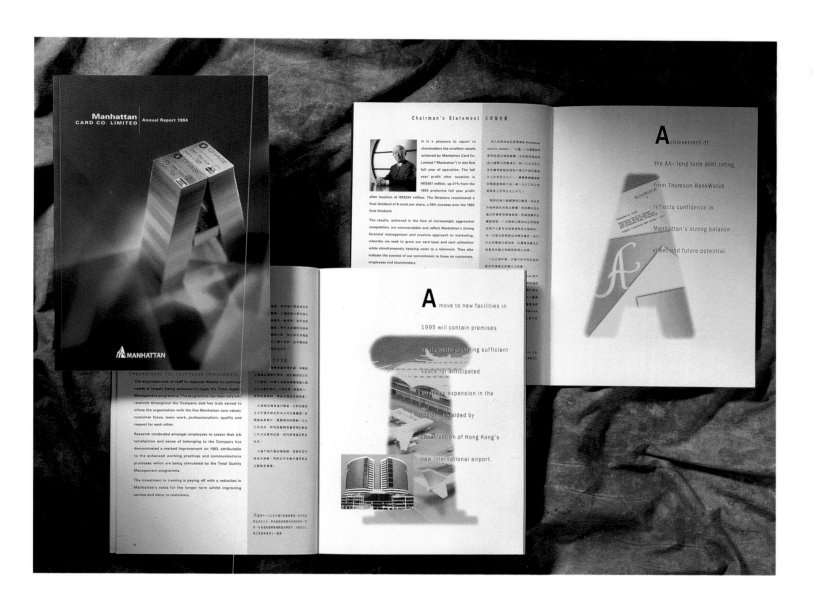

Design Firm **Kan Tai-keung Design & Associates Ltd.**
Art Directors **Kan Tai-keung, Freeman Lau Siu Hong,
 and Clement Yick Tat Wa**
Designers **Clement Yick Tat Wa and James Leung
 Wai Mo**
Photographer **Arthur Schulten**
Client **Manhattan Card Co. Ltd.**
Paper/Printer **Coated Art Paper, Elegance
 Printing Co. Ltd.**
Tools **Adobe Photoshop and Macromedia FreeHand**

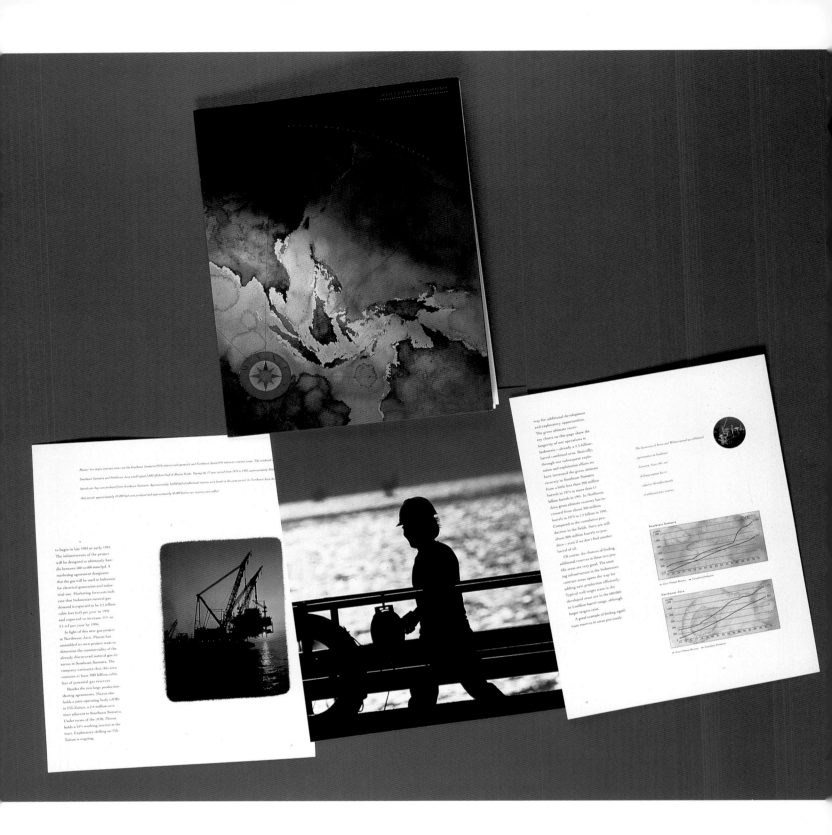

Design Firm **Peterson & Company**
Art Director **Scott Ray**
Designer **Scott Ray**
Illustrator **Mike Reagan**
Copywriter **Linda Covington**
Client **Maxus Energy Corporation**
Paper/Printer **Trophy, South Press**
Tools **QuarkXPress and Adobe Photoshop**

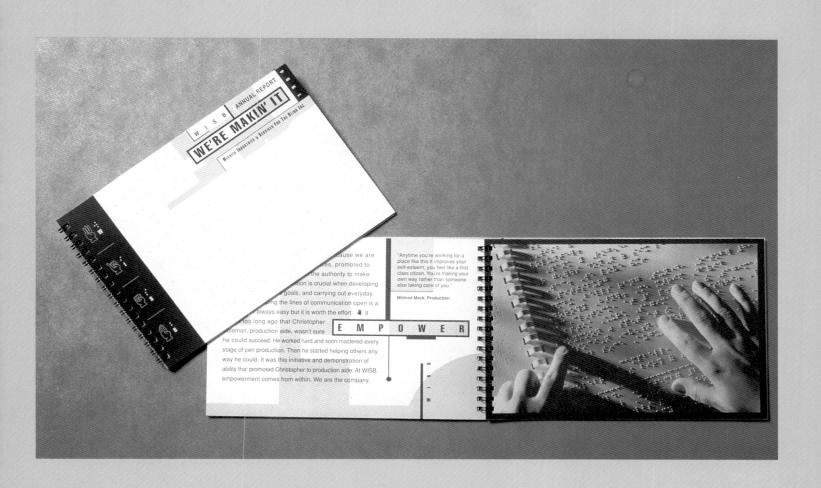

Design Firm **Greteman Group**
Art Director **Sonia Greteman, James Strange**
Photographer **Mark Weins**
Client **Wichita Industries & Services for the Blind**
Paper/Printer **Classic Crest**

This brochure serves as an annual report and service brochure for the blind. It employs both striking photography and embossing, which serves as braille.

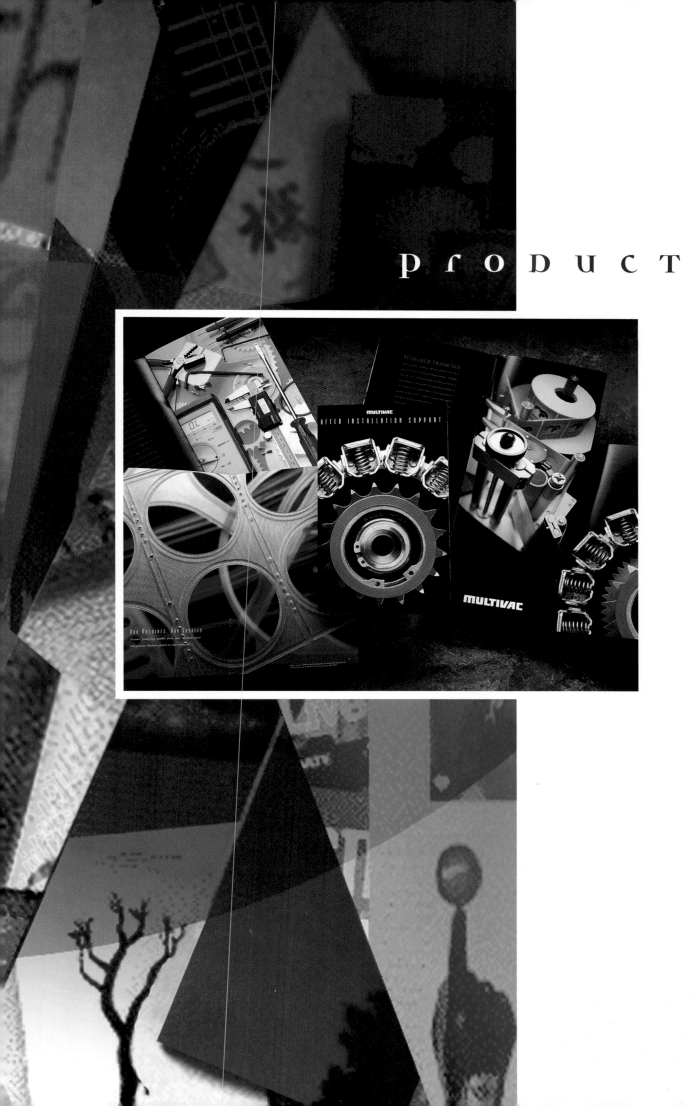

pro**DUCT**

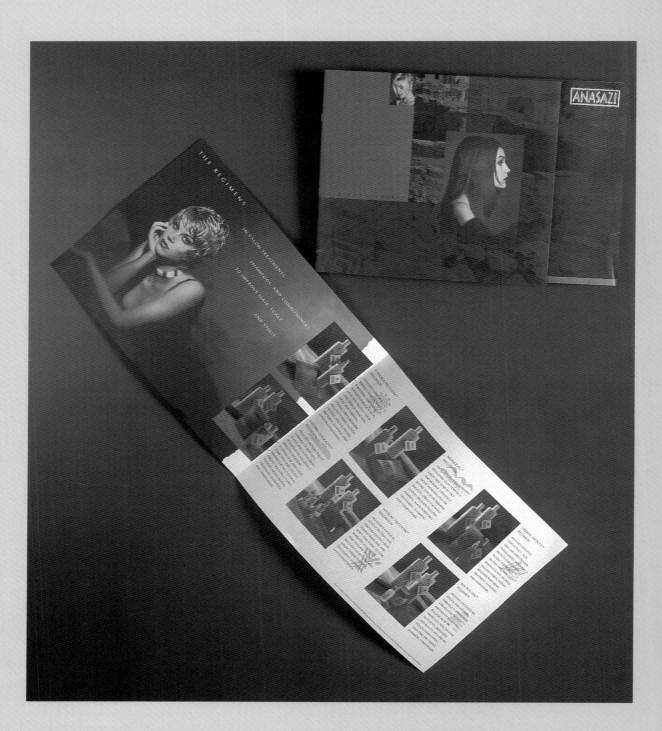

Design Firm **McCullough Creative Group, Inc.**
Art Director **Jeff MacFarlane**
Designer **Jeff MacFarlane**
Photographers **Ken Smith and James Cessna**
Copywriter **Bob Lupinacci**
Client **Anasazi Exclusive Salon Products, Inc.**
Paper/Printer **Royal Fiber Natural, Union-Hoermann
 Press**
Tools **QuarkXPress, Macromedia FreeHand,
 and Adobe Photoshop**

*The designer chose a 4-color process with a single
spot color.*

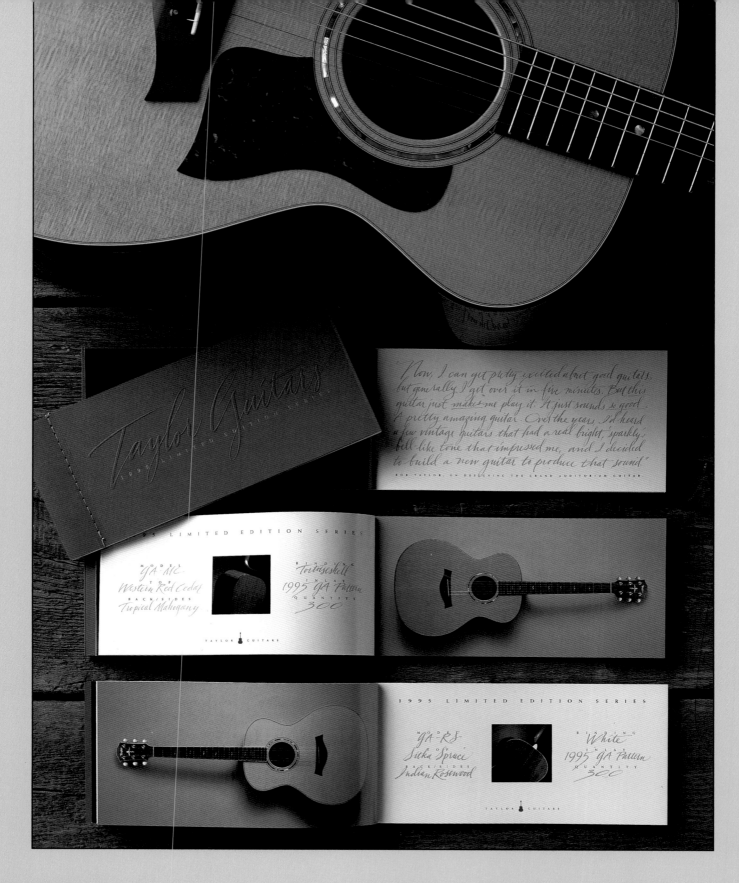

Design Firm **Mires Design, Inc.**
Art Director **Scott Mires**
Designer **Scott Mires**
Photographer **Marshall Harrington**
Calligrapher **Judythe Sieck**
Client **Taylor Guitars**

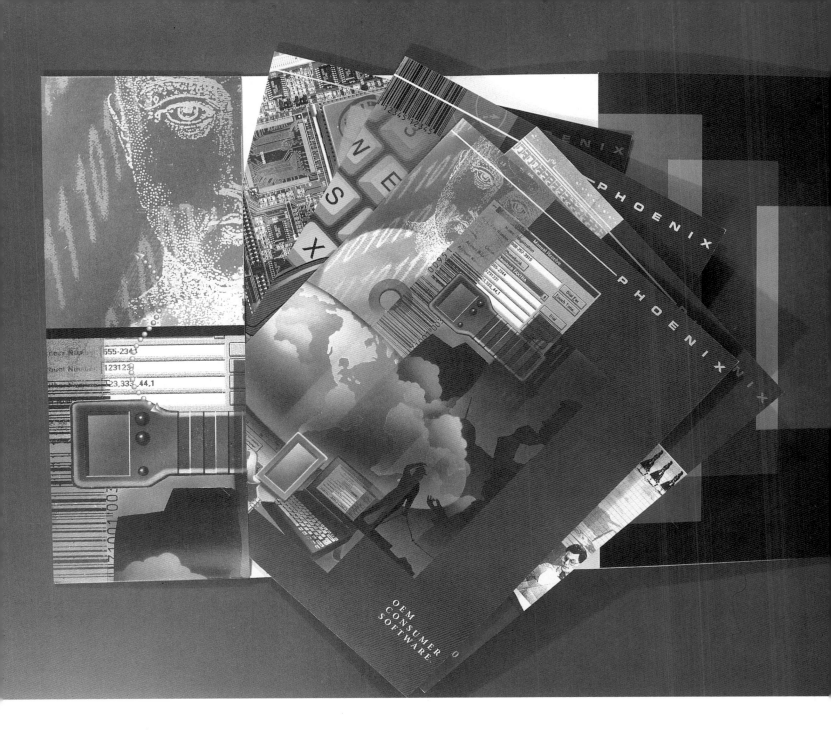

Design Firm **Stowe Design**
Art Director **Jodie Stowe**
Designers **Jodie Stowe, Jennifer Alexander**
Illustrators **Valerie Sinclar, Gary Eldridge, Jeffrey Pelo**
Copywriter **Phoenix Technologies, Inc.**
Client **Phoenix Technologies, Inc.**
Paper/Printer **Cover: Centura 80 lb., Creative Litho**

*The challenge in creating for this project was to repre-
sent several departments within Phoenix Technologies.
Each piece of the brochure has its own distinct look,
but reflects the corporate identity.*

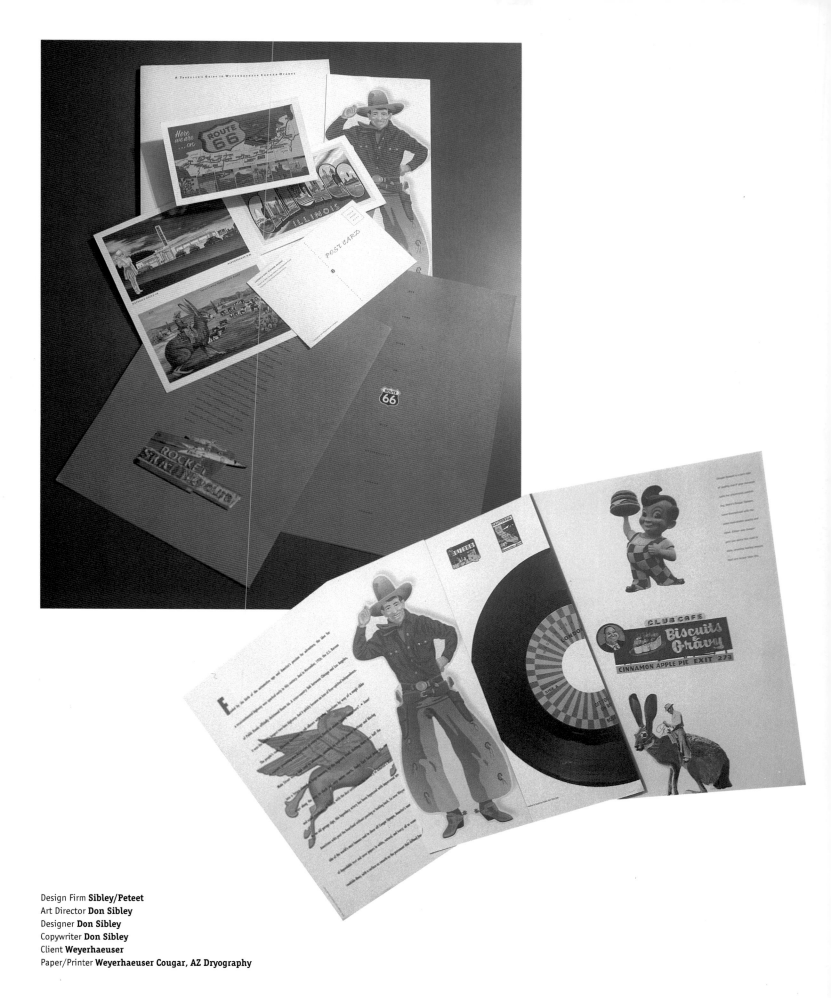

Design Firm **Sibley/Peteet**
Art Director **Don Sibley**
Designer **Don Sibley**
Copywriter **Don Sibley**
Client **Weyerhaeuser**
Paper/Printer **Weyerhaeuser Cougar, AZ Dryography**

1

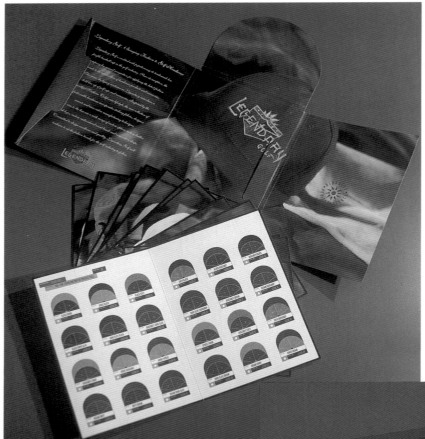

2

1
Design Firm **Beauchamp Design**
Art Director **Michele Beauchamp**
Designer **Michele Beauchamp**
Illustrator **Michele Beauchamp**
Photographer **Tom Page**
Client **Legendary Golf**
Paper/Printer **Productolith, Continental Graphics**
Tool **Macromedia FreeHand**

1➤ *The designer scanned the images using a Scitex system and the back fabric using an HP ScanJet IIcx. He used the Scitex for color correction. Each hat has its own card so that when a line of hats is discontinued a card can be removed and replaced without having to reprint the whole brochure.*

2
Design Firm **David Morris Design**
Art Director **Denise Anderson**
Designer **Denise Anderson**
Illustrator **Adam Cohe**
Client **Sharp Electronic**
Tools **Adobe Photoshop**

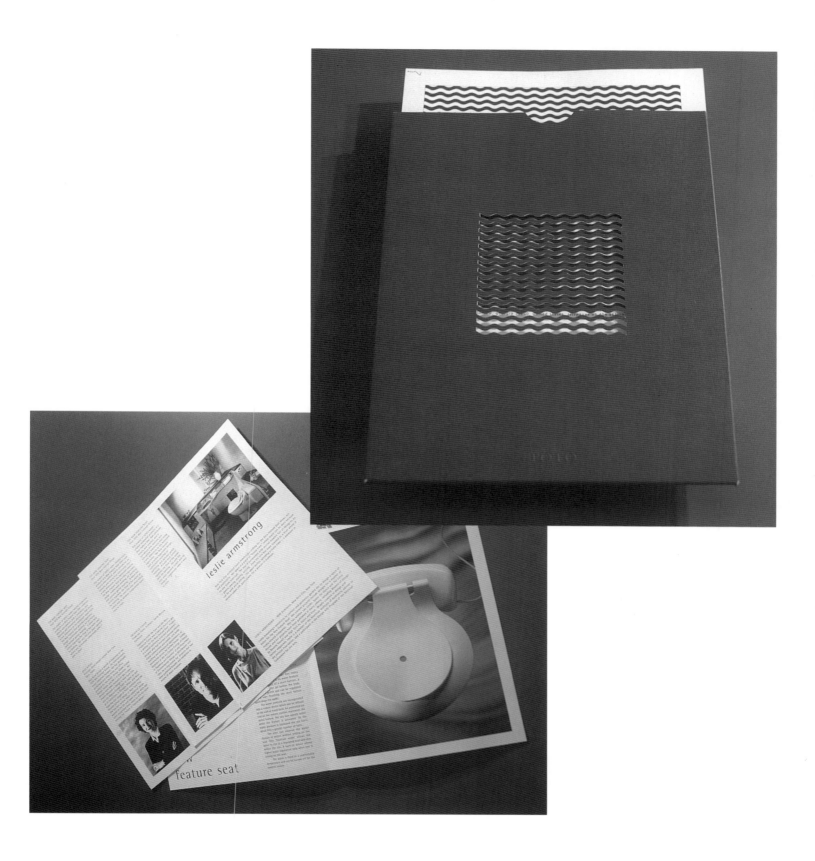

Design Firm **Sagmeister, Inc.**
Art Director **Stefan Sagmeister**
Designers **Stefan Sagmeister, Veronica Oh**
Photographers **Tom Vack, Michael Grim**
Copywriters **Alfred Polczyk, Ayse Birsel, Joan Capelin**
Client **Alfred Polczyk-Toto NCG**
Paper/Printer **Cover, 80 lb. Uncoated, Strathmore**
 Writing, Bolone Business Communication

*The brochure describes a unique product: a very, very
sophisticated toilet seat.*

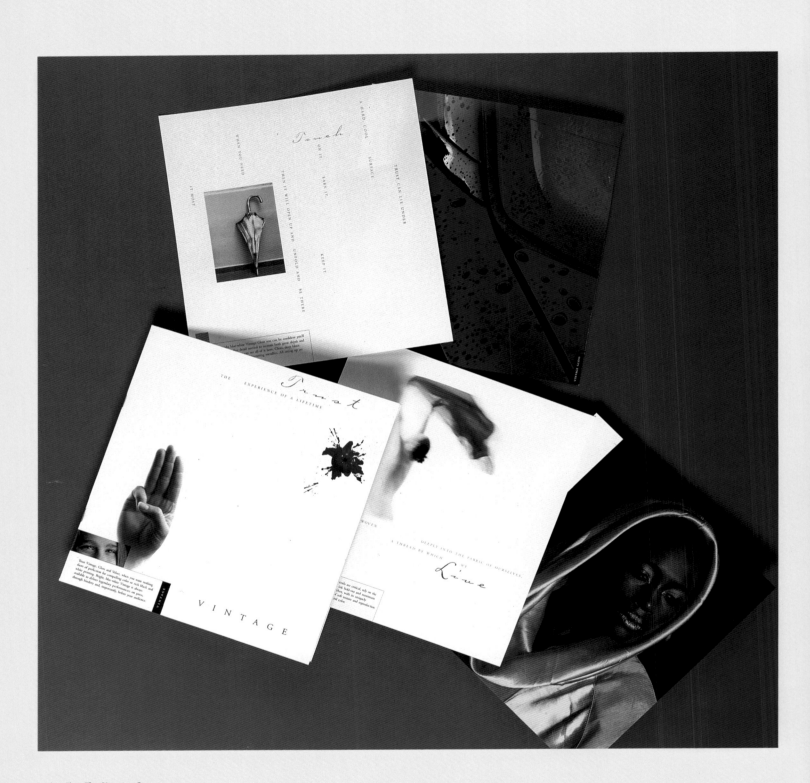

Design Firm **The Kuester Group**
Art Director **Kevin B. Kuester**
Designer **Tim Sauer**
Copywriter **David Forney**
Client **Potlatch Corporation, NW Paper Division**
Paper/Printer **Vintage Gloss and Velvet, Heritage Press**
Tools **QuarkXPress, Macromedia FreeHand,**
 and Adobe Photoshop

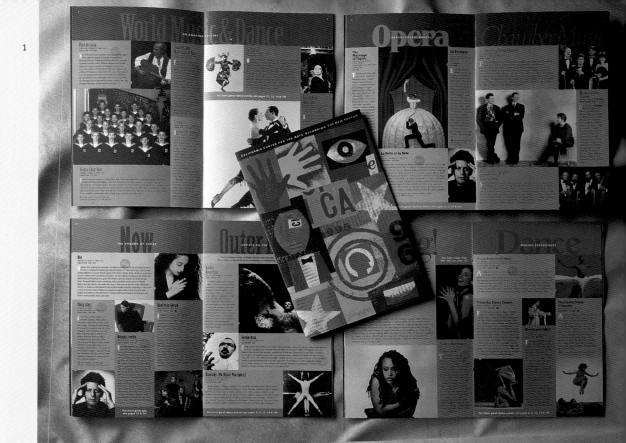

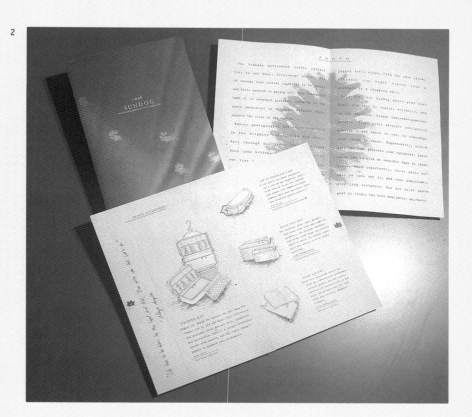

1
Design Firm **Mires Design, Inc.**
Art Director **John Ball**
Designers **John Ball and Kathy Carpentier-Moore**
Illustrator **Gerald Bustamante**
Client **California Center For The Arts, Escondido**
Tool **QuarkXPress**

1➤ *This 4-color brochure advertises tickets for the new season.*

2
Design Firm **Hornall Anderson Design Works, Inc.**
Art Director **Jack Anderson**
Designers **Jack Anderson, David Bates**
Illustrator **Todd Conno**
Photographer **Darrell Peterson**
Copywriter **SunDog, Inc.**
Client **SunDog, Inc.**
Paper **Recycled Paper**
Tools **Adobe Photoshop, QuarkXPress, and Macromedia FreeHand**

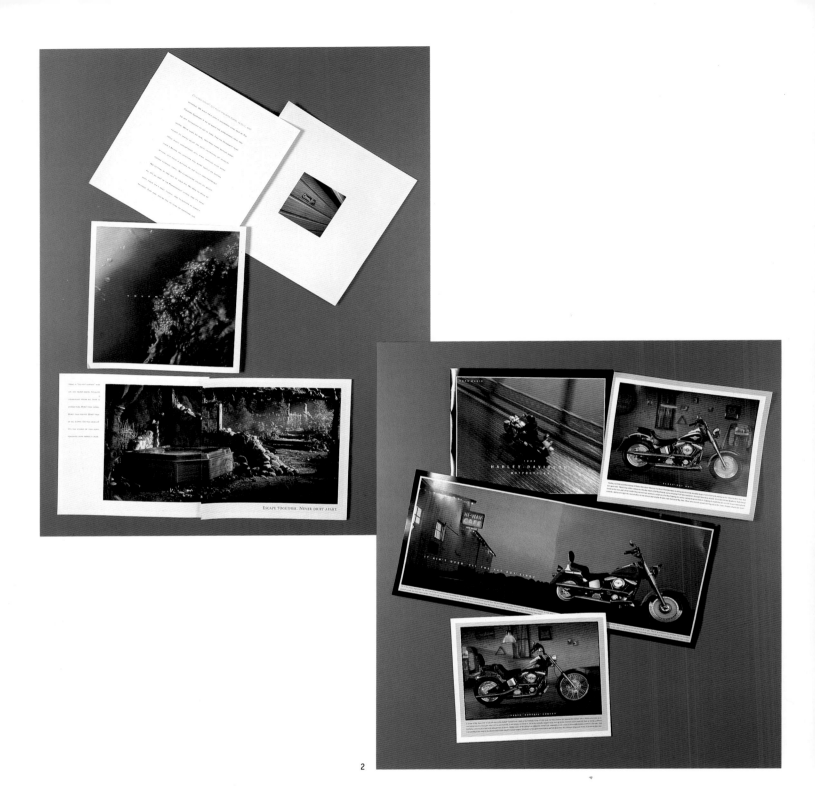

1
Design Firm **Carmichael Lynch**
Art Director **Pete Winecke**
Designer **Pete Winecke**
Photographers **Steve McHugh, Ron Crofoot**
Copywriter **Kathi Skow**
Client **Coleman Spas**
Tools **QuarkXPress and Adobe Photoshop**

2
Design Firm **Carmichael Lynch**
Art Director **Pete Winecke**
Designer **Pete Winecke**
Photographer **Erickerson Photo**
Copywriter **Sheldon Clay**
Client **Harley-Davidson**
Tools **QuarkXPress and Adobe Photoshop**

2➤ *The brochure portrays the "Harley" way of life and showcases the brand's motorcycles.*

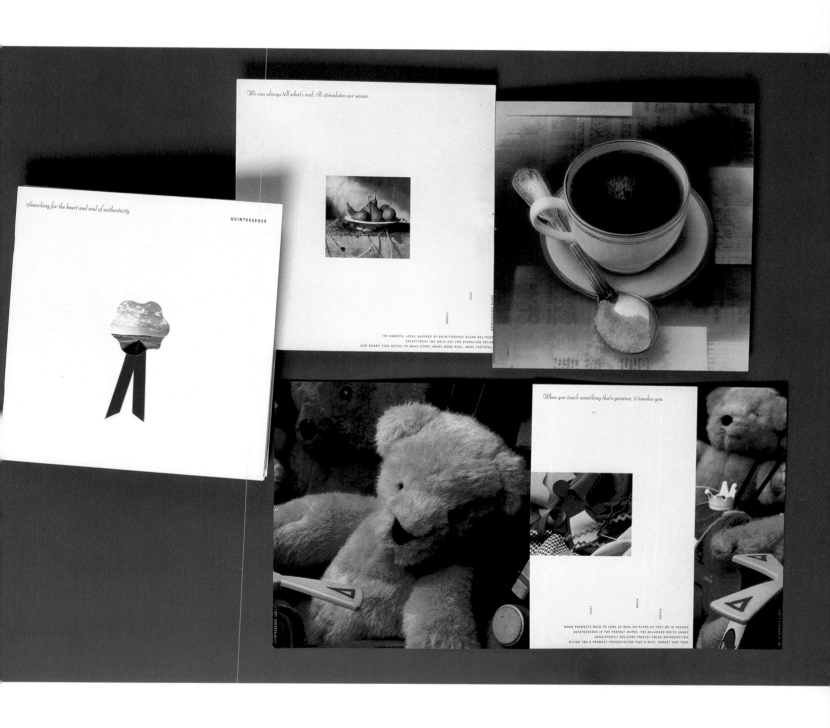

Design Firm **The Kuester Group**
Art Director **Kevin B. Kuester**
Designer **Bob Goebel**
Copywriter **David Forney**
Client **Potlatch Corporation, NW Paper Division**
Paper/Printer **Quintessence Gloss & Dull, Woods Lithographic**
Tools **QuarkXPress, Macromedia FreeHand, and Adobe Photoshop**

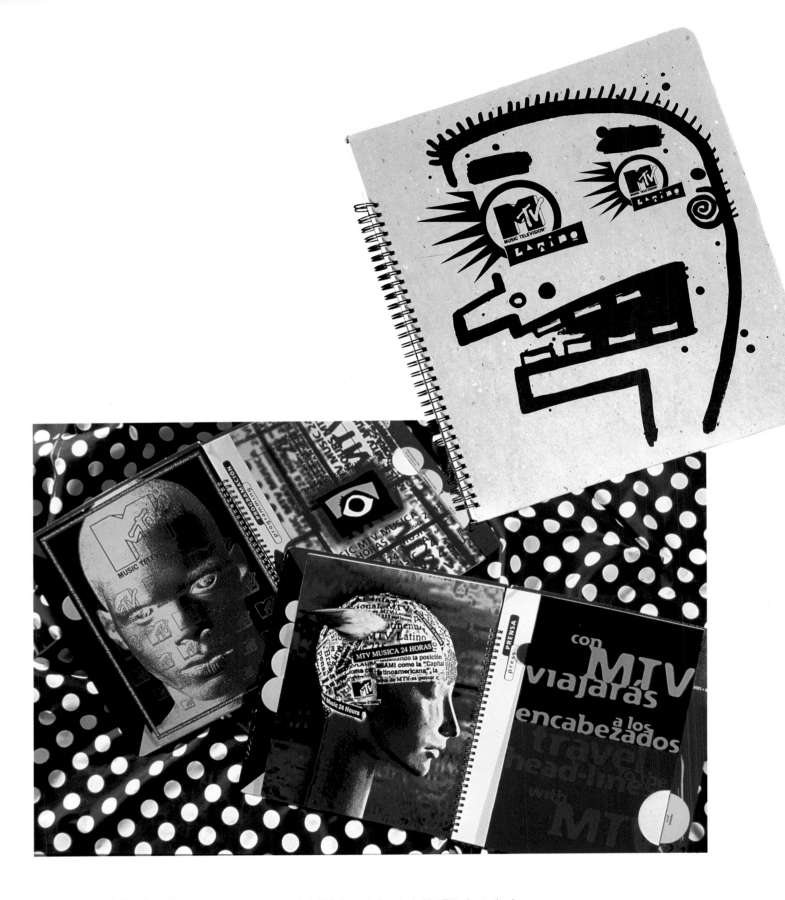

Design Firm **Luis Fitch Design Lab**
Art Director **Luis Fitch**
Designer **Luis Fitch**
Photographer **Will Shivley**
Client **MTV Latino**

Luis Fitch Design Lab worked with MTV Latino to develop a tangible piece that reflects MTV's marketing position: MTV communicates to 28 different countries, as well as to many different cultures. This piece embodies the ideas, feelings, and social status common to many Hispanic people (aged 15 to 30,) in Latin America. It also presents the advertising and sales goals for this product in countries whose people have never heard of MTV Latino.

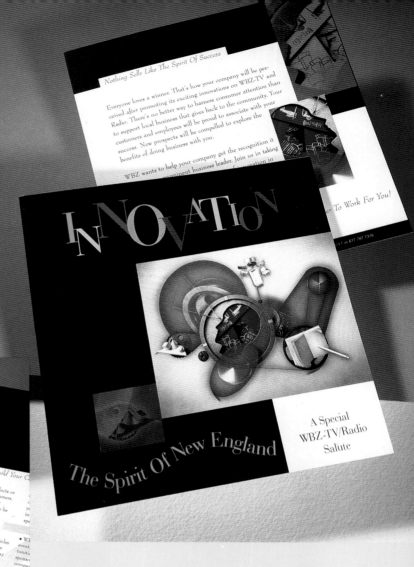

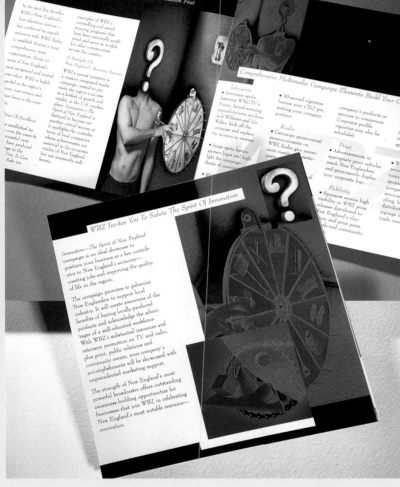

Design Firm **Group W Television**
Art Director **Marise Mizrahi**
Designer **Marise Mizrahi**
Photographer **Hugh Kretchmer**
Client **WBZ-TV Boston**
Paper **Reflections 100 lb. cover, uncoated with dull and gloss varnish**
Tools **Macintosh, QuarkXPress, and Adobe Photoshop**

The brochure promotes small businesses in the New England area.

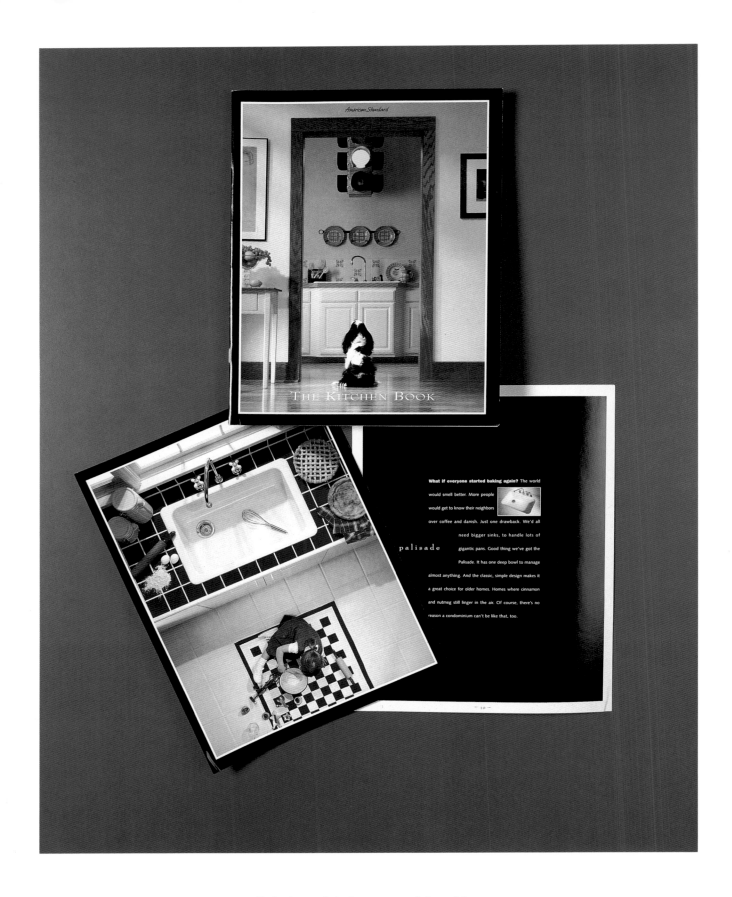

Design Firm **Carmichael Lynch**
Art Director **Pete Winecke**
Designer **Pete Winecke**
Photographer **Pat Fox Photo**
Copywriters **John Newmann, Ginnie Read**
Client **American Standard**
Tools **QuarkXPress and Adobe Photoshop**

The brochure seeks to change consumer's focus; delivering the message that American Standard makes things for the kitchen as well as the bathroom.

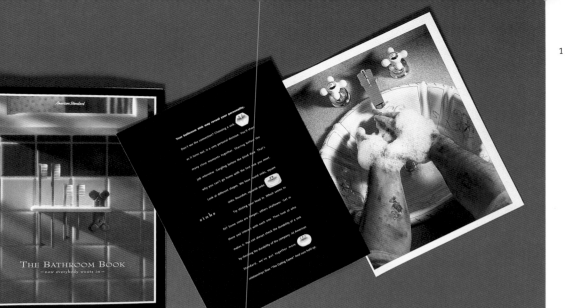

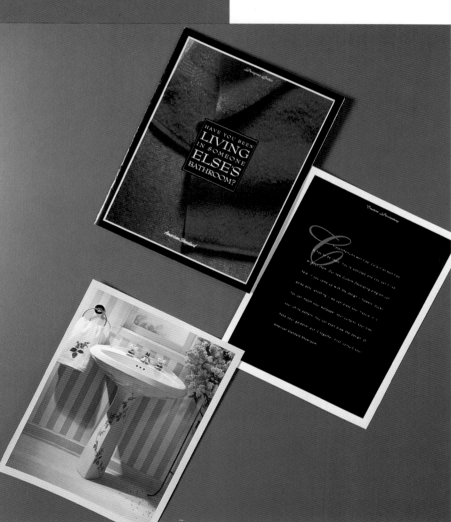

1

Design Firm **Carmichael Lynch**
Art Director **Pete Winecke**
Designer **Pete Winecke**
Photographer **Pat Fox Photo**
Copywriter **John Newmann**
Client **American Standard**
Tools **QuarkXPress and Adobe Photoshop**

1➤ *This brochure presented a physical challenge: How to fit a dog bone into a toothbrush holder.*

2➤ *This brochure anwers the question: How do you get people to believe that American Standard makes a designer series of products?*

2

Design Firm **Carmichael Lynch**
Art Director **Pete Winecke**
Designer **Pete Winecke**
Photographer **Pat Fox Photo**
Copywriter **John Newmann**
Client **American Standard**
Tools **QuarkXPress and Adobe Photoshop**

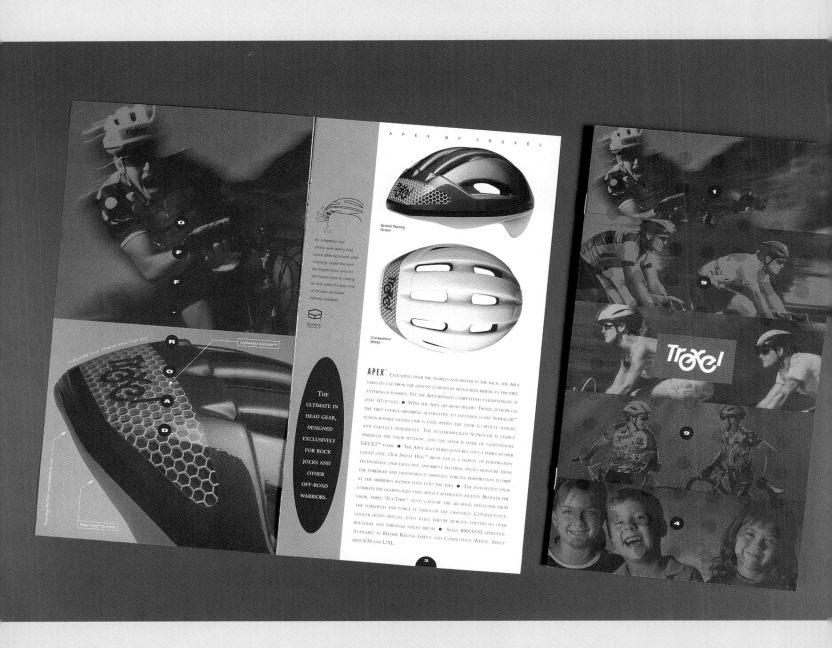

Design Firm **Caldera Design**
Art Directors **Paul Caldera, Doreen Caldera**
Designers **Bart Welch, Tim Fisher**
Photographer **Bob Carey**
Client **Troxel Cycling**
Tool **QuarkXPress**

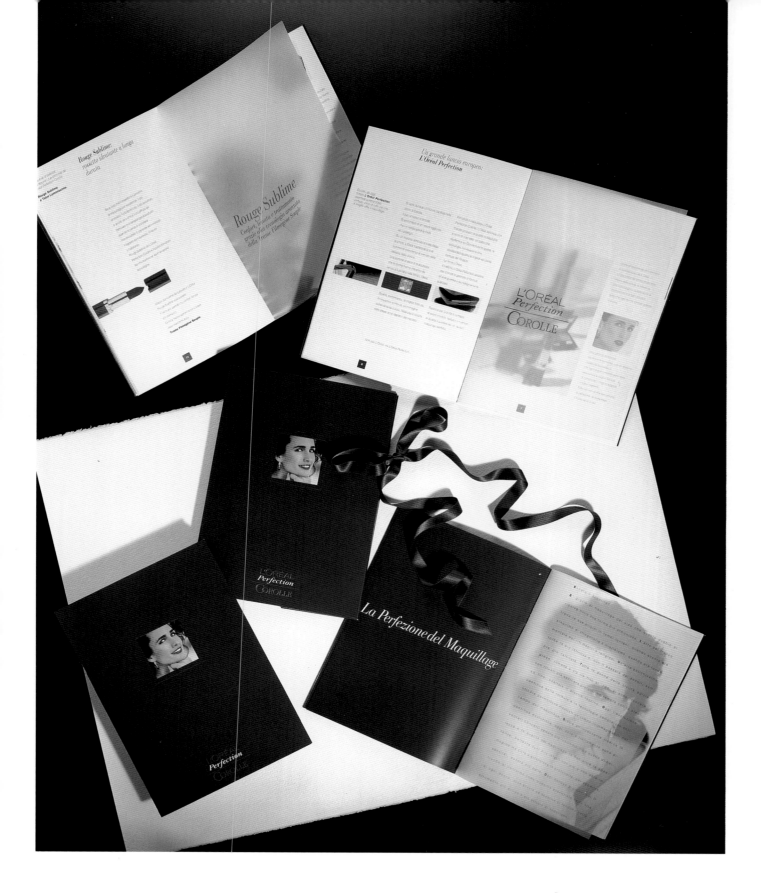

Design Firm **Giorgio Rocco Communications**
 Design Consultants
Art Director **Giorgio Rocco**
Designer **Giorgio Rocco**
Photographer **Archives L'Oréal**
Copywriter **Anna Andreuzzi**
Client **L'Oréal**
Paper/Printer **Zanders Matte Paper 167 lb.**
Tools **Macromedia FreeHand, and Adobe PageMaker**

This presentation kit was printed in 5 colors (4-color process and a single spot color) on matte and transparent papers. We used matt plastification, embossing, and hot gold on the covers. Actress Andie MacDowell provided the testimonial.

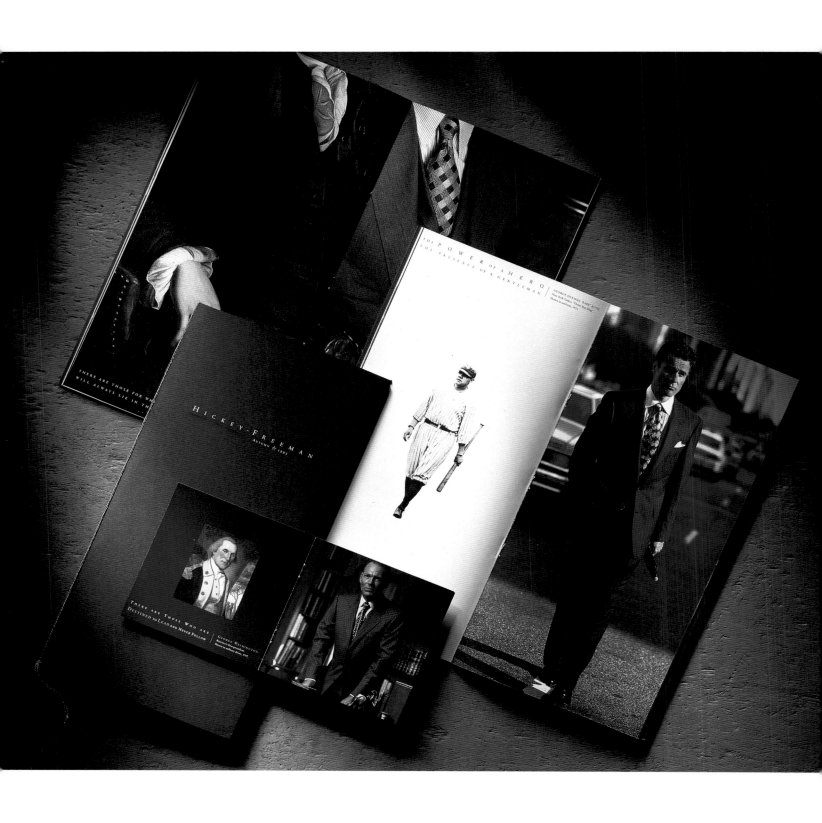

Design Firm **Grafik Communications**
Art Director **Melanie Bass**
Designers **Melanie Bass, Gregg Glaviano, and Judy Kirpich**
Photographer **Just Loomis**
Copywriter **Alan Schulman**
Client **Hart Marx Corporation**
Paper/Printer **Teton, Quintessence**

*This buyer's guide juxtaposes famous American
authors, businessmen, and visionaries with its fall line.
It asks, "How will you be remembered?"*

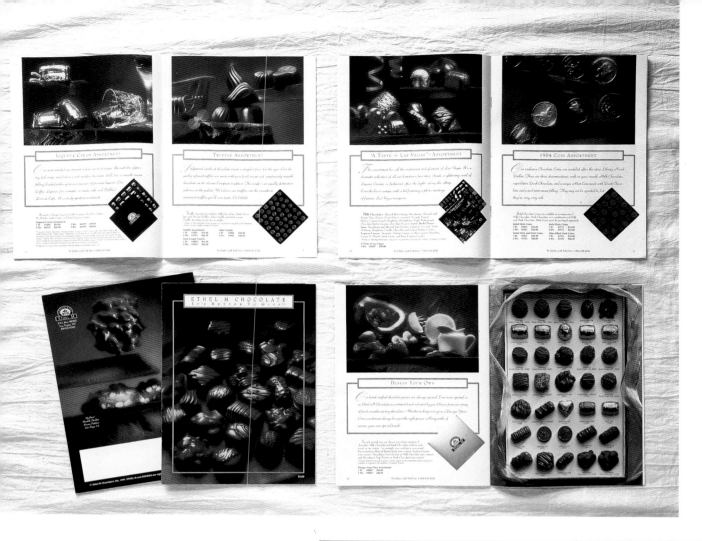

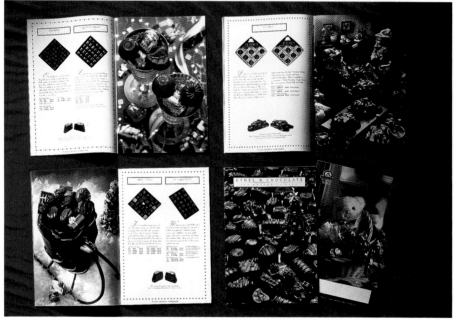

Design Firm **Mires Design, Inc.**
Art Director **Jose Serrano**
Designer **Jose Serrano**
Client **Ethel M**

The brochure was printed using a 4-color offset process.

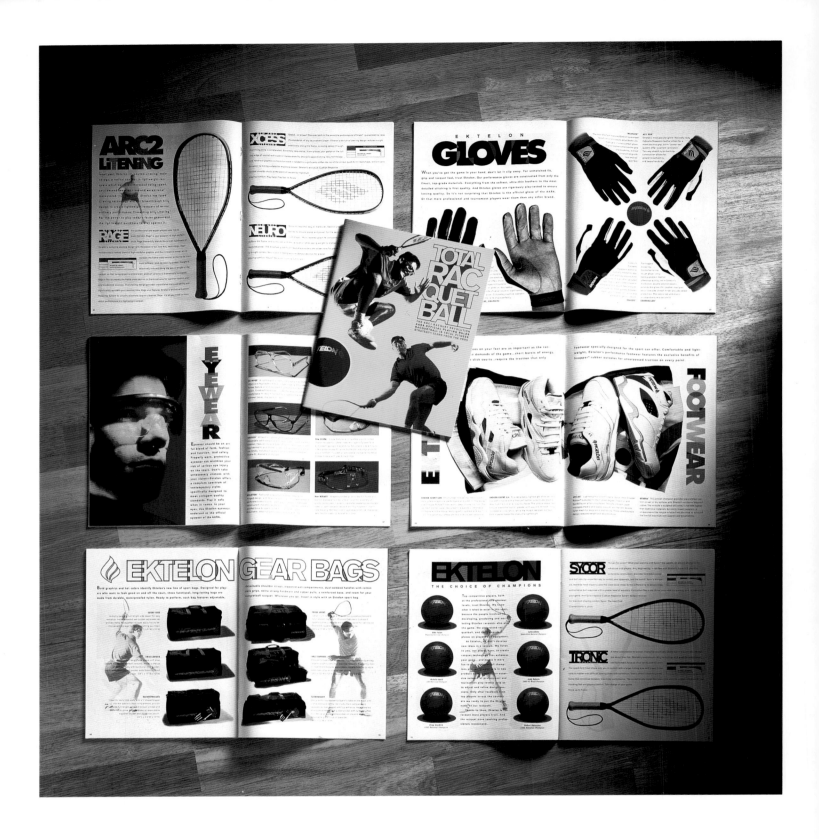

1
Design Firm **Mires Design**
Art Director **Jose Serrano**
Designer **Jose Serrano and Mike Brower**
Photographer **Carl Vanderschult**
Client **Ektelon**

2
Design Firm **Playboy**
Art Director **Marise Mizrahi**
Designer **Marise Mizrahi**
Copywriter **Irv Kornblau**
Client **Playboy Magazine**
Paper **Cover 100 lb. cover**
Tools **Adobe Illustrator**

2 ➤ *Playboy created this brochure to promote a fashion event in New York. The cover uses five colors and a dull and gloss varnish to achieve its effect. The firm distributed the brochures with 2-color invitations that open to a 1-color map of the New York subway printed on vellum.*

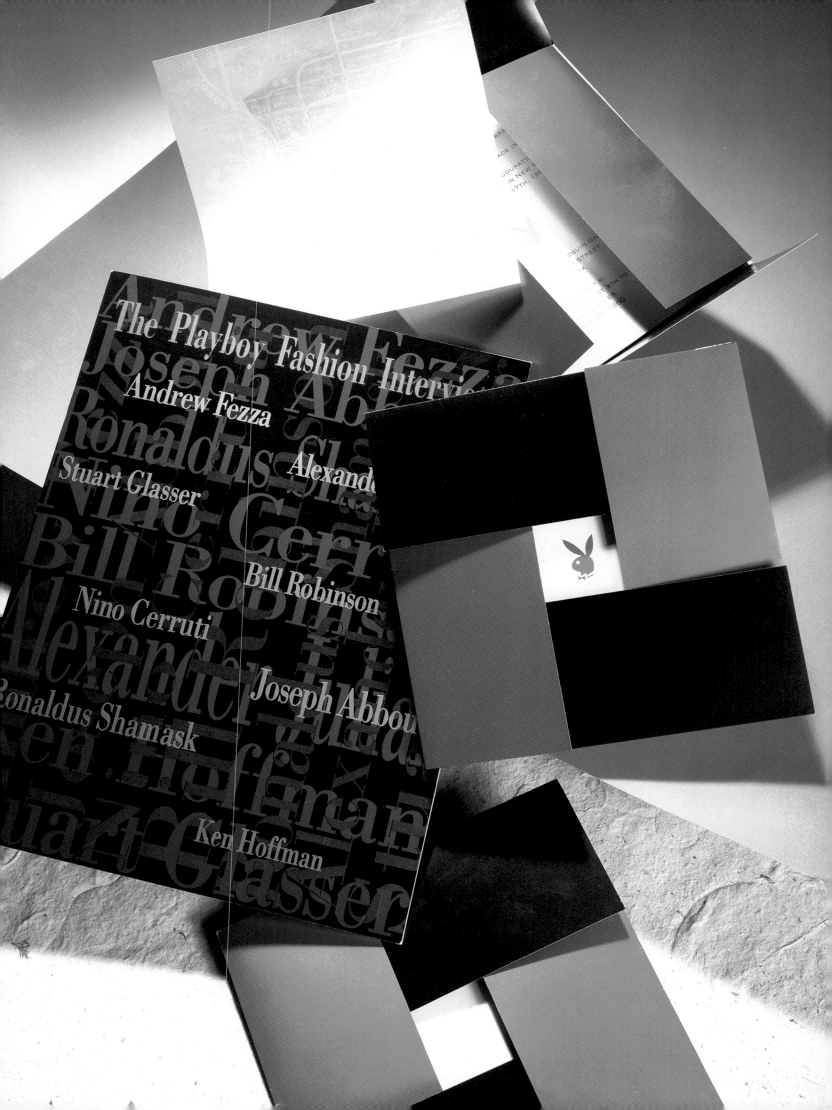

The Playboy Fashion Intervi...

Andrew Fezza

Stuart Glasser

Alexand...

Bill Robinson

Nino Cerruti

Joseph Abbou...

Ronaldus Shamask

Ken Hoffman

OIL of ULAY

NEW *Skin* DISCOVERY

SCIENTIFIC
PROFILE

NEW *Skin* DISCOVERY OIL of ULAY

Ageing and the epidermal renewal process

The skin must maintain its condition by the constant replacement of cells at the surface. As the skin ages, this process becomes less efficient. It takes old skin almost twice as long to replace a single cell at the surface. The cells of the ageing stratum corneum become larger and more flaky, the germinative cells of the ageing epidermis become smaller and less efficient. Cells that stay at the surface longer and that are replaced less frequently receive more environmental damage, more exposure to soaps, and suffer more from the effects of pollution and weather. Combined with the changes in dermal structure and pigmentation so typical of increasing age and sun damage, these changes can contribute to the dry, dull and uneven appearance of ageing skin.

Improving the efficiency of the stratum corneum renewal process, removing old flaky corneocytes and replacing them with a fresh stratum corneum, helps to alleviate some of the typical signs of aged skin.

Hydroxy acids, in particular salicylic acid, can enhance the renewal process in normal skin.

Hydroxy acids are known to enhance the renewal process by reducing the strength of the bonds between the cells of the stratum corneum. The alpha hydroxy acids have recently started to be used in cosmetic moisturising formulae, with superior benefits to the consumer over the use of ordinary moisturisers (e.g. in the areas of skin texture and tone). The recent availability of skin care products based on hydroxy acid technology has been greeted with great enthusiasm by consumers, who have actively sought the benefits of such products and also been willing to accept certain potential trade-offs in the area of skin irritation. Recent data, however, have highlighted the performance of an acid from a different class of hydroxy compounds, salicylic acid. In our internal research, we found that salicylic acid can produce benefits over alpha hydroxy acids in achieving both efficacy and skin tolerance / compatibility and, as such, salicylic acid is our hydroxy acid of choice.

NEW *Skin* DISCOVERY **INTRODUCTION**

Design Firm **Yellow M**
Art Director **Craig Falconer**
Designer **Craig Falconer**
Client **Proctor & Gamble**
Paper/Printer **117 lb. Silk Art**
Tools **QuarkXPress and Macromedia FreeHand**

This scientific profile gives guidance to chemists and doctors about Oil of Olay. It was challenging using so many graphs and charts while trying to retain a subtle and professional image. The brochure was printed using five colors with a UV varnish on the cover.

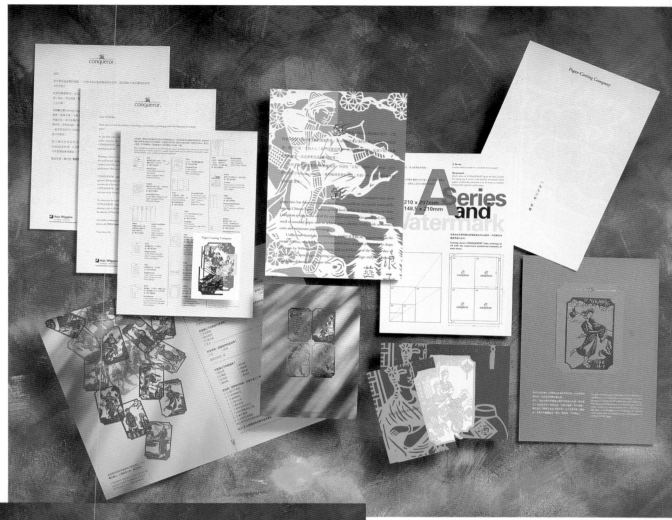

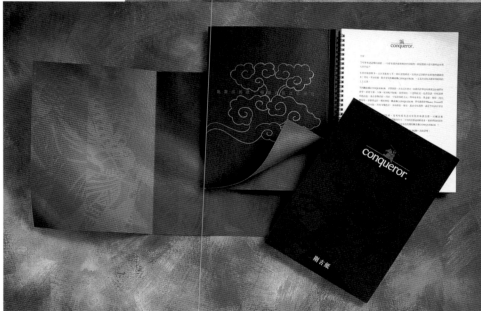

Design Firm **Artailor Design House**
Art Director **Raymond Lam**
Designer **Raymond Lam**
Photographer **Dynasty Commercial Photography**
Client **Enpa Company Limited**
Paper/Printer **Conqueror**

The brochure describes the company's products and
capabilities using the theme of "The Liangshan
Heroes"—an ancient Chinese legend about warriors who
brought unruly times to order. The piece aims to edu-
cate its market about the standardization of paper
sizes in a confused and non-standard printing environ-
ment. Actual paper and printing samples demonstrate
the company's ability to conquer even the most chal-
lenging high-tech printing effects.

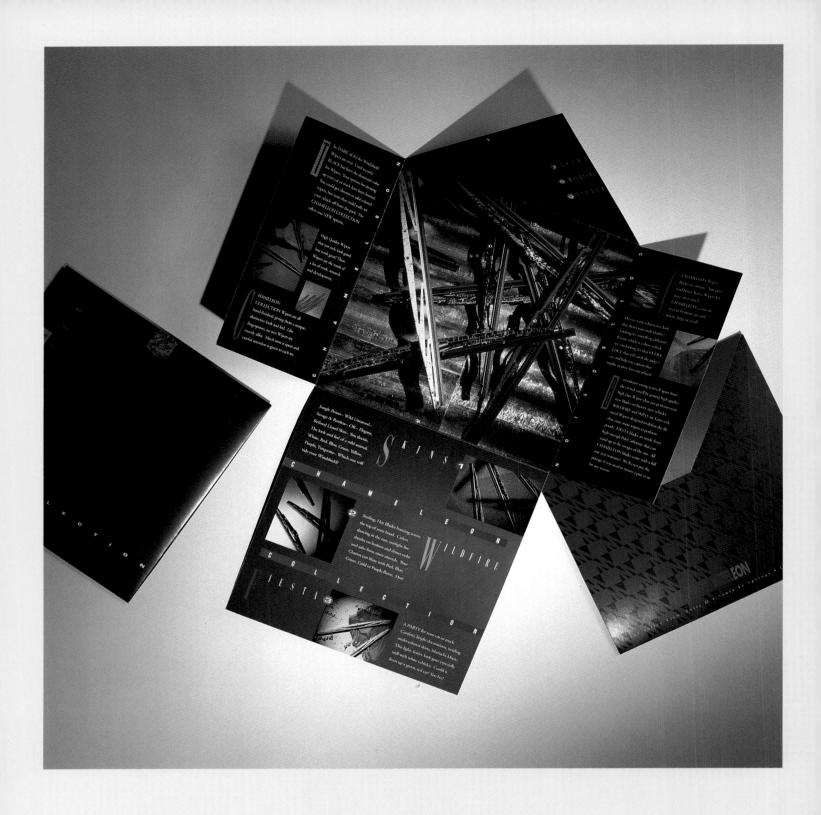

Design Firm **Wonder Studio**
Art Director **Sherri Yu**
Designer **Julian Shin**
Photographer **Howard Yang**
Copywriter **Mike Dunn**
Client **Facet Technologies, Inc.**
Printer **Ralph's Printing**
Tools **Macromedia FreeHand**

This brochure is also a self-contained mailer. The special die-cuts allow you to fold it into a square.

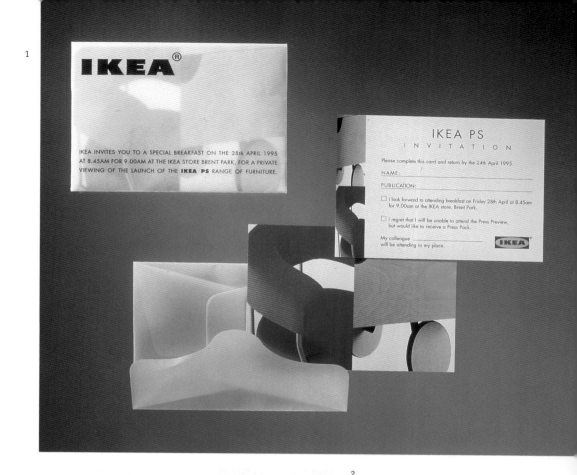

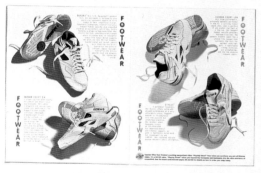

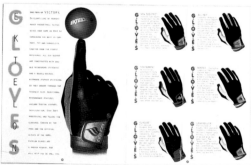

1

Design Firm **Yellow M**
Art Director **Simon Cunningham**
Designer **Simon Cunningham**
Client **IKEA**
Tools **QuarkXPress and Adobe Photoshop**

1➤ *This collection of literature helps launch a new range of products for IKEA. The design reflects the style of the furniture. The use of various papers emphasizes the various aesthetics of the furniture.*

2

Design Firm **Mires Design, Inc.**
Art Director **Jose Serrano**
Designer **Jose Serrano and Mike Brower**
Photographer **Carl Vanderschult**
Client **Ektelon**

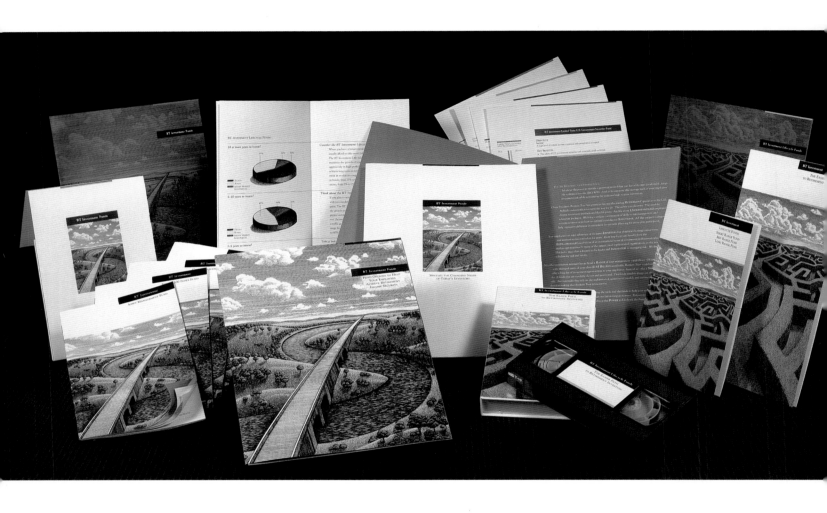

Design Firm **Bernhardt Fudyma Design Group**
Art Director **Craig Bernhardt and Jane Sobczak**
Designer **Jane Sobczak**
Illustrator **Douglas Smith**
Client **Bankers Trust Company**
Paper/Printer **Ikonofix Matte, Tanagraphics**
Tools **QuarkXPress**

*The scratchboard technique enhances the images
and makes them work in this brochure.*

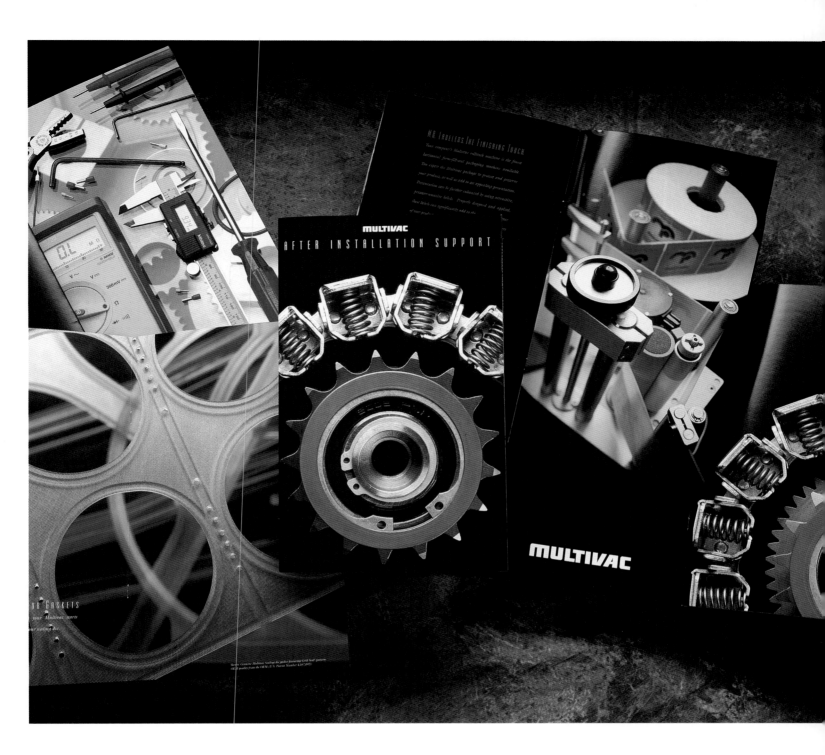

Design Firm **Fluty Art Direction/Design**
Art Director **Sheryl Fluty**
Designer **Sheryl Fluty**
Photographer **Julie Robertson**
Copywriter **Heartland Writers Group**
Client **Multivac, Incorporated**
Printer **Spangler, Incorporated**

*This piece was designed as part of a semi-permanent,
"image" brochure. Designed for repeated use as a
parts, pricing, and availability piece, the brochure has
a pocket on the back page to hold pricing information
that changes frequently. The strong, graphic effect is
created with "layered" photographs, and glass sets
with back-and side-lighting that heightens contrast
between similarly colored objects. The resulting pho-
tographs give depth, texture, and visual appeal to
parts that are aesthetically limited.*

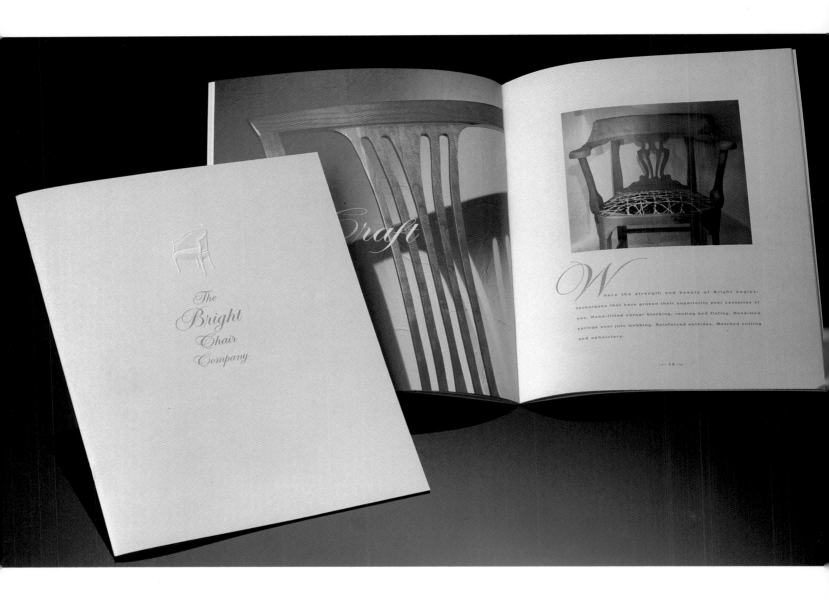

Design Firm **Diana Howard Design**
Art Director **Diana Howard**
Designer **Diana Howard**
Photographer **Deborah Klesenski**
Copywriter **Paul Stiga**
Paper/Printer **Vintage Cream, Quintessence Woods
 Lithographics**
Tool **QuarkXPress**

*The brochure uses old-style photo lettering. The main
challenge the designer faced was finding a tinted
varnish to match the color of the paper.*

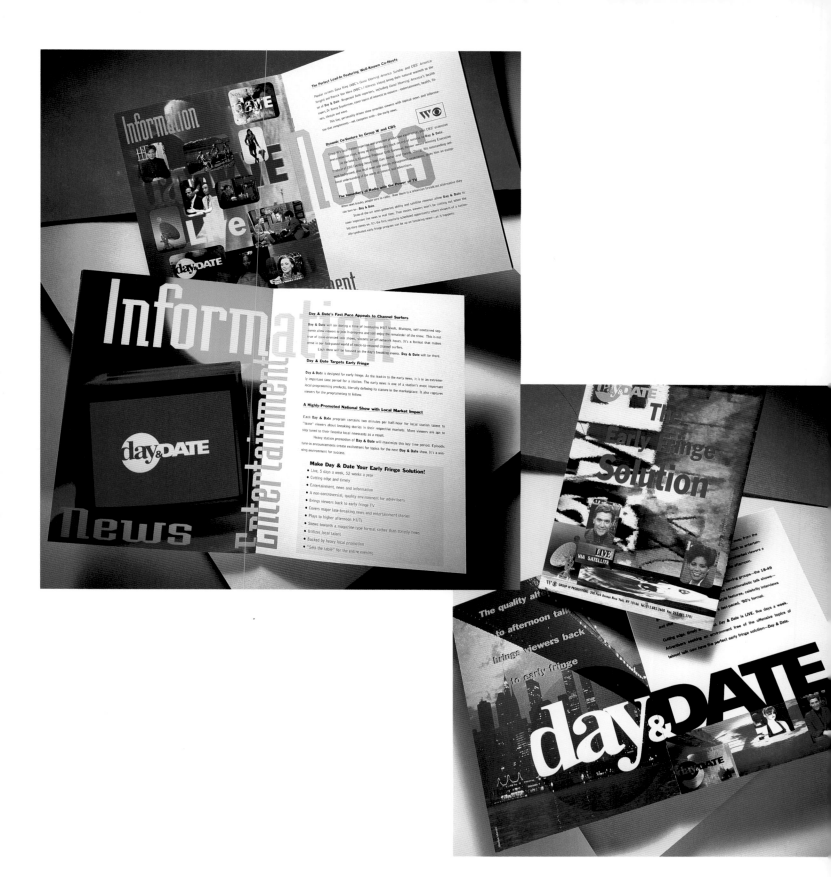

Design Firm **Group W Television**
Art Director **Marise Mizrahi**
Designer **Marise Mizrahi**
Copywriter **Barbara Rockefeller**
Client **Group W Productions**
Paper/Printer **Cover Centura 100 lb. Laminated cover**
Tools **QuarkXPress and Adobe Photoshop**

This piece was particularly difficult because most images were pulled from video and manipulated in Photoshop. The brochure promotes a new television show.

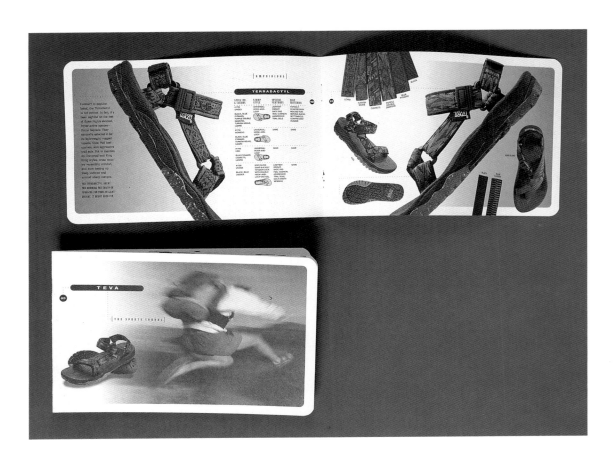

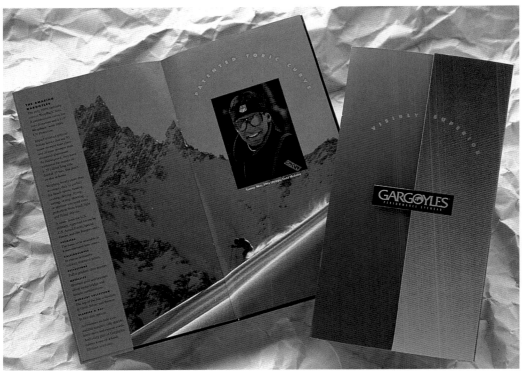

1
Design Firm **Caldera Design**
Art Director **Paul Caldera**
Designer **Tim Fisher**
Photographer **Bob Carey**
Copywriter **Imagineering**
Client **Teva, Deckers**
Tool **QuarkXPress**

2
Design Firm **Hornall Anderson Design Works, Inc.**
Art Director **John Hornall**
Designers **John Hornall, Mary Chin Hutchison,
 and Viola Lehr**
Illustrator **Gargoyles stock file**
Photographers **Darrell Peterson and Stewart Tilger**
Copywriter **Bill Bailey Carter**
Client **Gargoyles Performance Eyewear**
Paper **Vintage Gloss**
Tools **QuarkXPress and Adobe Photoshop**

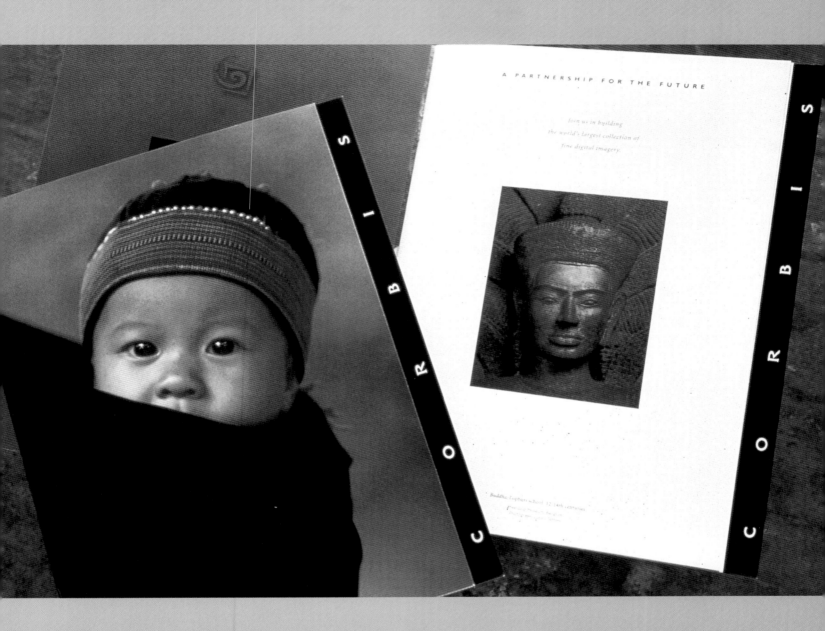

Design Firm **Hornall Anderson Design Works, Inc.**
Art Director **Jack Anderson**
Designer **Jack Anderson, John Anicker, and David Bates**
Photography **Corbis stock archives**
Copywriter **Lisa Marie Ford**
Client **Corbis**
Paper/Printer **Vintage Velvet**
Tools **QuarkXPress, Adobe Photoshop, and Macromedia FreeHand**

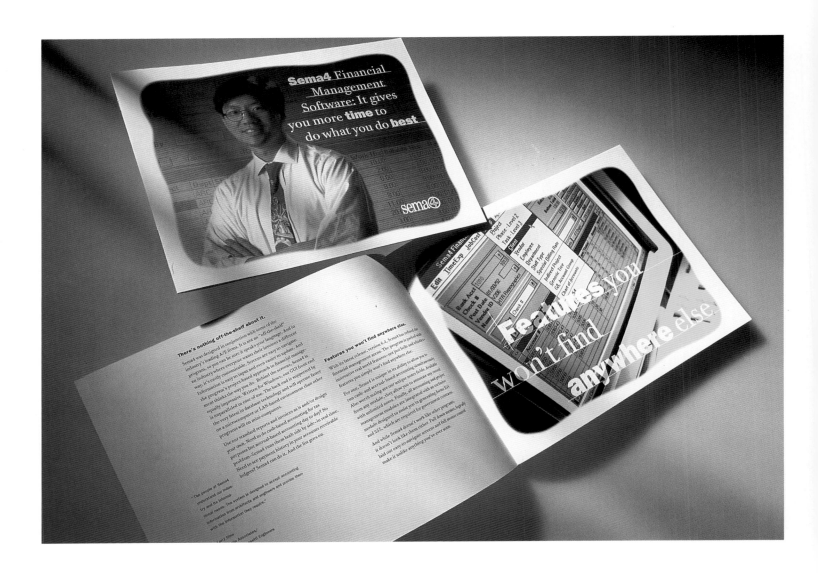

Design Firm **Lee + Yin**
Art Director **Chris Yin**
Designer **Chris Yin**
Illustrator **Chris Yin**
Photographer **Andy Shen**
Copywriter **Dan Icolari**
Client **Sema4, Inc.**
Paper/Printer **Vintage Velvet, Colahan Saunders**
Tools **Adobe Illustrator, Adobe Photoshop, and QuarkXPress**

The designer scanned the material for this brochure using a Kodak Photo CD Pro. It was printed in five colors with a varnish.

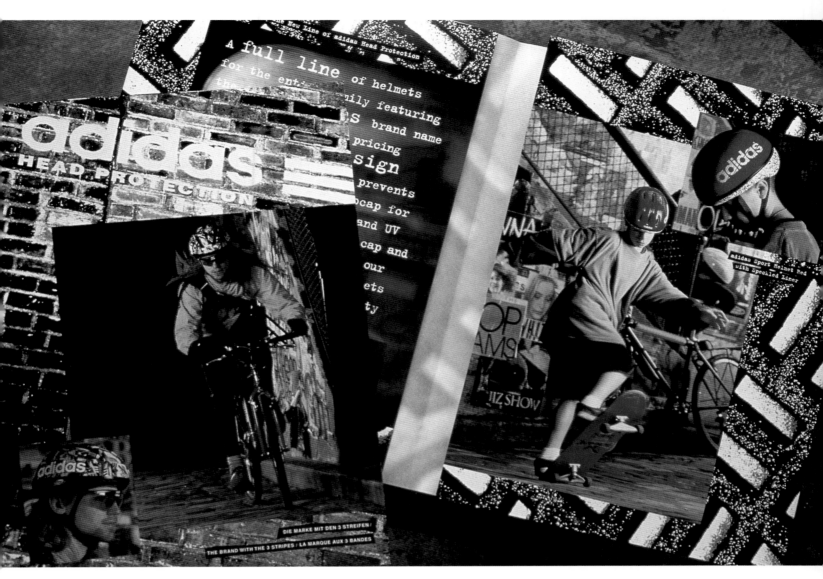

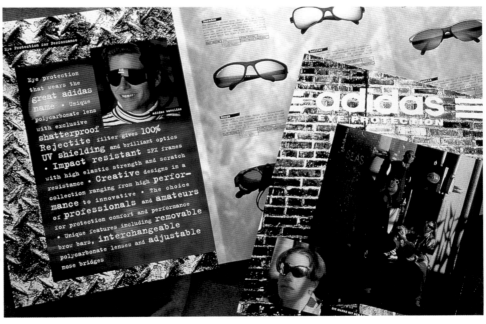

Design Firm **Hornall Anderson Design Works, Inc.**
Art Director **John Hornall**
Client **Gargoyles Performance Eyewear**

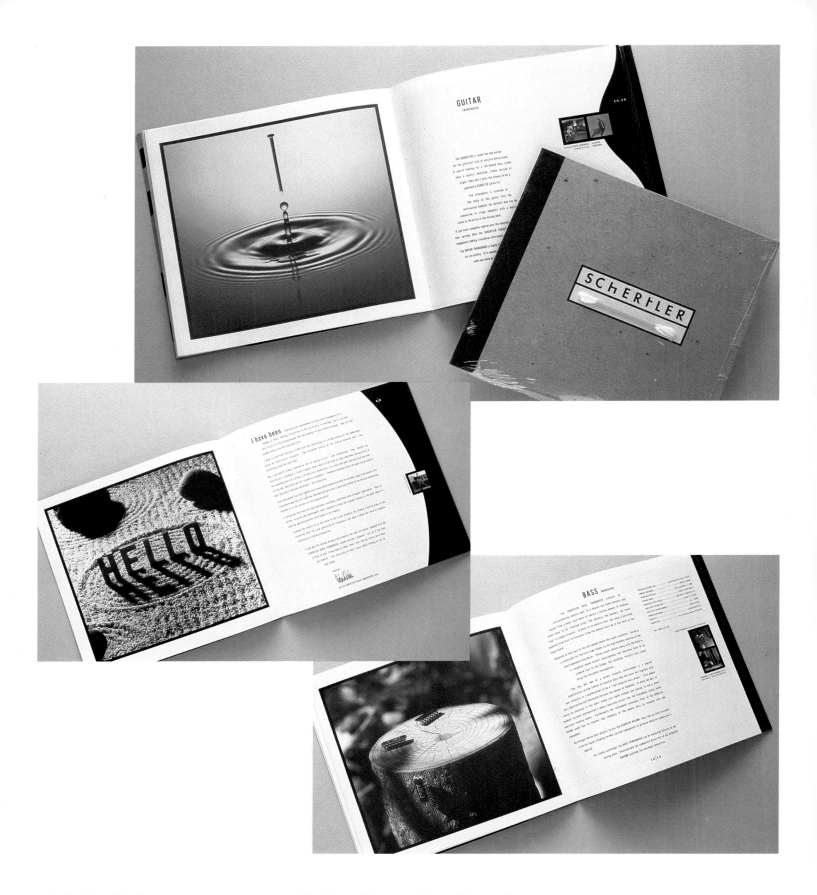

Design Firm **Sagmeister, Inc.**
Art Director **Stefan Sagmeister**
Designers **Stefan Sagmeister and Eric Zim**
Illustrator **Eric Zim**
Photographer **Tom Schierlitz**
Copywriter **Stephan Schertler**
Client **Schertler Audio Transducers**
Paper/Printer **80 lb. Matte Coated, Cover Chipboard**

Robert Kushner Schertler manufactures high-end audio pick-ups for acoustic instruments. Their logo is made up of concentric ellipses. Each chapter shows a photographic presentation of the logo.

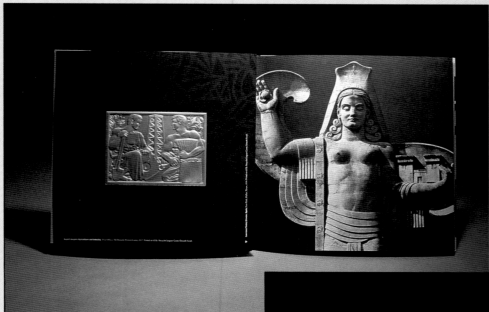

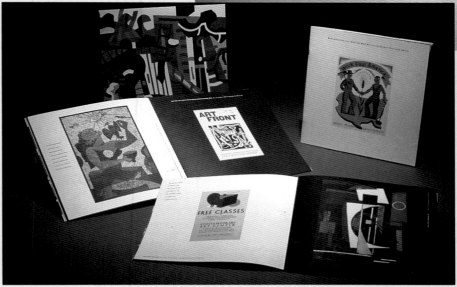

Design Firm **Sibley/Peteet**
Art Director **Don Sibley**
Designer **Don Sibley**
Copywriter **Kevin Johnson**
Client **Weyerhaeuser**
Paper/Printer **Weyerhaeuser Jaguar, Woods
 Lithographics**

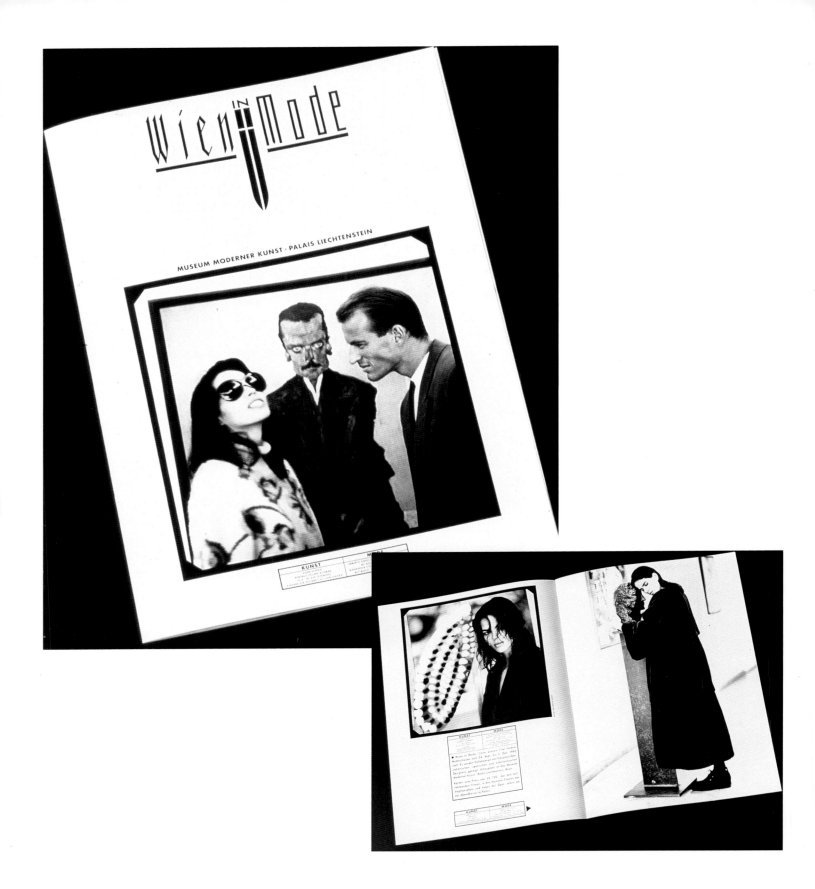

Design Firm **Sagmeister, Inc.**
Art Directors **Stefan Sagmeister**
 and Gunther Hrazdijra
Designer **Stefan Sagmeister**
Photographer **Elfie Semothan**
Copywriter **Gunther Hrazdijra**
Client **Motiva Studio**
Paper/Printer **Vogue, Germany**

*This brochure for a fashion show at the Museum of
Modern Art in Vienna draws you to the show because
the brochure itself was shot in the museum.*

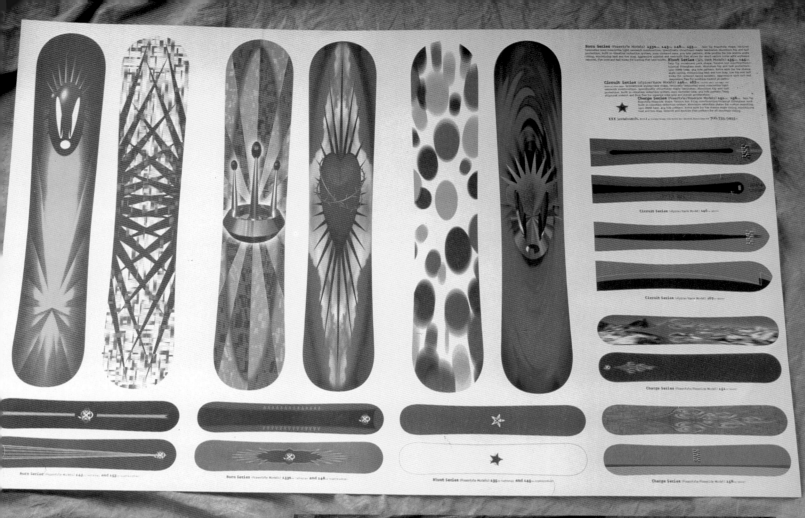

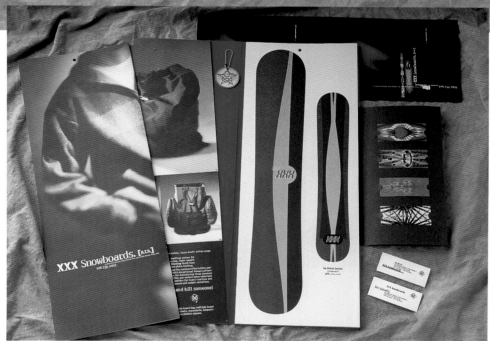

Design Firm **Segura, Inc.**
Art Director **Carlos Segura**
Designer **Carlos Segura**
Illustrators **Tony Klassen and Carlos Segura**
Photographer **Jeff Sciortino**
Client **Snowboards**
Paper/Printer **Bradley**
Tools **Adobe Illustrator, QuarkXPress,
 Adobe Photoshop, Ray Dream Designer**

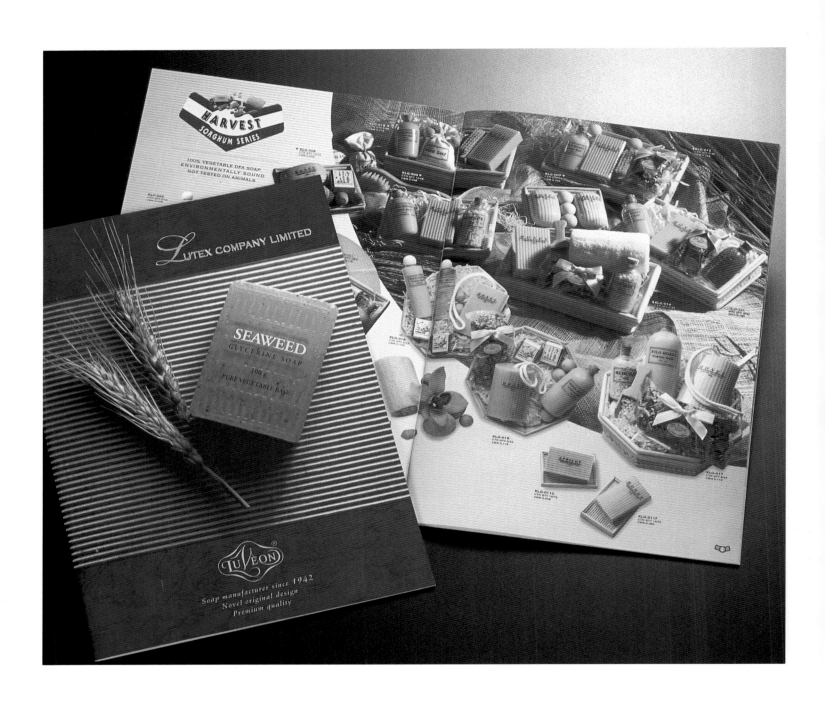

Design Firm **Grand Design Company**
Art Directors **Grand So and Rex Lee**
Designer **Rex Lee**
Photographer **David Lo, Studio Rad**
Client **Lutex Company Ltd.**
Paper/Printer **Hoi Kwong Printing Co., Ltd.**

Trying to photograph the translucent beauty of soap was quite challenging for the Grand Design Company. The front cover shows how they overcame the challenge.

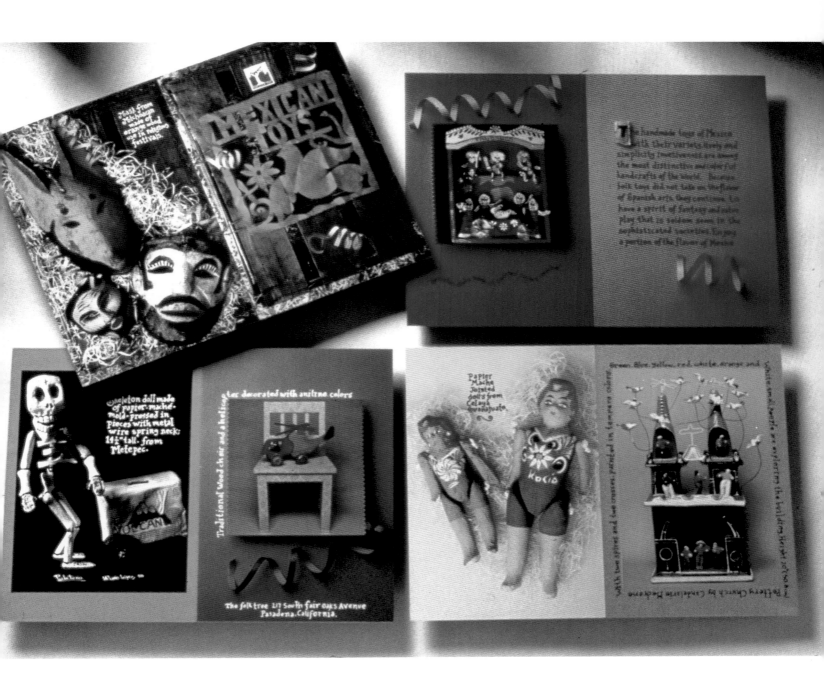

Design Firm **Luis Fitch Design Lab**
Art Director **Luis Fitch**
Designer **Luis Fitch**
Photographer **Patricia de LaRosa**
Copywriter **Luis Fitch**
Client **The Folk Tree**

This brochure evolved from a desire to explore, in words and pictures, the concept of toys and artifacts for decoration. Given the immensity of the task, Luis Fitch Design Lab decided to focus on some of the most colorful, playful, and famous toys from different states and indigenous groups in Mexico.

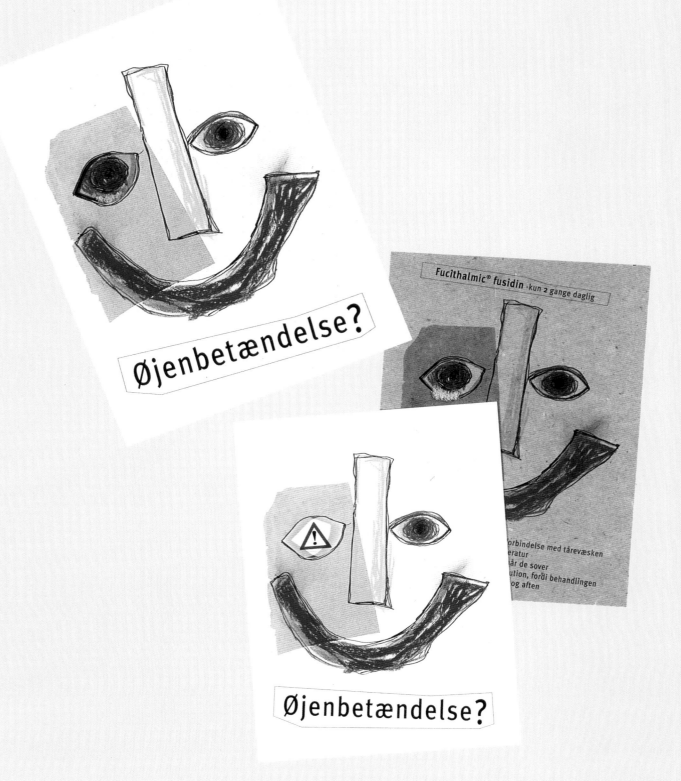

Design **Leo Pharmaceuticals**
Art Director **Vibeke Nodskov**
Designer **Vibeke Nodskov**
Illustrator **Vibeke Nodskov**
Copywriter **Mogens Norn**
Client **Leo Pharmaceuticals**
Paper/Printer **Zanders Mega Mzt, brown recycled**
Tools **QuarkXPress**

The illustration was made with cut paper, crayons, and ballpoint pen. Real salt is glued in the eye to demonstrate how the consistency of the eye creme changes when it touches salt (the eye).

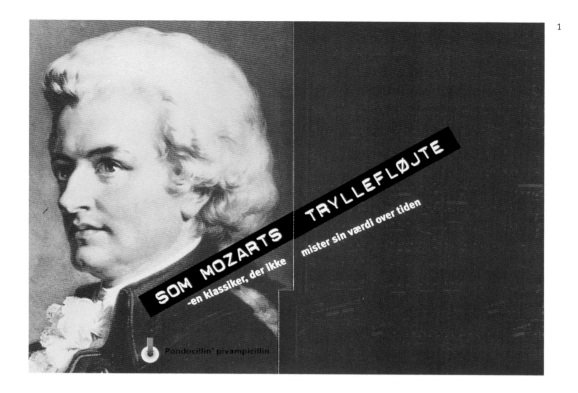

1
Design **Leo Pharmaceuticals**
Art Director **Vibeke Nodskov**
Designer **Jean Rasmussen**
Illustrator **Jean Rasmussen**
Copywriters **Vibeke Nodskov and Flemming Frandsen**
Client **Leo Pharmaceuticals**
Paper/Printer **Royal Consort Silk, 250 gr.**
Tools **Adobe Illustrator and QuarkXPress**

1► *For Leo Pharmaceuticals in-house design depart-ment, the trickiest elements of the brochure were the die-cut and the partial UV-lacquer on the Dynomoe boxes.*

2
Design Firm **Elton Ward Design**
Art Director **Steve Coleman**
Designer **Simon Macrae**
Client **Weston Baked Foods Australia**
Tools **Adobe Illustrator, QuarkXPress**

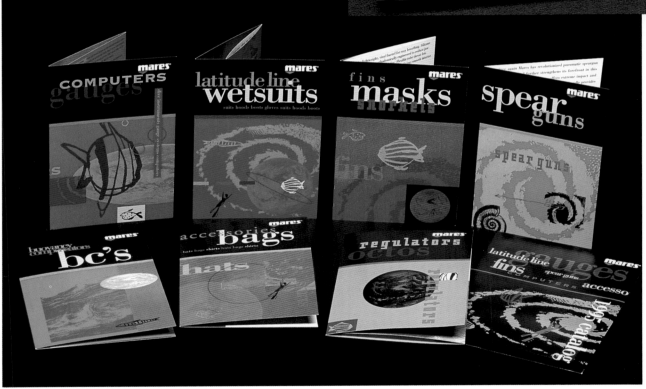

1

Design Firm **Lee Reedy Design**
Art Director **Lee Reedy**
Designer **Heather Haworth**
Illustrator **Heather Haworth**
Copywriter **Suzy Patterson**
Client **Mares**
Paper/Printer **Lithofect, Phoenix Press**
Tools **QuarkXPress**

1➤ *The photos were scanned and then manipulated and colorized in Adobe Photoshop. The figure is from the "Big Cheese" Emigre font.*

2➤ *The images for this brochure were scanned and then colorized.*

2

Design Firm **Lee Reedy Design**
Art Director **Lee Reedy**
Designer **Kathy Thompson**
Photography **Stock**
Client **Hewlett-Packard**
Paper/Printer **Speckletone, Center Printing**
Tools **QuarkXPress and Adobe Photoshop**

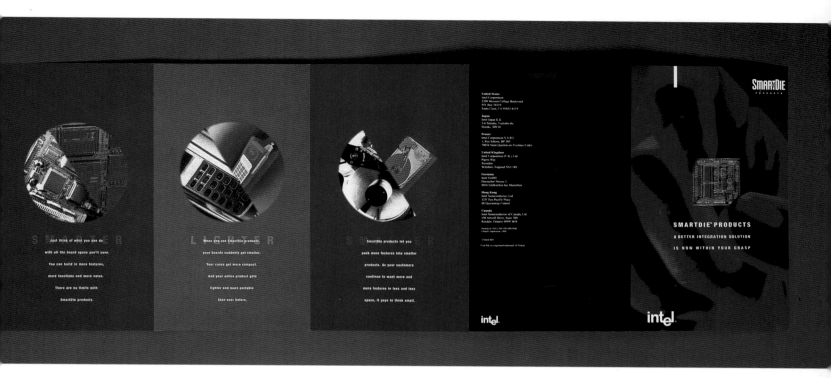

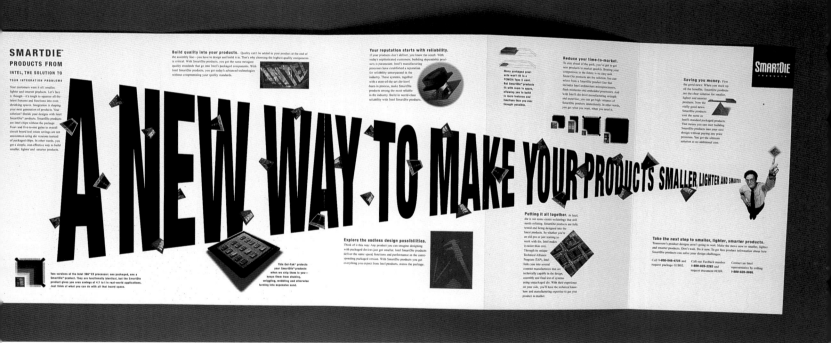

Design Firm **Mires Design**
Art Director **Scott Mires**
Designer **Scott Mires**
Photographer **Carl Vanderschult**
Client **Intel Corporation**
Tools **QuarkXPress**

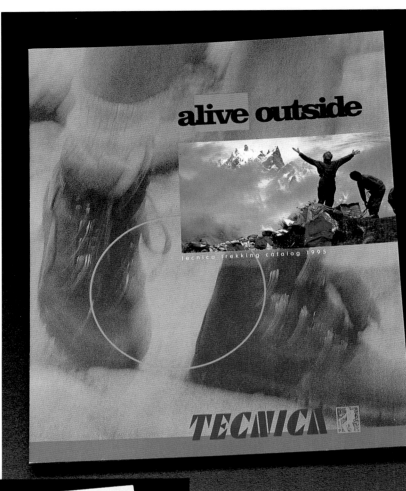

1

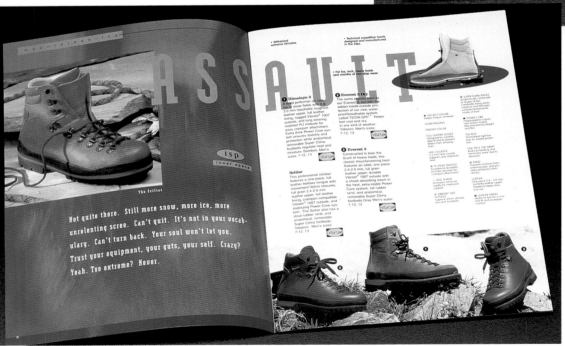

2

Design Firm **Lee Reedy Design**
Art Director **Lee Reedy**
Designer **Heather Haworth**
Illustrator **Heather Haworth**
Photographers **Greg Chrisman and Lisa Winston**
Copywriter **Jim Mitchell**
Client **Tecnica**
Paper/Printer **Warren Lustro, Pressworks**
Tools **QuarkXPress and Adobe Photoshop**

Design Firm **Lee Reedy Design**
Art Director **Lee Reedy**
Designer **Lee Reedy**
Illustrator **Mathew McFarren**
Photographer **Dan Sidor**
Copywriter **Bill Holshevnikoff**
Client **Chimera**
Paper/Printer **LOE, Communigraphics**
Tools **QuarkXPress and Macromedia FreeHand**

CHIMERA

PHOTOGRAPHIC LIGHTING 1994·95

Light. Made by Hand

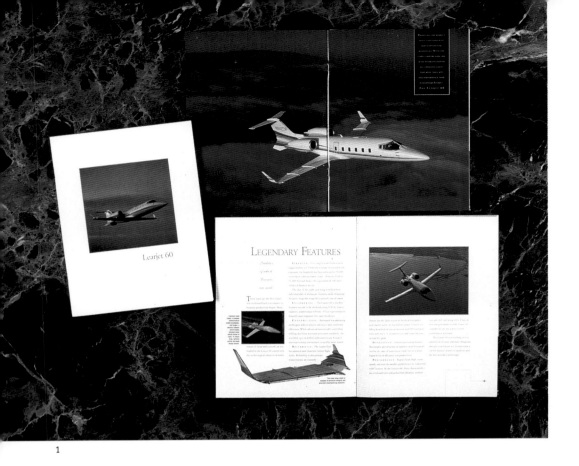

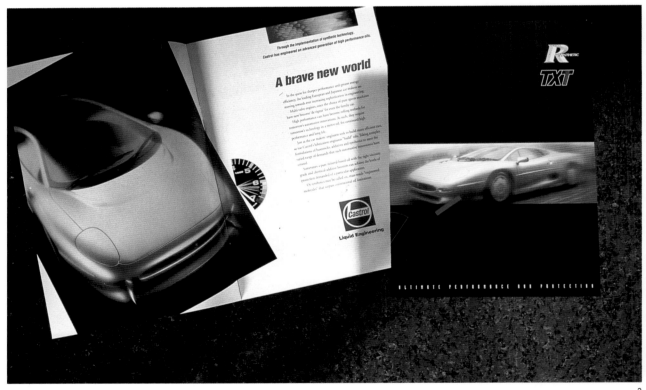

1
Design Firm **Greteman Group**
Art Director **Sonia Greteman**
Designers **Sonia Greteman and James Strange**
Photographer **Paul Bowen**
Client **Learjet**
Paper/Printer **Reflections, Donlevy**
Tools **Macromedia FreeHand**

1➤ *The brochure was printed using the 4-color process
with two spot colors and two varnishes.*

2
Design Firm **Elton Ward Design**
Art Director **Steve Coleman**
Designer **Andrew Schipp**
Client **Castrol Oils Australia**
Tools **Adobe Illustrator and QuarkXPress**

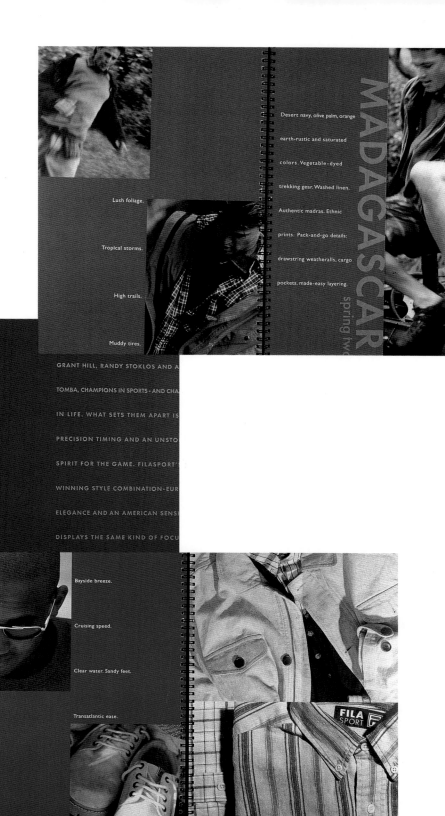

Desert navy, olive palm, orange earth-rustic and saturated colors. Vegetable-dyed trekking gear. Washed linen. Authentic madras. Ethnic prints. Pack-and-go details: drawstring weatheralls, cargo pockets, made-easy layering.

MADAGASCAR spring two

Lush foliage.

Tropical storms.

High trails.

Muddy tires.

GRANT HILL, RANDY STOKLOS AND A
TOMBA, CHAMPIONS IN SPORTS- AND CHA
IN LIFE. WHAT SETS THEM APART IS
PRECISION TIMING AND AN UNSTO
SPIRIT FOR THE GAME. FILASPORT'
WINNING STYLE COMBINATION-EUR
ELEGANCE AND AN AMERICAN SENS
DISPLAYS THE SAME KIND OF FOCU

collection, we now offer a complete line for the fashion-conscious man: performance wear and casual sportswear as well as modern tailored jackets, suits and ties. Our sports heritage, European elegance and American lifestyle make us truly unique. The result is a new concept in menswear: "tailored active elegance".

Sincerely,

Dr. Enrico Frachey,
President & CEO

real people
real athletes
real style

Bayside breeze.

Cruising speed.

Clear water. Sandy feet.

Transatlantic ease.

FILA SPORT

Design Firm **Desgrippes Gobé & Associates**
Art Director **Peter Levine**
Designers **Sara Allen and Michael Milley**
Photographer **Guzman**
Copywriter **Veronique Vienne**
Client **Filasport USA**

Since the Filasport brand has begun to shape itself into "collections," the company requested a brochure that would maintain the consistency of brand identity and product position.

1

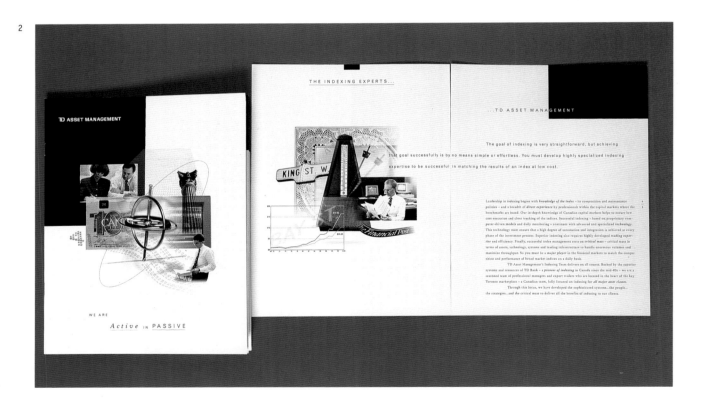

2

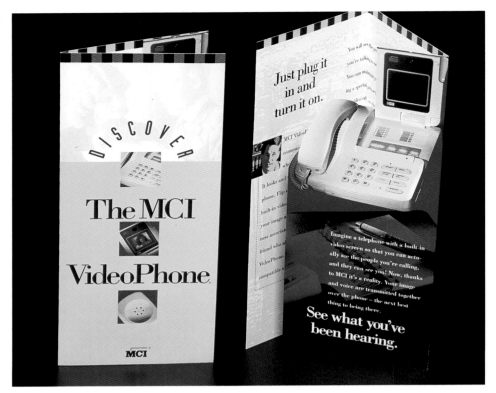

1
Design Firm **Lee Reedy Design**
Art Director **Lee Reedy**
Designer **Kathy Thompson**
Photographer **Frank Cruz**
Client **MCI**
Paper/Printer **Centura Gloss, L & M printing**

2
Design Firm **Eskind Waddell**
Art Director **Roslyn Eskind**
Designers **Roslyn Eskind and Nicola Lyon**
Illustrator **Franklin Hammond**
Copywriter **Toronto Dominion Bank**
Client **Toronto Dominion Bank**
Printer **Arthurs - Jones Lithographing Ltd.**
Tools **Adobe Illustrator, QuarkXPress,
 and Adobe Photoshop**

2➤ *The report is organized in tiered, manageable
sections, with varying amounts of detail and
complexity—so it appeals to a variety of
audiences.*

What does it mean to be active? The modern definition doesn't require world records or perfect form. It's about synchronizing mind and body, pushing performance levels, covering new ground, and always

you don't
miss a thing.
very detail
has to be
just so.
's not about
erfection,
's about style.
Ve've paid
ttention
n case
ou're busy
lsewhere.

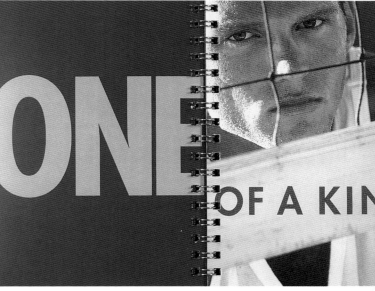

ONE OF A KIN

Design Firm **Desgrippes Gobé & Associates**
Art Director **William Hovard**
Designer **Michael English**
Photographer **Guzman**
Copywriters **Tara Kasaks and Leslie Sherr**
Client **Filasport USA**

This is a teaser: as the first piece of communications sent to buyers and the press to introduce the Filasport collection, the brochure had to be eye-catching, emotional, and memorable. It also has to introduce an Italian brand to the American market.

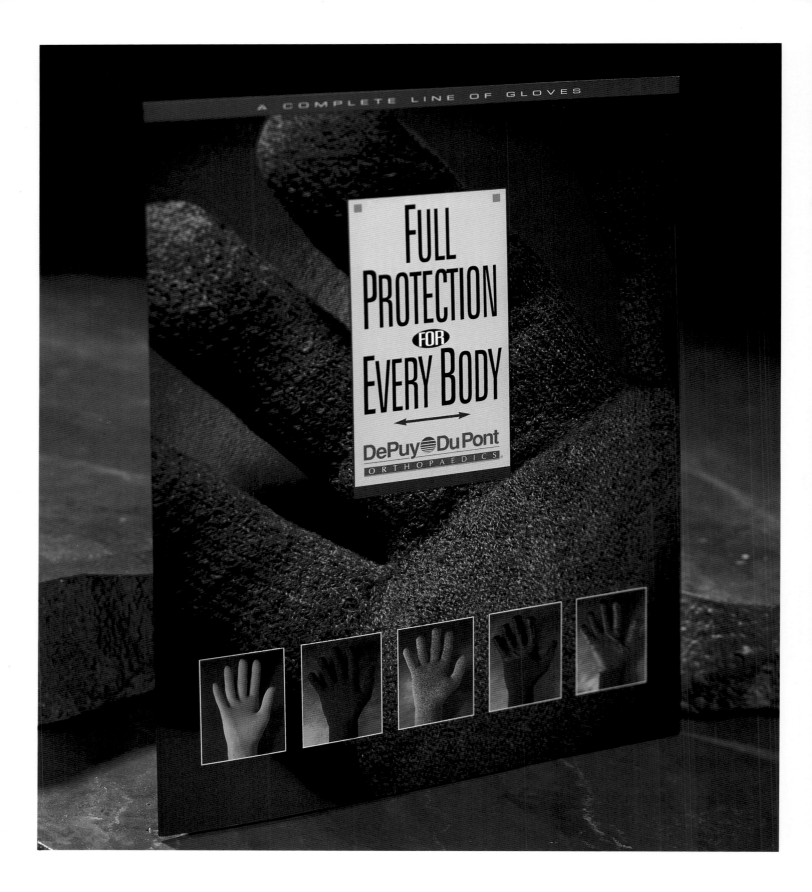

Design Firm **Held Diedrich**
Art Director **Dick Held**
Photographer **Partners Photograph**
Copywriter **Linda Lazier**
Client **DePuy DuPont Orthopaedics**
Paper/Printer **EPI**
Tools **QuarkXPress**

DePuy Dupont Orthopaedics offers a line of protective gloves made with Kevlar (the same material commonly used for bulletproof vests). The designers bring attention to the line by employing macrophotography of one of the gloves in the brochure. The backdrops for photography were hand-painted.

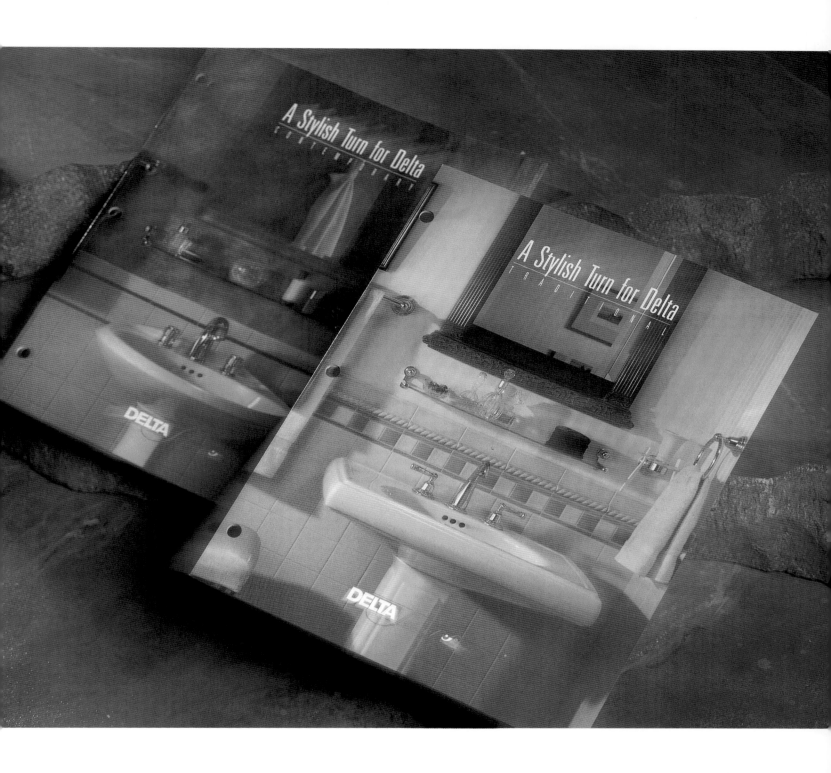

Design Firm **Held Diedrich**
Art Director **Doug Diedrich**
Designer **Doug Diedrich**
Photographer **Sparks-Hauser**
Copywriter **Debi Keay**
Client **Delta Select**
Paper/Printer **Lustra Offest Enamel**

Dedicated to the launch of the luxurious Delta Select line of faucets, this brochure emphasizes the interchangeability of the faucet handles and spouts. A "short sheet" approach reduces the redundancy of showing the accessories on every page. Printing is 4-color process, with a metallic PMS for the logo only, as well as UV coating on the outside cover.

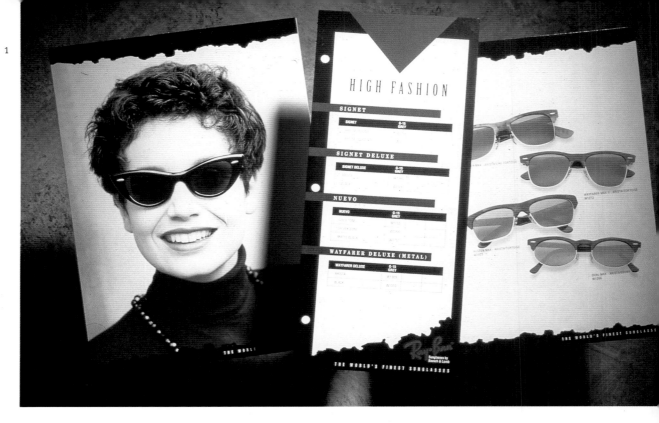

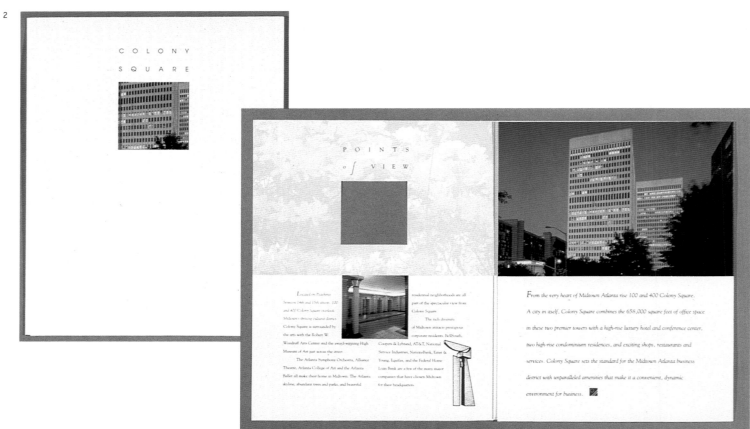

1
Design Firm **Elton Ward Design**
Art Director **Steve Coleman**
Designer **Andrew Schipp**
Client **Ray-Ban Australia**
Tools **Adobe Illustrator, QuarkXPress**

2
Design Firm **Gregory Group**
Art Director **Jon Gregory**
Client **Premisys Real Estate**
Paper/Printer **Loe Gloss 100 lb. Cover Gloss,
 Graphics Group**
Tools **Quark XPress**

2➤ *To promote a mixed-use facility in Atlanta, this
brochure blends large grids of photography with
stylized, spot-art details. A die-cut square on the
cover highlights closeup photos of the building.*

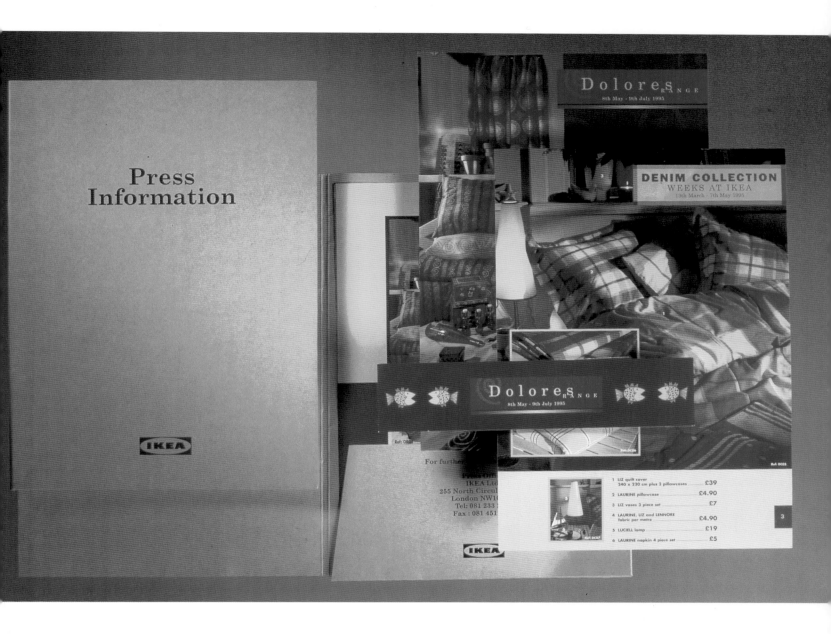

Design **Firm Yellow M**
Art Director **Craig Falconer, Simon Cunningham**
Client **IKEA**
Paper/Printer **Silk 133 lb., N.B. print**
Tools **QuarkXPress, Adobe Photoshop**

The design challenge in creating this product-launch packet for IKEA home furnishings was retaining the IKEA corporate image, yet giving the individual ranges there own identity.

1

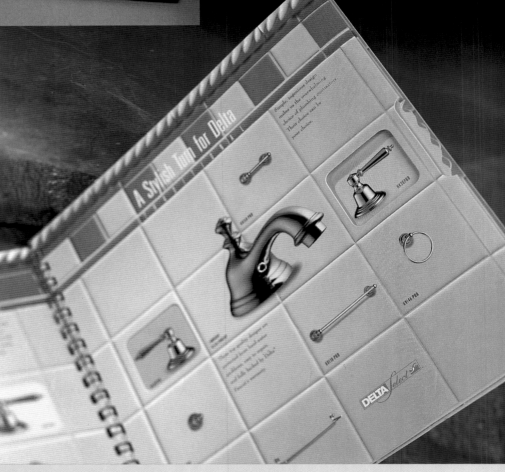

2

1
Design Firm **Sibley/Peteet**
Art Director **Don Sibley**
Designer **Don Sibley**
Copywriter **Don Sibley**
Client **Weyerhaeuser**
Paper/Printer **Weyerhaeuser Cougar, Heritage Press**

2➤ *This point of purchase display was designed to launch Delta Select faucets. To entice customers–and to help them in the selection process–the display design includes a spinner-wheel emblazoned with the slogan "Take a Stylish Turn for Delta".*

2
Design Firm **Held Diedrich**
Art Director **Doug Diedrich**
Designer **Doug Diedrich**
Photographer **Sparks Hauser**
Copywriters **Debi Keay, Doug Diedrich**
Client **Delta Select**

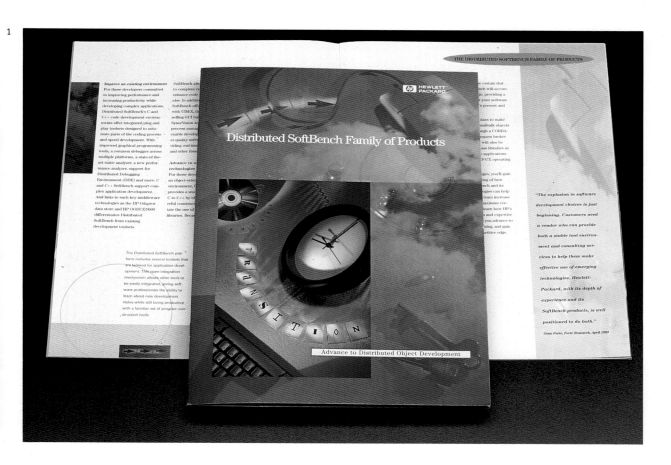

1
Design Firm **Lee Reedy Design**
Art Director **Lee Reedy**
Designer **Heather Haworth**
Illustrator **Heather Haworth**
Photographer **Frank Cruz**
Copywriter **Bonnie Garmus**
Client **Hewlett-Packard**
Paper/Printer **Centura Dull, L & M Printing**
Tools **QuarkXPress, with photo manipulations created
 in Adobe Illustrator**

2
Design Firm **Elton Ward Design**
Art Director **Steve Coleman**
Designer **James Williamson**
Photographer **Andrew Koy**
Copywriter **Colgate Palmolive in-house division**
Tools **Adobe Illustrator, QuarkXPress**

2➤ *Produced as an A-frame, flip-top presentation, this
brochure contains 20 pages of high-impact photo-
graphy to reinforce the products high-tech posi-
tioning in the marketplace.*

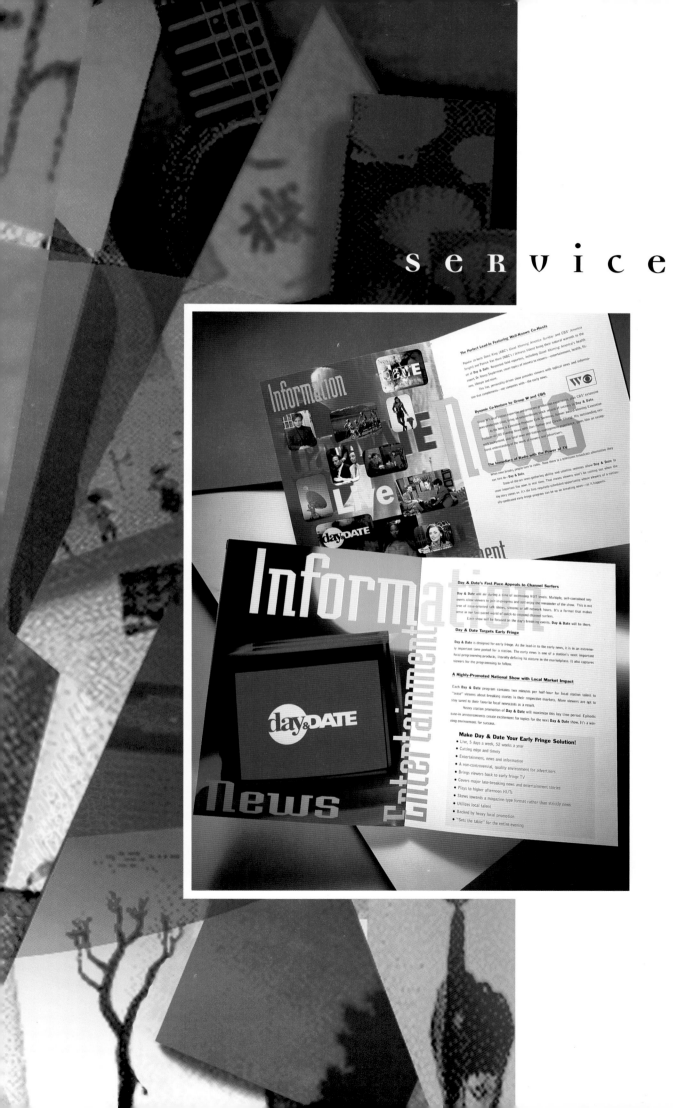

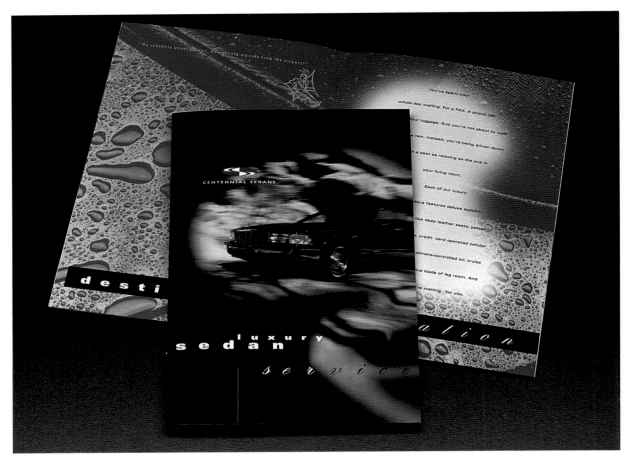

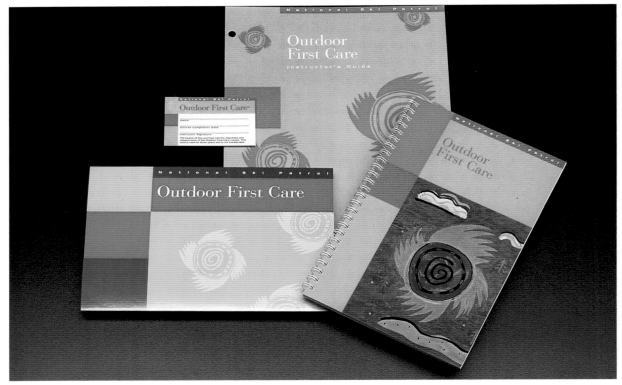

1
Design Firm **Lee Reedy Design**
Art Director **Lee Reedy**
Designer **Karey Christ-Janer**
Illustrator **Karey Christ-Janer**
Photographer **Howard Sokol**
Copywriter **Janet Aitken**
Client **Centennial Sedans**
Paper/Printer **Lustrocoat, Phoenix Press**
Tools **QuarkXPress and Adobe Photoshop**

2
Design Firm **Lee Reedy Design**
Art Director **Lee Reedy**
Designers **Heather Haworth and Kathy Thompson**
Illustrator **Heather Haworth**
Client **National Ski Patrol**
Printer **Knuntsen Printing, Lange Graphics**
Tool **QuarkXPress**

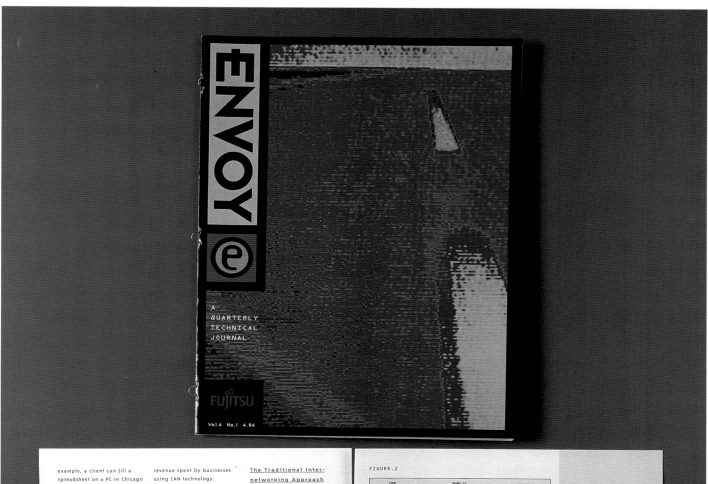

example, a client can fill a spreadsheet on a PC in Chicago with data from a server in Atlanta, and then print the output on a laser printer in Dallas. Businesses are using this kind of company-wide internetworking to give their customers better service.

What's in it for the Public Network Provider?

With the kinds of advantages LAN internetworking can provide, it is no surprise that billions of dollars are spent on it each year. It is an industry that is here today, rather than a market that must wait to become economically feasible. Therefore, a remarkable opportunity exists for the public network providers to capture a larger part of the enormous

revenue spent by businesses using LAN technology.

More of this revenue can be captured for the telcos using the Fujitsu/Wellfleet product because it solves so many problems with internetworking. Better LAN connectivity should result in higher tariffs and more subscribers. Currently, most LANs are connected to private line services via a router or multiplexer that is on the customer's side of the network interface or demarcation point. The telephone company supplies only the T1, leaving the customer to deal with all the protocol compatibility problems, poor throughput, hard-to-provision equipment, and potentially no survivability. **Figure 1** is a diagram of the traditional configuration.

The Traditional Internetworking Approach

The LAN office wiring from each PC and peripheral homes into a wiring concentrator. The concentrator in turn has a LAN interface which is connected to another piece of customer equipment, typically a router or a T1 multiplexer. Then, a DS1 interface from the router is connected to a Channel Service Unit (CSU), which finally connects the office to the public network. The connection could also be frame relay, DS3, fractional T1, or digital private line, but the principle is the same. Unfortunately, the customer also has to manage an extensive set of customer premise equipment (CPE) that does not make the wide area network (WAN) transparent to the client.

Problems with Traditional Interworking Become Revenue Opportunities

Customers Do Not Like Managing Complicated CPE
Problem: The customer has to purchase and manage the router and CSU. Anyone who has constructed a private network will admit that all the protocols and interface really add up to one big headache. The customer wants to know, "Why can't I just plug my LAN into the wall and

let the telephone company do all the work? I have to have my own staff to administer this stuff. I'd rather spend time making widgets, and let the telco worry about integrating all these technologies."
Solution: *Move the CPE into the Public Network.* Fujitsu and Wellfleet can provide a combined solution today that gives the business customer a LAN interface rather than a T1, and a hardware solution that works with the FLM 150 ADM (Fujitsu's OC-3/12 SONET multiplexer) and FACTR® (access platform) systems. The integration between Wellfleet's router and Fujitsu's SONET transmission products will evolve over time (as described in AN-94-002), but for now, the two vendors are working together to bring graceful LAN internetworking

to the public network. The telephone company can move the demarcation point further into the customer's premises, all the way to the wiring concentrator. The resulting data service offering translates into a source of new cash flow. **Figure 2** shows how the new service could be configured.

The Fujitsu/Wellfleet Approach

As Fujitsu's SONET products work closely with Wellfleet's router, many of the problems of connecting LANs to the network are solved. The SONET/Router functions are being placed into one integrated system that accomplishes LAN connections directly into the SONET network, seamlessly and easily.

The public network provider

With the kinds of advantages LAN internetworking can provide, it is no surprise that billions of dollars are spent on it each year. It is an industry that is here today, rather than a market that must wait to become economically feasible.

FIGURE.1

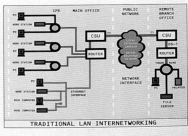

TRADITIONAL LAN INTERNETWORKING

FIGURE.2

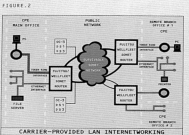

CARRIER-PROVIDED LAN INTERNETWORKING

Design Firm **Swieter Design U.S.**
Art Director **John Swieter**
Designer **Mark Ford**
Client **Fujitsu-Envoy**
Tools **QuarkXPress, Adobe Illustrator, and Adobe Photoshop**

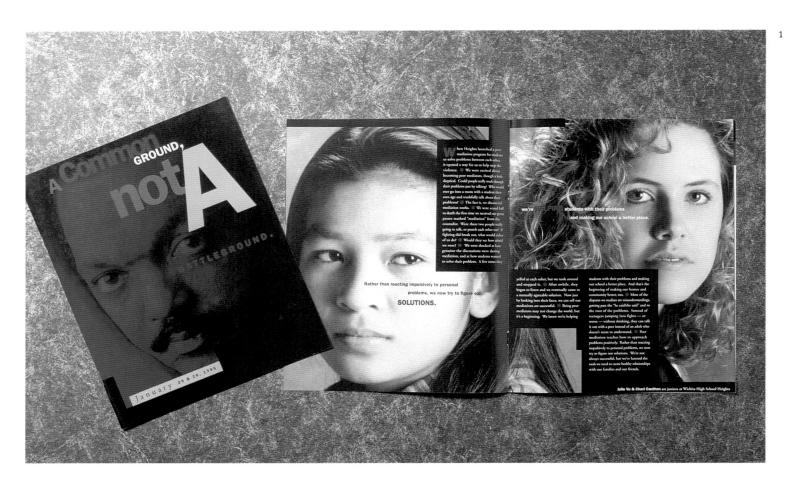

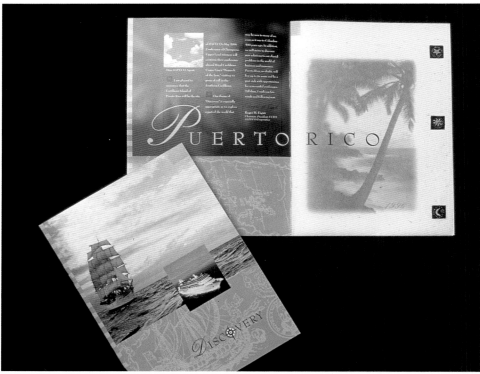

1

Design Firm **Greteman Group**
Art Director **Sonia Greteman**
Designers **Sonia Greteman and James Strange**
Photographer **Larry Fleming**
Client **Koch Crime Commission**
Printer **Donlevey**
Tool **Macromedia FreeHand**

1➤ *This brochure was used to promote Jesse Jackson's appearance in Wichita. The piece illustrates Jackson's stand on education and crime and depicts students in dramatic photos.*

2➤ *The objective of this brochure is to compel insurance agents to sell Safeco insurance products and earn incentive points that could add up to a prize-winning cruise.*

2

Design Firm **Gable Design Group**
Art Director **Tony Gable**
Designers **Tony Gable and Karin Yamagiwa**
Illustrator **Karin Yamagiwa**
Copywriter **Safeco Insurance Co.**
Client **Safeco Insurance Co.**
Printer **Heath Printers**
Tool **Adobe PageMaker**

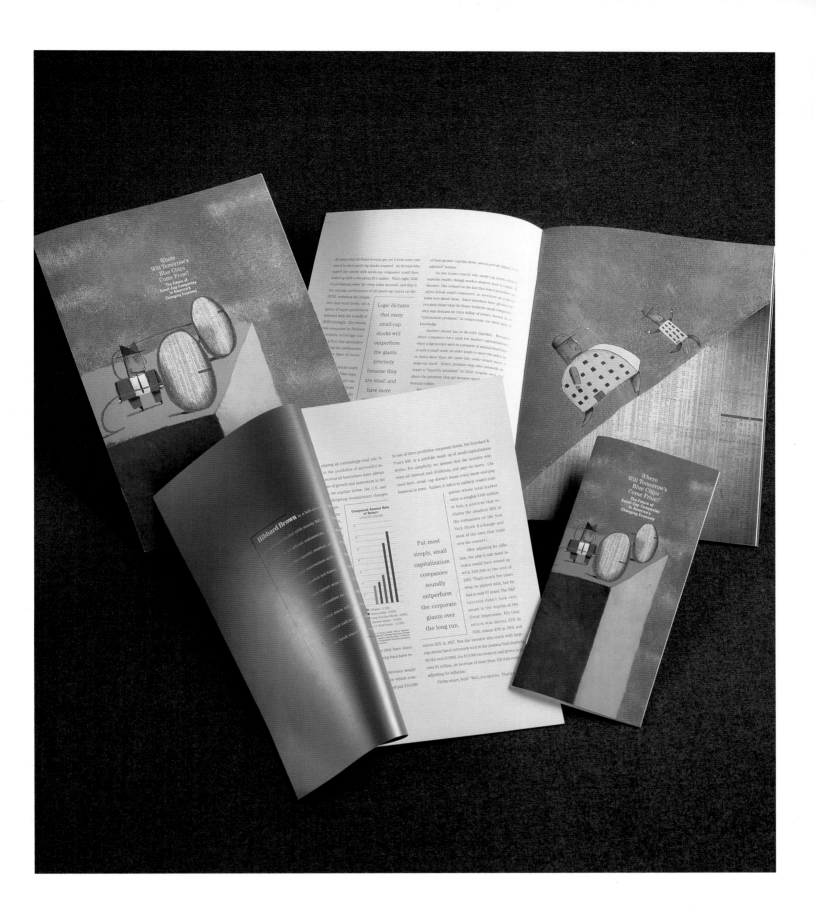

Design Firm **Bernhardt Fudyma Design Group**
Art Director **Craig Bernhardt**
Designer **Janice Fudyma**
Illustrator **James Yang**
Copywriter **Jerry Mosier**
Client **Hibbard Brown**
Printer **Quality House of Graphics**
Tool **QuarkXPress**

1
Design Firm **Lee Reedy Design**
Art Director **Lee Reedy**
Designer **Lee Reedy**
Photographer **Chris McCallister**
Copywriter **Bonnie Garmus**
Client **Consumer Health**
Paper/Printer **Lithofect, L & M Printing**
Tool **QuarkXPress**

2
Design Firm **Murrie Lienhart Rysner & Associates**
Art Director **Jim Lienhart**
Designer **Jim Lienhart**
Illustrator **Jim Lienhart**
Client **Egg Packaging**
Tool **Adobe Illustrator**

2➤ *This brochure was commissioned to announce the premier of the first national company to develop and produce all aspects of "the package"-from strategic planning, marketing, and design through to container implementation and production.*

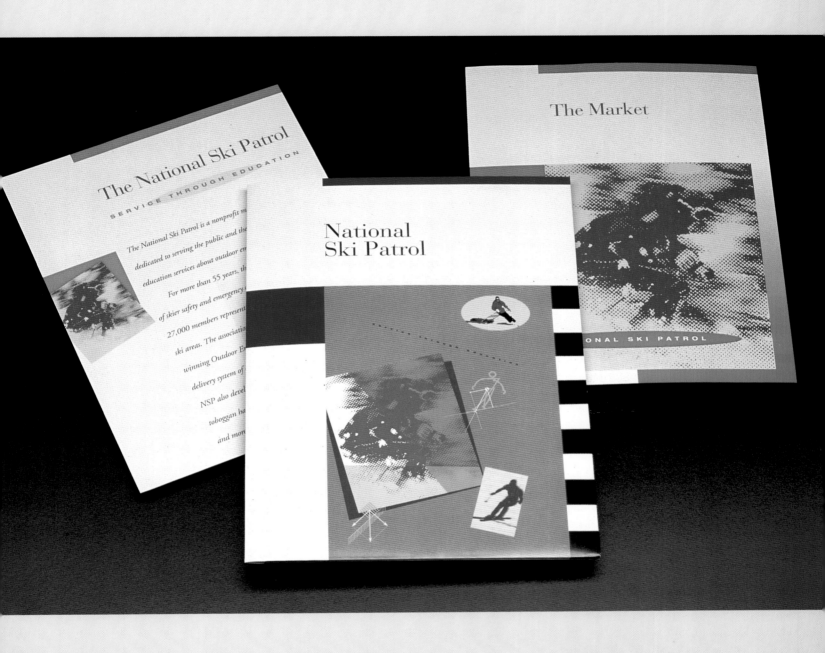

Design Firm **Lee Reedy Design**
Art Director **Lee Reedy**
Designers **Heather Haworth and Kathy Thompson**
Illustrator **Jon Wretlind**
Client **National Ski Patrol**
Paper/Printer **LOE, Lange Graphics**
Tools **QuarkXPress, Adobe Photoshop,
and Adobe Illustrator**

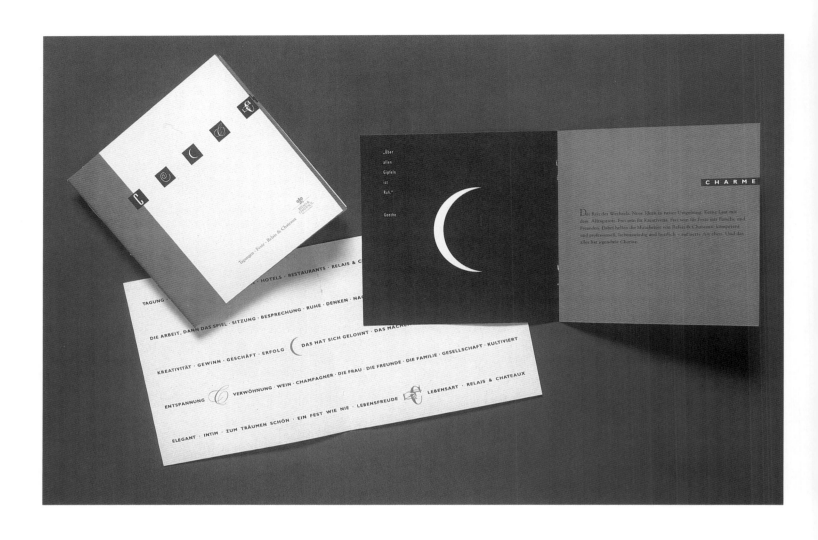

Design Firm **Marc Marahrens**
Art Director **Marc Marahrens**
Designer **Marc Marahrens**
Copywriter **Relais & Chateaux**
Client **Relais & Chateaux, Deutschland**
Printer **Format Offset**
Tools **Macromedia FreeHand and QuarkXPress**

*The main theme of the brochure is the 5 Cs which
is the principle of Relais & Chateaux restaurant
and hotel guides.*

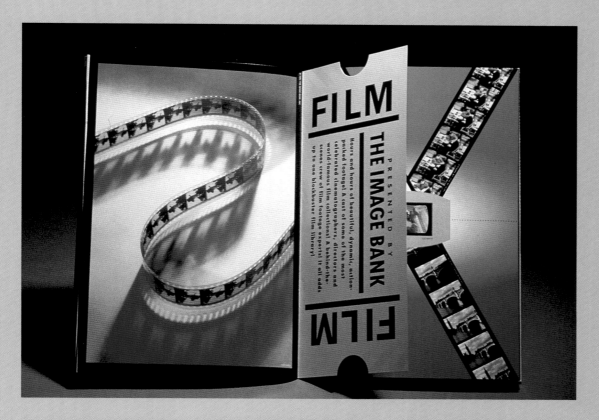

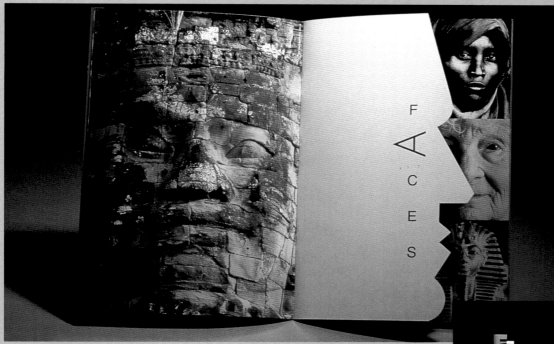

Design Firm **Sibley/Peteet**
Art Director **David Beck**
Designer **David Beck**
Client **The Image Bank**

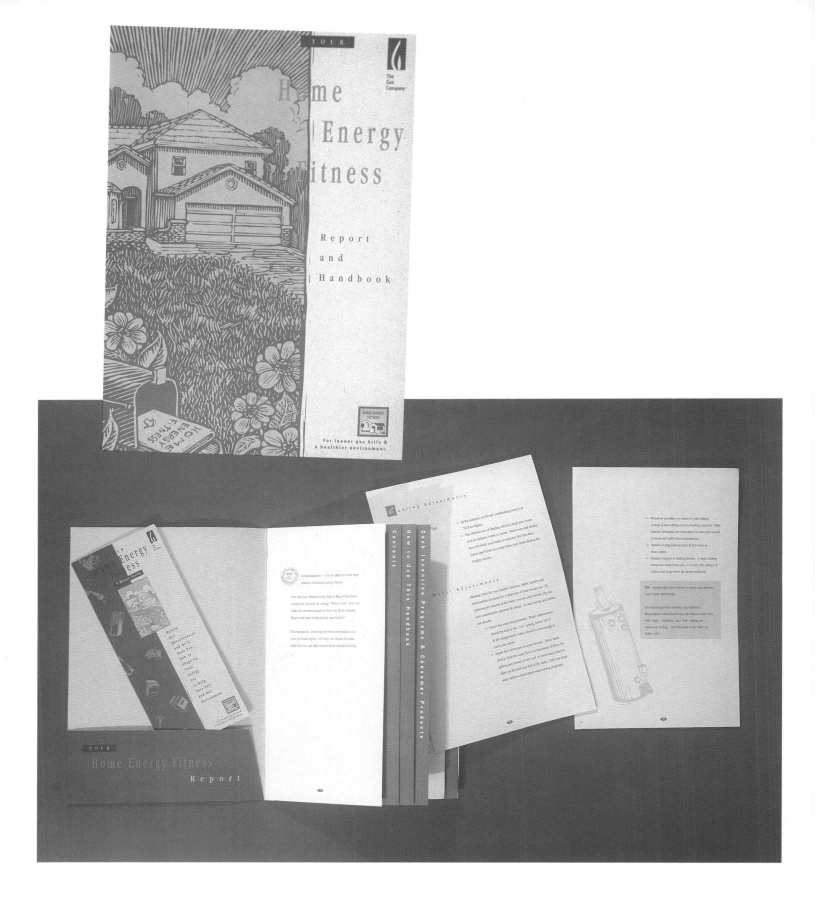

Design Firm **Julia Tam Design**
Art Director **Julia Chong Tam**
Designer **Julia Chong Tam**
Illustrator **Carol O'malia**
Client **Southern California Gas Company**
Paper/Printer **Proterra Flecks Oyster, Straw Industry Color Printing**
Tools **Adobe Illustrator and QuarkXPress**

This low-budget brochure uses colors from the client's corporate palette, inexpensive woodcut illustrations, and recycled paper.

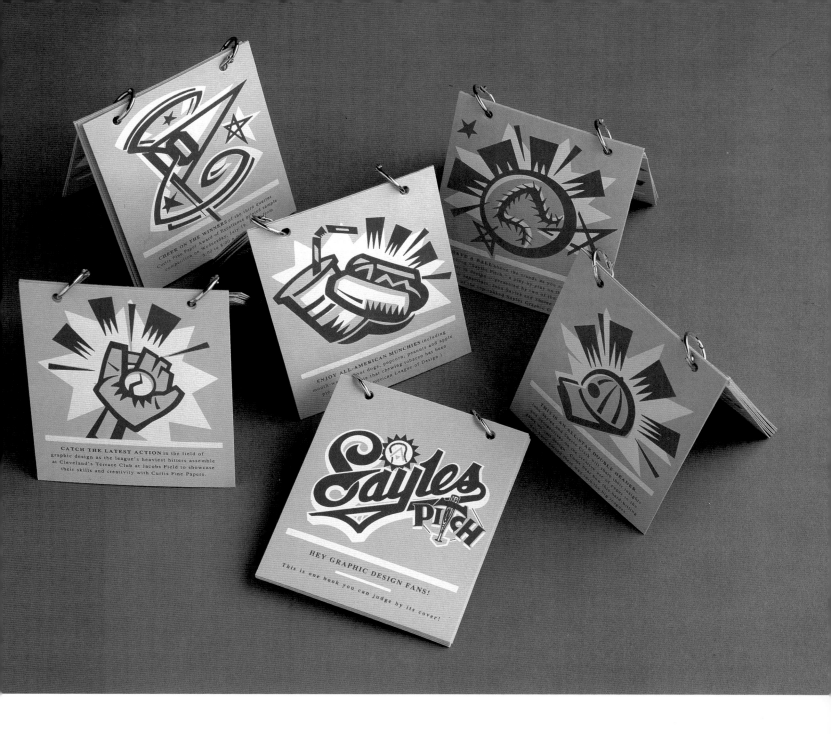

Design Firm **Sayles Graphic Design**
Art Director **John Sayles**
Designer **John Sayles**
Illustrator **John Sayles**
Copywriter **Jack Jordison**
Client **James River, Curtis Fine Papers**
Paper/Printer **Curtis Antique Grey 130 lb.,**
 Image Maker

Two colors of ink are used on the grey paper and the
piece is bound by 9/16-inch loose-leaf rings.

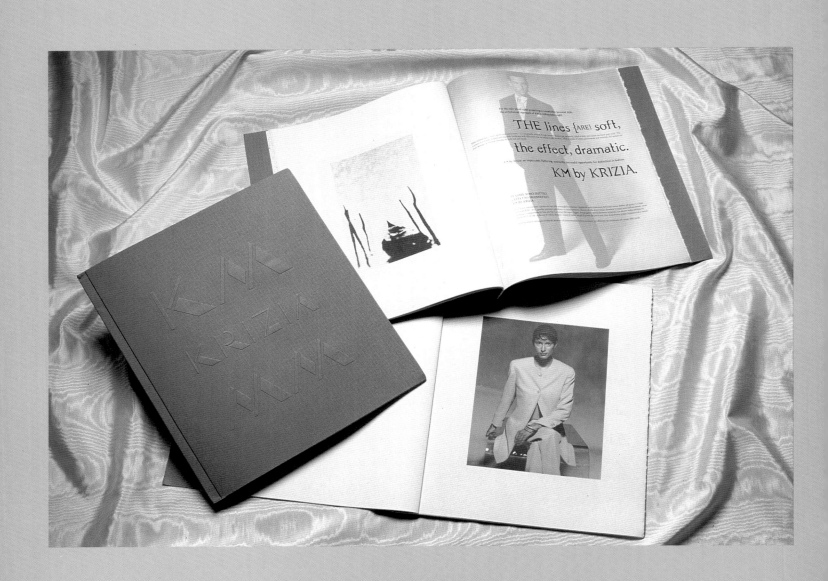

Design Firm **Segura Inc.**
Art Director **Carlos Segura**
Designer **Carlos Segura**
Copywriter **Alan Gandelman**
Client **Hart Marx**
Tools **Adobe Illustrator, QuarkXPress,
 and Adobe Photoshop**

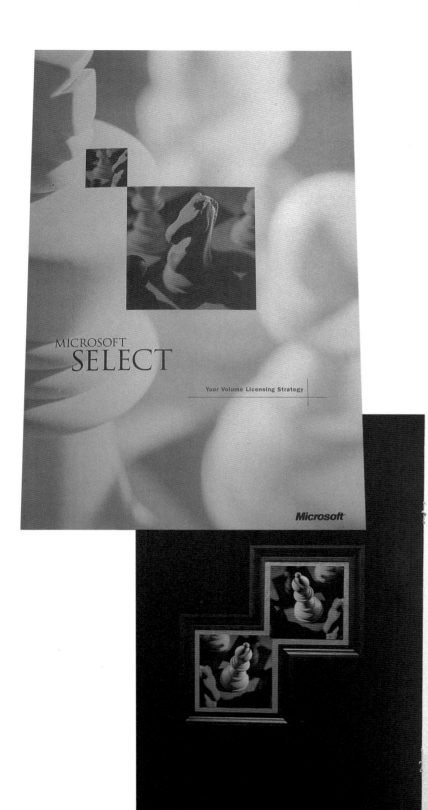

REDUCING YOUR RISK OF PIRACY

An Overall View

Copyright law around the world is becoming increasingly more stringent, with severe penalties for software piracy. More than 112 countries are signatories to the General Agreement on Tariffs and Trade (GATT), which provides comprehensive protection of computer software.

The Challenge

It is both difficult and expensive for large organizations to track and audit proper use of software, ensuring compliance with strict copyright laws. Piracy is a major risk and exposure can be disastrous.

Unauthorized software copies lack the strict quality controls built into the original disks, making them far more prone to computer viruses. Viruses put your entire enterprise at risk, including data resources, financial systems and other vital computer functions. The losses go beyond time and money. An organization may never fully recover from negative publicity, diminished credibility and the loss of potential business.

Illegal copies also result in higher prices for upgrades. No technical support is available. And reliability is always suspect. The vast majority of large organizations want to comply with prevailing laws. However, they fear exposure somewhere in their organization because of the difficulty of tracking software acquisition and use.

A Winning Strategy

Legally acquiring software for every machine is the only way to completely protect against illegal copying. Select offers an acquisition option that ensures you own a legal license for every qualifying computer or employee in your organization that's running a particular Microsoft software product.

As an enrollee in the Select program, you will receive quarterly summary reports detailing the total number of purchases you have made to date. That way, you can track what you own without having to do regular spot-checks or internal audits. Select is the most thorough, cost-effective way to ensure complete compliance worldwide — and peace of mind.

Design Firm **The Leonhardt Group**
Designers **Tim Young and Jon Cannell**
Photographer **Daniel Langley**
Copywriter **Tyler Cartier**
Client **Microsoft**
Paper/Printer **Zanders Ikonofix Matt, United Graphics**

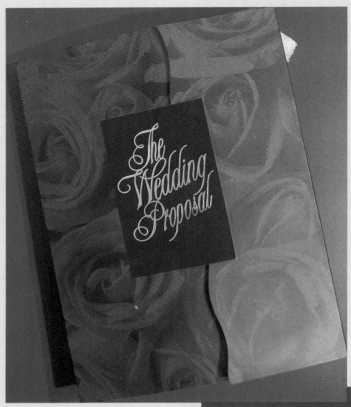

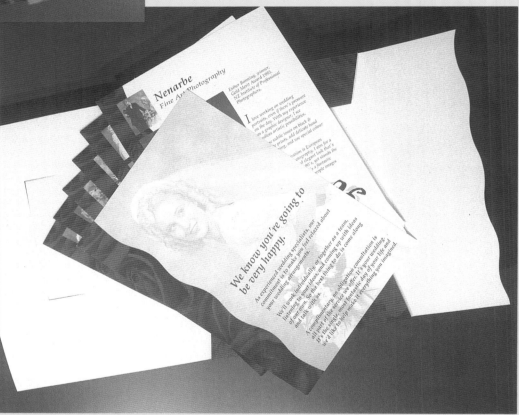

Design Firm **Raven Madd Design**
Art Director **Mark Curtis**
Designer **Mark Curtis**
Photographer **Esther Bunning**
Clients **Essence Beauty Therapy, Grace Hair Design,
 Partridge Jewellers, Nenarbe Fine Art Photography,
 Daisy A Day, Amanda, Nicolle Millinery,
 Alison Blain Designer**
Printer **Neal Print**
Tools **Macintosh and Macromedia FreeHand**

The inserts in this piece are loose, not bound, so recipients can remove the sections most relevant to their work.

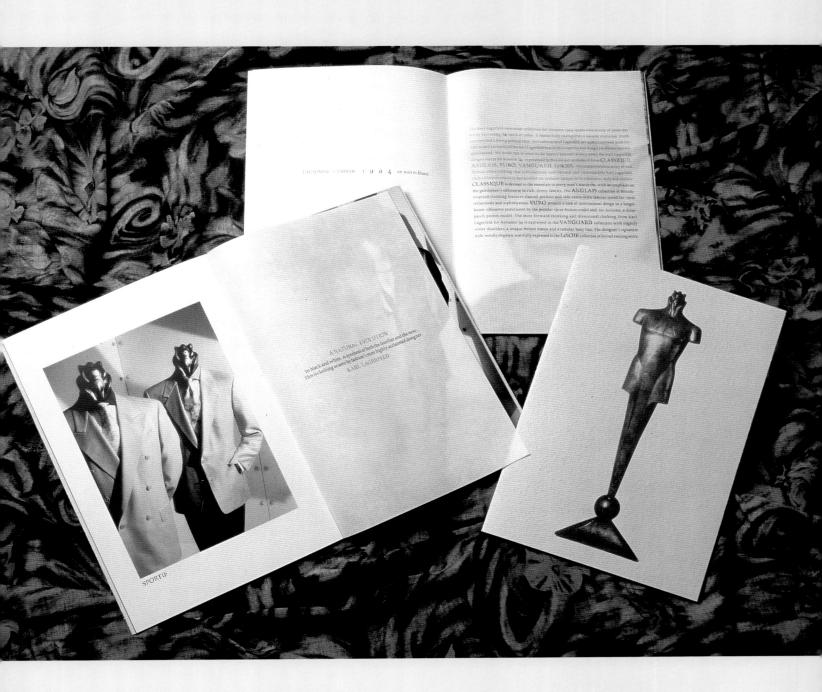

Design Firm **Segura Inc.**
Art Director **Carlos Segura**
Designer **Carlos Segura**
Copywriter **Alan Gandelman**
Client **Hart Marx**
Printer **Argus Press**
Tools **Adobe Illustrator, QuarkXPress,**
 and Adobe Photoshop

1

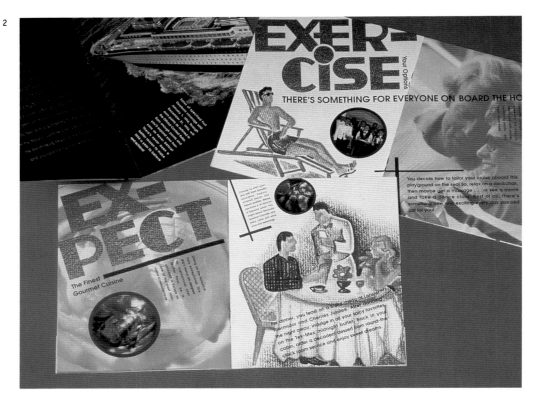

2

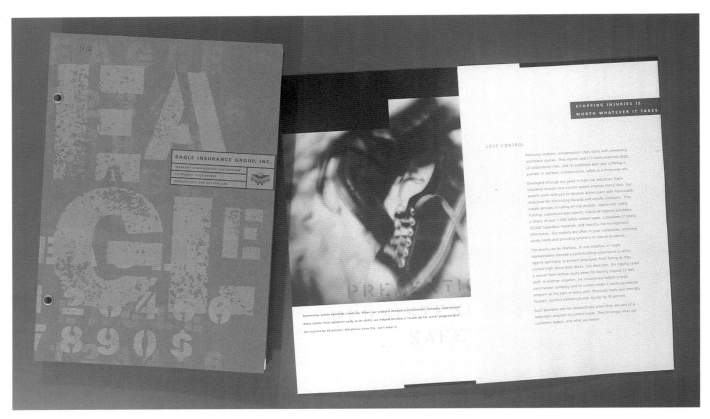

1
Design Firm **The Leonhardt Group**
Designers **Tim Young and Dennis Clouse**
Photographer **David Crosier**
Copywriter **Steven Boyer**
Client **Eagle Insurance**
Paper/Printer **Zanders Ikonofix Matt, Heath Printers**

2
Design Firm **Sayles Graphic Design**
Art Director **John Sayles**
Designer **John Sayles**
Illustrator **John Sayles**
Copywriter **Wendy Lyons**
Client **Fort Dearborn Life Insurance Company**
Paper/Printer **Graphika Natural 70 lb., cover 80 lb.,
Acme Printing**

2➤ *The cover of this brochure features a die-cut ship
silhouette and its inside pages combine stock
photos with original, 4-color illustrations in
charcoal and pastel.*

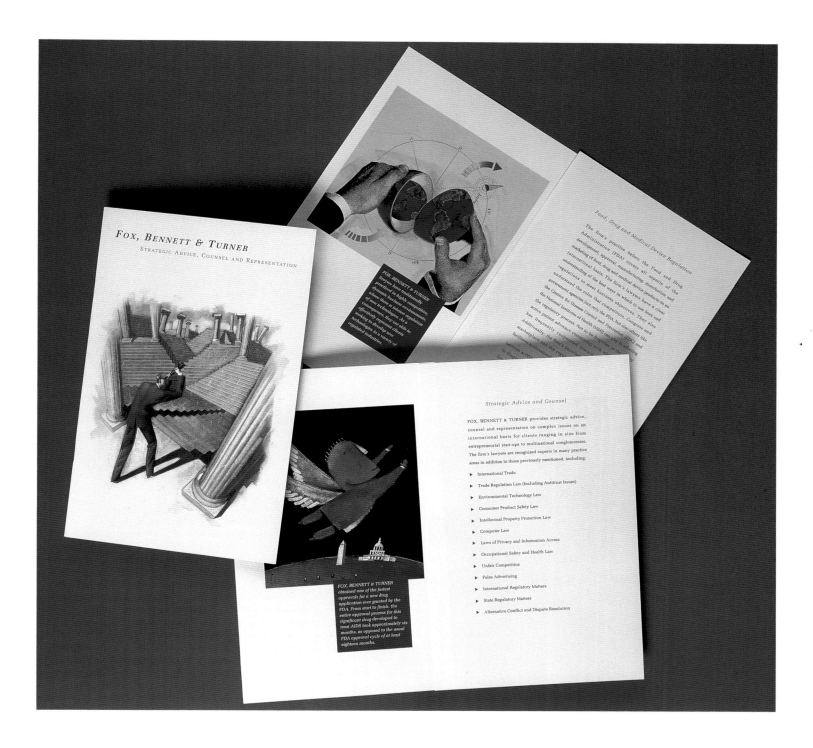

Design Firm **Jill Tanenbaum Graphic Design**
 & Advertising
Art Director **Jill Tanenbaum**
Designers **Pat Mulcahy and Catherine Mason**
Illustrators **Sally Comport, James Yang, Richard**
 Goldberg, Gregory Dearth, Whitney Sherman,
 and Rom Bookwalter
Copywriter **Fox Bennett & Turner**
Client **Fox Bennett & Turner**
Paper/Printer **Consort Royal, Westland Printers**
Tool **QuarkXPress**

*This piece took two years to complete because the
three law partners could not agree on the way the
brochure should look and read.*

MELBOURNE WATER IS ENHANCING THE QUALITY

OF LIFE IN WORLD COMMUNITIES BY PROVIDING

ENVIRONMENTAL AND ENGINEERING SOLUTIONS THROUGH

EXCELLENCE IN CONSULTANCY, TECHNOLOGIES AND

OPERATING SERVICES IN THE MANAGEMENT OF WATER

Design Firm **Cato Design Inc.**
Designer **Jeff Thornton**
Client **Melbourne Water**

Designed to promote Melbourne Water to Asian clients,
this piece presents the history of Melbourne Water.

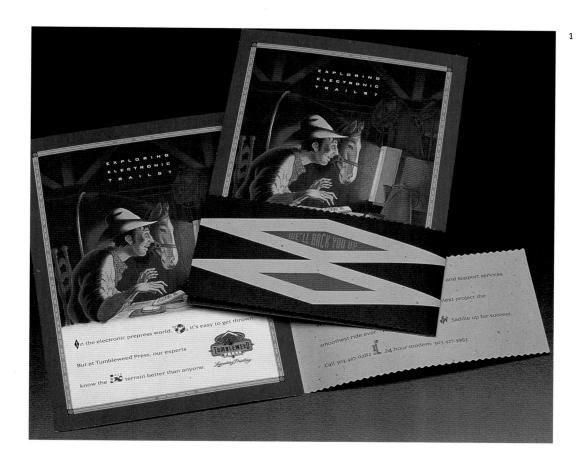

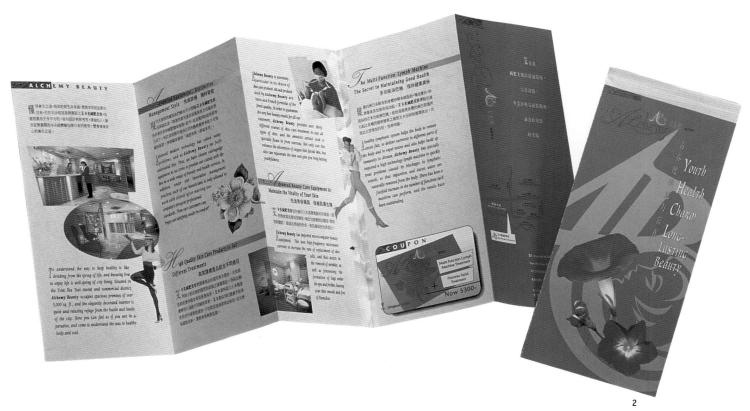

1
Design Firm **Lee Reedy Design**
Art Director **Lee Reedy**
Designer **Lee Reedy**
Illustrator **Patrick Merewether**
Copywriter **Lee Reedy**
Client **Tumbleweed Press**
Paper/Printer **Environment, Tumbleweed Press**
Tool **QuarkXPress**

1➤ *The dies and colored pencil were scanned into this piece.*

2
Design Firm **Grand Design Co.**
Art Directors **Grand So and Rex Lee**
Designer **Rex Lee**
Illustrator **Rex Lee**
Copywriter **Finny Maddess Consultants Ltd.**
Client **Alchemy Beauty**
Printer **Goldjoin (Ricky) Printing Co., Ltd.**
Tool **Adobe PageMaker**

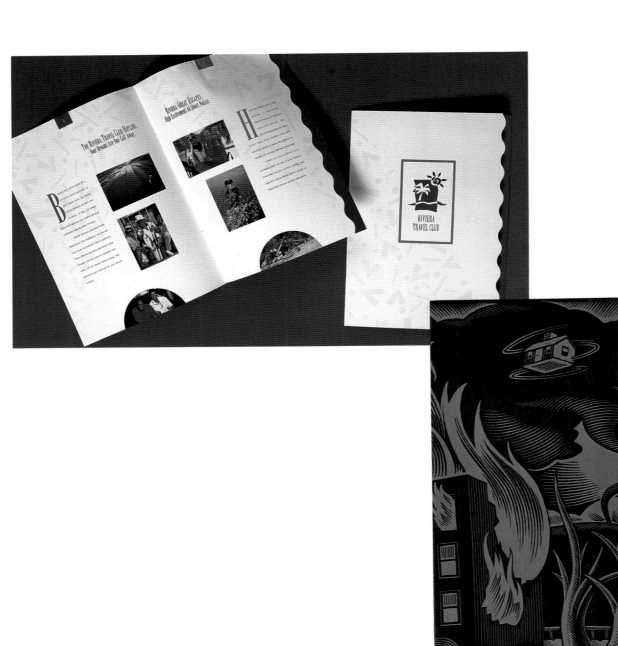

1

Design Firm **The Criterion Group**
Art Director **Allison Edwards Cottrill**
Designer **Allison Edwards Cottrill**
Illustrator **Allison Edwards Cottrill**
Copywriter **Richard Shaw**
Client **Rivera Travel Club**
Tool **QuarkXPress**

1➤ *This piece uses seven colors, and is tinted with varnish. The firm's objective was to create a fun but cleanly designed brochure.*

2

Design Firm **Swieter Design U.S.**
Art Director **John Swieter**
Designers **John Swieter and Kevin Flatt**
Illustrators **Jim Vogel and Chris Gall**
Client **The Marshall Companies**
Printer **Williamson Printing**
Tools **Adobe Illustrator, Adobe Photoshop, and QuarkXPress**

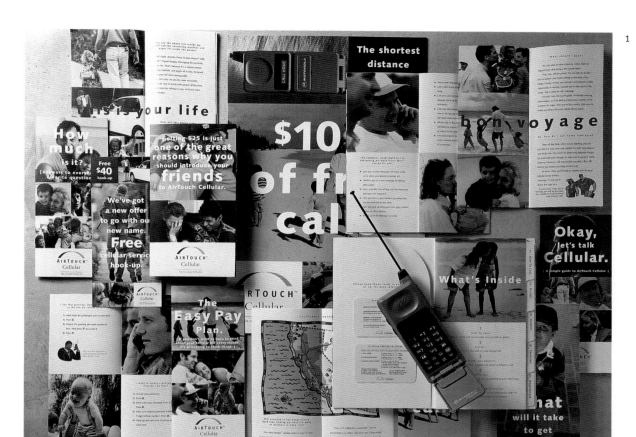

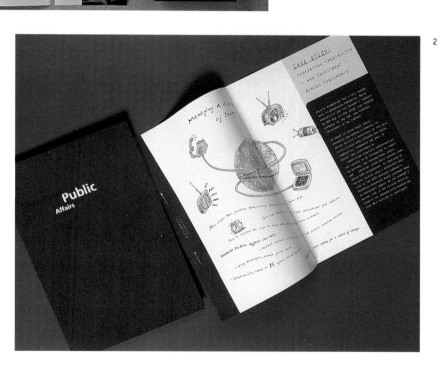

1
Design Firm **Mires Design**
Art Director **Scott Mires**
Designer **Scott Mires**
Illustrator **Tracy Sabin**
Photographer **Chris Wimpey**
Client **Airtouch Cellular**

2
Design Firm **Prospera**
Art Director **Karen Geiger**
Designers **Karen Geiger and Bettina Dehuhard**
Illustrator **Eric Hanson**
Copywriter **Shandwick Public Affairs**
Client **Shandwick Public Affairs**
Paper **Neenah Columns, French Newsprint, Potlatch, Vintage Velvet**
Tools **QuarkXPress and Adobe Illustrator**

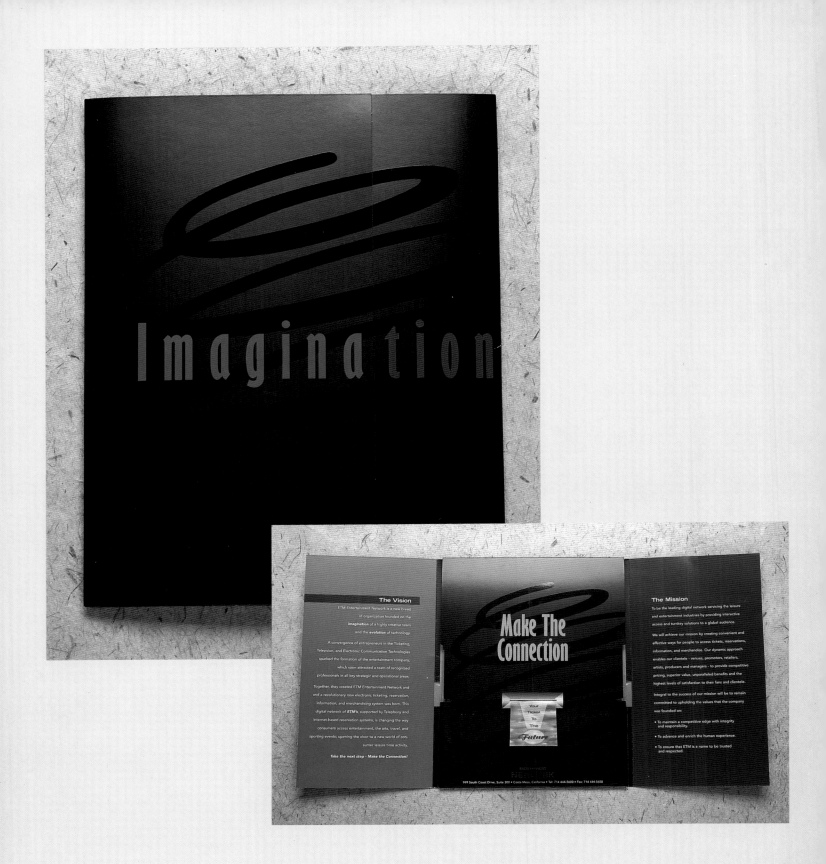

Design Firm **Ad Dimension II, Inc.**
Art Director **Robert Bynder**
Designer **Robert Bynder**
Illustrator **Robert Bynder**
Photographer **Brad Mooberry**
Client **ETM Entertainment Networks**
Tools **QuarkXPress, Adobe Photoshop,
and Adobe Illustrator**

This kit features a spot UV coated, custom-designed pocket folder that houses a four-page brochure and several 4-color sales sheets. The designer delivered the finished piece within ten days of the initial meeting with his client.

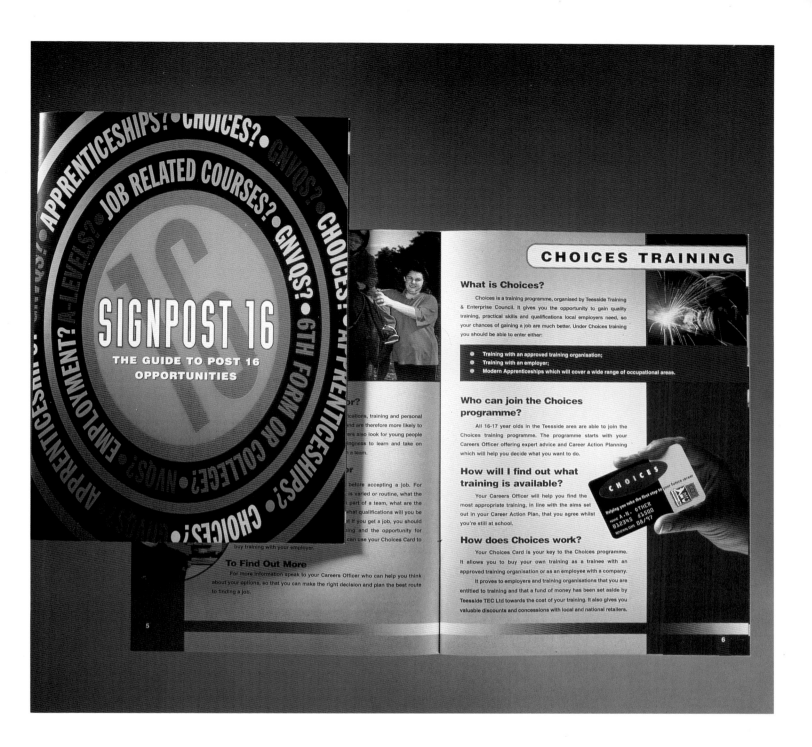

Design Firm **Yellow M**
Art Director **Paul Storie**
Designer **Paul Storie**
Client **Teesside T.E.C.**
Paper/Printer **Matte Art 100 lb.**

The Post 16 Guidance manual is designed to appeal to fifteen and sixteen year olds looking for guidance on career moves. The colors and layout highlight the opportunities available, but still engage the interest of a young person.

1
Design Firm **Held Diedrich**
Art Director **Dick Held**
Designer **Dick Held**
Copywriter **Cathy Harmon**
Client **Amateur Athletic Union of United States Inc.**
Paper/Printer **Strathmore Elements**
Tools **QuarkXPress**

1► *Originally developed as both a fundraising vehicle and to promote membership, this brochure started out as a typewritten, Xeroxed sheet. The designers convinced the client that there was an economical way to upgrade the booklet. Using clip-art and 2-color printing, they produced an attractive, affordable solution.*

2
Design Firm, **Bernhardt Fudyma Design Group**
Art Director, **Craig Bernhardt**
Designer, **Frank Baseman/Craig Bernhardt**
Illustrator, **Brian Cronin**
Copywriter, **Rena Grossfield**
Client, **AIG Financial Products**
Paper **Six colors on Strathmore Rhododendron, Reflections text**

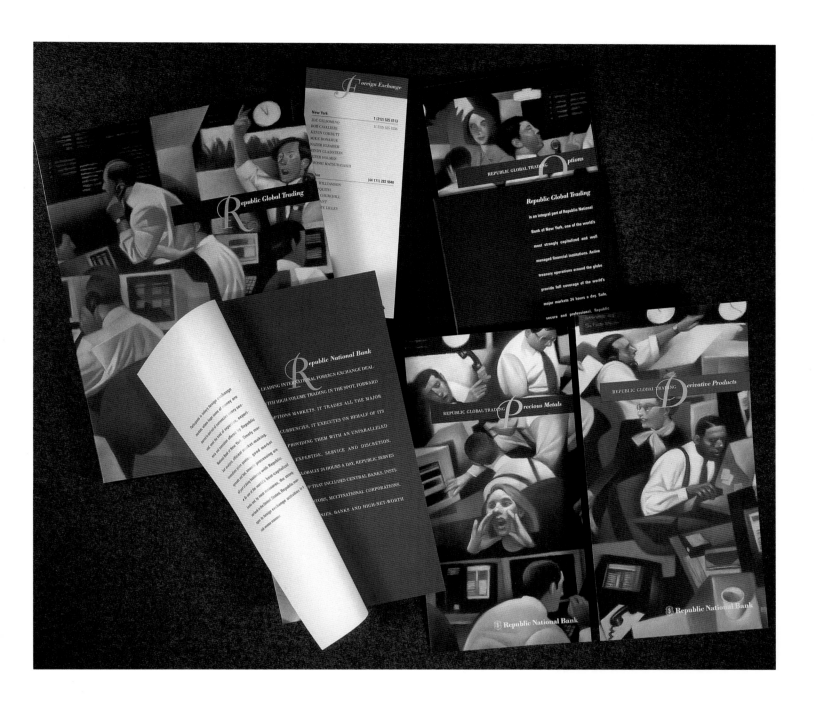

Design Firm **Bernhardt Fudyma Design Group**
Art Director **Janice Fudyma**
Designer **Janice Fudyma**
Illustrator **Gary Kelley**
Copywriter **Rena Grossfield**
Client **Republic National Bank**
Printer **Tanagraphics**
Tool **QuarkXPress**

This piece is effective as a single composition and also when used as individual brochure covers.

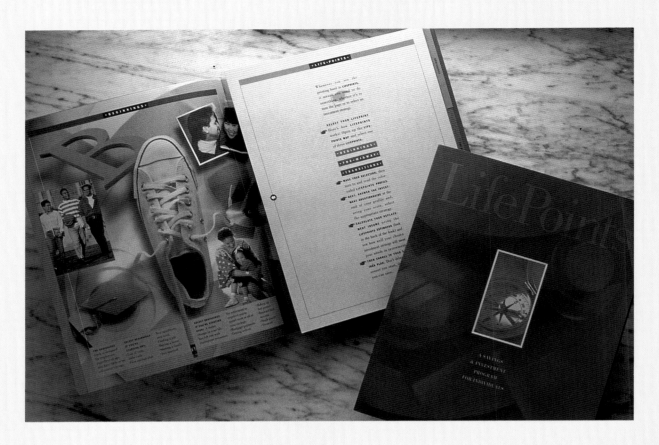

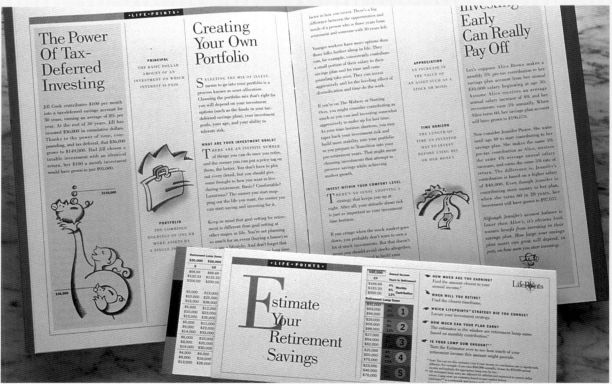

Design Firm **Hornall Anderson Design Works, Inc.**
Art Director **Jack Anderson**
Designers **Jack Anderson, Lisa Cerveny,**
 and Suzanne Haddon
Illustrator **Julia LaPine**
Photographer **John Still**
Copywriter **Frank Russell Company**
Client **Frank Russell Company**
Paper **Text Mohawk Opaque 65 lb., 80 lb. for cover**
Tools **QuarkXPress, Macromedia FreeHand,**
 and Adobe Photoshop

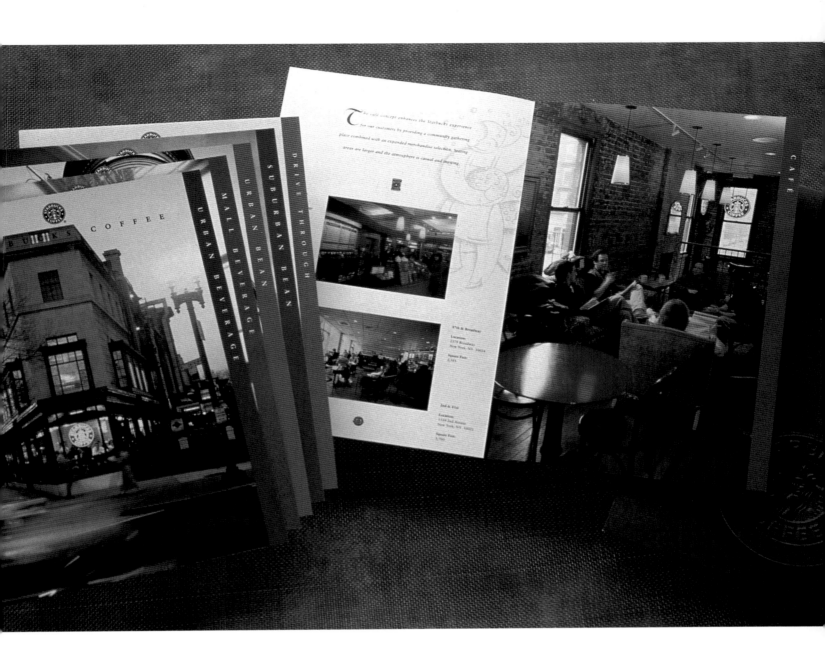

Design Firm **Hornall Anderson Design Works, Inc.**
Art Director **Jack Anderson**
Designers **Jack Anderson, Julie Lock, Julie Keenan,**
 and Jenny Woyvodich
Illustrator **Julia LaPine**
Photographer **Jim Fagiolo**
Client **Starbucks Coffee Company**
Paper **Evergreen Matte Natural, Colored Speckletone**
Tools **QuarkXPress and Adobe Photoshop**

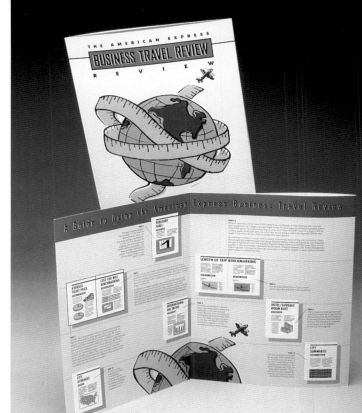

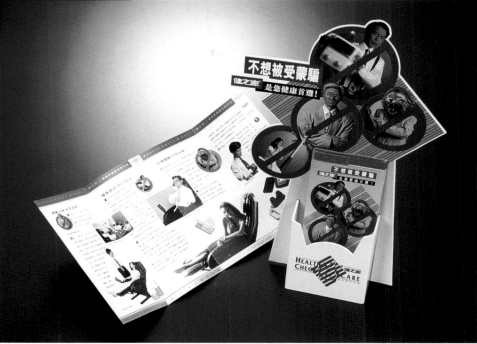

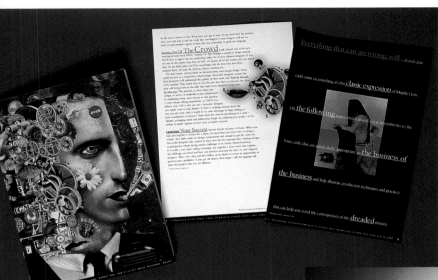

1
Design Firm **Mike Quon Design Office**
Art Directors **Mike Quon and J. Scholfield**
Designers **Mike Quon and E. Kuo**
Illustrator **Mike Quon**
Client **American Express Co.**
Tools **QuarkXPress and Adobe Illustrator**

2
Design Firm **The Kuester Group**
Art Director **Kevin B. Kuester**
Designer **Bob Goebel**
Copywriter **David Forney and Sarah Vander Zanden**
Client **Potlatch Corporation, NW Paper Division**
Paper/Printer **Vintage Gloss, Diversified Graphics**
Tools **QuarkXPress, Macromedia FreeHand
 and Adobe Photoshop**

A3
Design Firm **Masterline Communications Ltd.**
Art Director **Mr. Grand So, Mr. Hair Ng**
Photographer **Mr. David Lo, Mr. Franco Lai**
Copywriter **Mr. Spencer Wong**
Client **Asia Growth Co., Ltd.**
Paper/Printer **Goldjoin (Ricky) Printing Co., Ltd.**

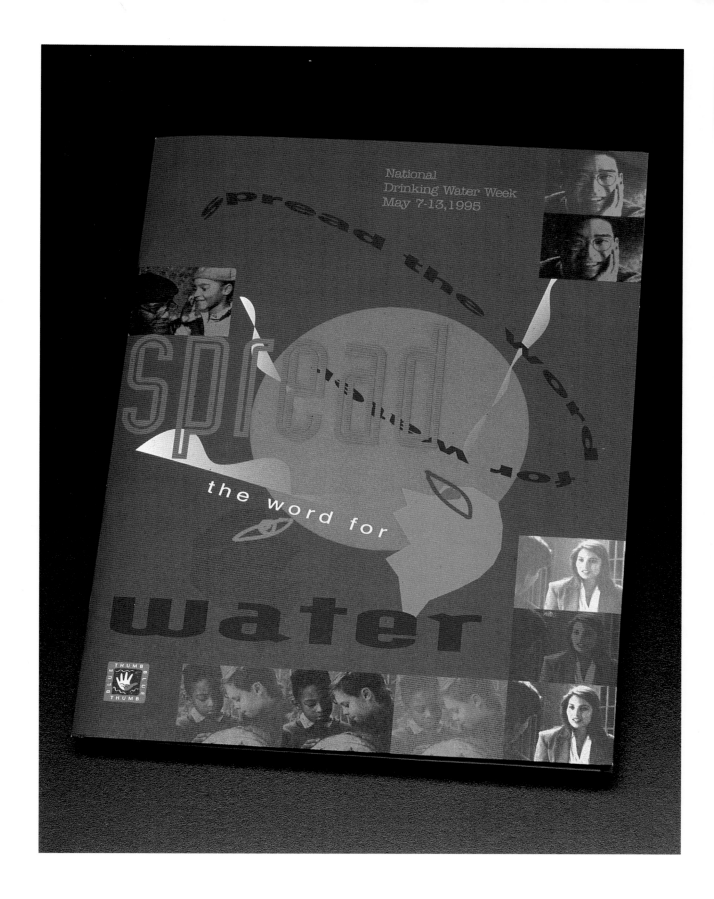

Design Firm **Lee Reedy Design**
Art Director **Lee Reedy**
Designer **Heather Haworth**
Illustrator **Heather Haworth**
Photographer **Ron Coppock**
Copywriter **Joan Dent**
Client **American Water Works Assn.**
Paper/Printer **Environment, Frederic Printing**
Tools **QuarkXPress and Adobe Photoshop**

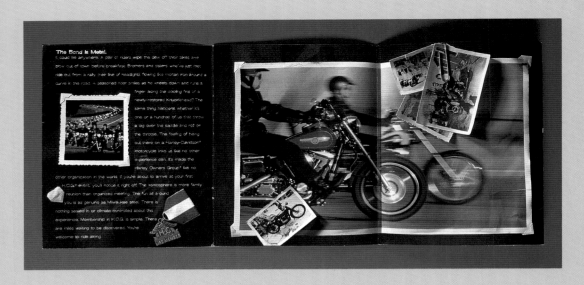

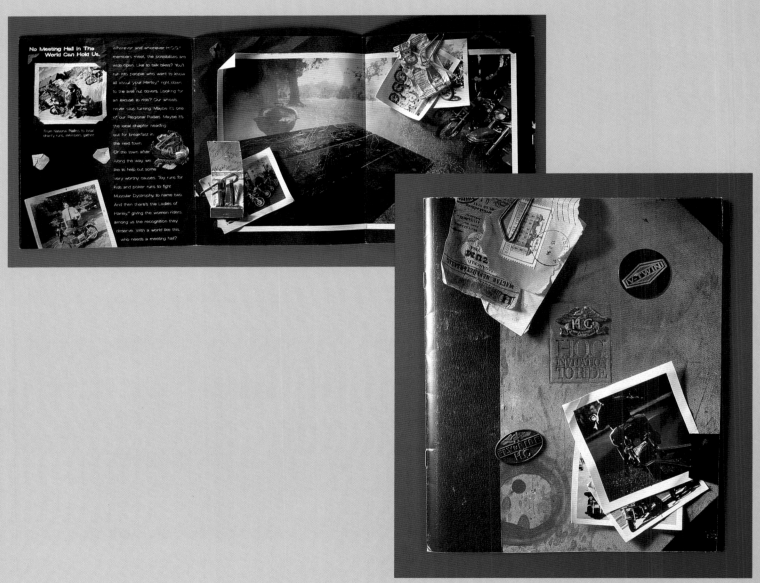

Design Firm **Carmichael Lynch**
Art Director **Pete Winecke**
Designer **Pete Winecke**
Photographer **Pat Fox Photo**
Copywriter **Sheldon Glay**
Client **Harley-Davidson H.O.G. Division**
Tools **QuarkXPress and Adobe Photoshop**

The challenge here was to design a brochure that reflects a "Harley" way of life.

2

1
Design Firm **Studio W. Inc.**
Art Director **Fo Wilson**
Designer **Fo Wilson**
Photographer **Impact Visuals**
Copywriter **Impact Visuals**
Client **Impact Visuals**
Paper/Printer **Mohawk, Enterprise Press**
Tools **QuarkXPress**

2
Design Firm **Sayles Graphic Design**
Art Director **John Sayles**
Designer **John Sayles**
Illustrator **John Sayles**
Copywriter **Wendy Lyons**
Client **MWR Telecom**
Paper/Printer **Curtis Papers, Artcraft Printing**

2➤ *Designed to promote fiber-optic network services to local businesses, this dictionary-sized piece is made from chip board laminated with paper. The brochure explains the benefits of fiber optics; even in a raging flood, MWR Telecom can transmit the entire dictionary in 1/16 of a second.*

Design Firm **Jill Tanenbaum Graphic Design**
& Advertising
Art Director **Jill Tanenbaum**
Designer **Pat Mulcahy**
Illustrator **Raphael Lopez**
Copywriter **Gary Woonteiler**
Client **Incenter Strategies, Inc.**
Paper/Printer **Consort Royal, Westland Printers**
Tool **QuarkXPress**

This client changed its company name and wanted to let clients know that it was still the same company.

1

Design Firm **Lee Reedy Design**
Art Director **Lee Reedy**
Designer **Lee Reedy**
Illustrator **Jon Wretlind**
Copywriter **Lee Reedy**
Client **Tumbleweed Press**
Paper/Printer **Environment, Tumbleweed Press**
Tools **QuarkXPress and Adobe Illustrator**

2

Design Firm **Jill Tanenbaum Graphic Design
 & Advertising**
Art Director **Jill Tanenbaum**
Designer **Catherine Mason**
Photographer **Britton Littlehales**
Copywriter **US Postal Service**
Client **US Postal Service**
Tools **QuarkXPress and Adobe Photoshop**

2➤ *The designers were given only three weeks to create
and produce this piece. They worked with stock
photography and with local photo reps to quickly
find images relating to blues and jazz. To get in the
right frame of mind, they had old jazz and blues all
day in the studio for weeks!*

INDEX

DIRECTORY

Ad Dimension II, Inc.
2118 Wilshire Boulevard, #205
Santa Monica, CA 90403

Artailor Design House
4th Floor, 414, Section 4
Shin Yi Road
Taipei, TAIWAN R.O.C.

Beauchamp Design
11027 Camino Arcada
San Diego, CA 92131

Belyea Design Alliance
1809 7th Avenue, Suite 1007
Seattle, WA 98101

Bernhardt Fudyma Design Group
133 East 36th Street
New York, NY 10016

Caldera Design
1201 East Jefferson, #A25
Phoenix, AZ 85034

Carmichael Lynch
800 Hennepin Avenue
Minneapolis, MN 55403

Cato Design Inc.
254 Swan Street
Richmond
3121 AUSTRALIA

Chameleon Graphics, Inc.
310 East Main Street
Lakeland, FL 33801

Creative Media
200 Vesey Street
New York, NY 10285-0110

The Criterion Group
12 Piedmont Center, Suite 100
Atlanta, GA 30308

David Balzer
1017 East Harrison, Apt. 304
Seattle, WA 98102

Desgrippes Gobé & Associates
411 Lafayette Street
New York, NY 10003

Design Ahead
Kirchfeldstrasse 16
45219 Essen-Kettwig
GERMANY

The Design Group
Sagmeister, Inc.
222 West 14th Street
New York, NY 10011

Diana Howard Design
2025 Stockton, #4
San Francisco, CA 94133

Elton Ward Design
P.O. Box 802
Parramatta, New South Wales
2124 AUSTRALIA

Eskind Waddell
471 Richmond Street West
Toronto, Ontario
M5V 1X9 CANADA

Fluty Art Direction/Design
9243 Moody Park Drive
Overland Park, KS 66212

Gable Design Group
1809 7th Avenue, #1205
Seattle, WA 98101

George Tscherny
238 East 72nd Street
New York, NY 10021

Giorgio Rocco Communications
Design Consultants
Via Domenichino 27
20149 Milano
ITALY

Graef & Ziller Design
330 Fell Street
San Francisco, CA 94102

Grafik Communications, Ltd.
1199 North Fairfax Street, #700
Alexandria, VA 22314

Grand Design Company
Rm 1901, Valley Centre
80-82 Morrison Hill Road
Wanchai, HONG KONG

Gregory Group
2811 McKinney, Suite 216
Dallas, TX 75204

Greteman Group
142 North Mosley
Wichita, KS 67202

Group W Television
565 5th Avenue
New York, NY 10017

Held Diedrich
703 East 30th, Suite 16
Indianapolis, IN 46205

Hornall Anderson Design Works, Inc.
1008 Western Avenue, Suite 600
Seattle, WA 98104

Jill Tanenbaum
Graphic Design and Advertising, Inc.
4701 Sangamore Road, Suite 235 South
Bethesda, MD 20816

Julia Tam Design
2216 Via La Brea
Palos Verdes, CA 90274

Kan Tai-keung Design & Associates, Ltd.
28/F Great Smart Tower
230 Wanchai Road
HONG KONG

Kimberly Cooke and Ann Freerks
631 East Jefferson Street
Iowa City, IA 52245

The Kuester Group
81 South 9th Street, Suite 300
Minneapolis, MN 55402

Lee & Yin
56 Livingston Street, 2C
Brooklyn, NY 11201

Lee Reedy Design
1542 Williams Street
Denver, CO 80218

Leo in House
Industriparken 55
DK-2750 Ballerup
DENMARK

Leo Pharmaceuticals
Industriparken 55
DK-2750 Ballerup
DENMARK

The Leonhardt Group
1218 Third Avenue, #620
Seattle, WA 98101

Ligature, Inc.
165 North Canal
Chicago, IL 60606

Luis Fitch Design Lab
1171 Neil Avenue
Columbus, OH 43201

M & Company
Sagmeister Inc.
222 West 19th Street
New York, NY 10011

Marc Marahrens
Flotowstrasse 14
22083 Hamburg
GERMANY

Masterline Communications, Ltd.
Rm 1902, Valley Centre
80-82 Morrison Hill Road
Wanchai, HONG KONG

McCullough Creative Group, Inc.
890 Iowa Street
Dubuque, IA 52001

Melissa Passehl Design
875 El Rio Drive
San Jose, CA 95125

Metropolis Corporation
56 Broad Street
Milford, CT 06460

Mike Quon Design Office
568 Broadway #703
New York, NY 10012

Mike Salisbury Communications
2200 Amapola Court
Suite 202
Torrance, CA 90501

Mires Design, Inc.
2345 Kettner Boulevard
San Diego, CA 92101

Murrie Lienhart Rysner & Associates
58 West Huron Street
Chicago, IL 60610

Northern Illinois University
Office of Publications
Altgeld 301
DeKalb, IL 60115

Peterson & Company
2200 North Lamar, Suite 310
Dallas, TX

Playboy Enterprises
Marise Mizrahi GWTS
565 5th Avenue
New York, NY 10017

Prospera
8400 Normandale Lake Boulevard
Minneapolis, MN 55437

Raven Madd Design
P.O. Box 11-331
Wellington
NEW ZEALAND

Richard Endly Design, Inc.
510 First Avenue, Suite 206
Minneapolis, MN 55403

The Riordon Design Group, Inc.
131 George Street
Oakville, Ontario
L6J 3B9 CANADA

Sackett Design Associates
2103 Scott Street
San Francisco, CA 94115-2120

Sagmeister, Inc.
222 West 14th Street
New York, NY 10011

Sayles Graphic Design
308 Eighth Street
Des Moines, IA 50309

Segura Inc.
361 West Chestnut Street
1st Floor
Chicago, IL 60610

Shari Flack
P.O. Box 1354
Pacifica, CA 94044

Sibley/Peteet
3232 McKinney, #1200
Dallas, TX 75204

Stamats Communications, Inc.
427 Sixth Avenue SE
P.O. Box 1888
Cedar Rapid, IA 52406

Stowe Design
125 University Avenue, Suite 220
Palo Alto, CA 94301

Studio W, Inc.
17 Vestry Street
Ground Floor
New York, NY 10013

Swieter Design U.S.
3227 McKinney Avenue, Suite 201
Dallas, TX 75204

TAB Graphics Design, Inc.
1120 Lincoln Street, Suite 700
Denver CO 80203

246 Fifth Design
1379 Bank
Ottawa, Ontario
K1H 8N3 CANADA

W Design
411 Washington Avenue North
Suite 104
Minneapolis, MN 55401

Wehrman & Company, Inc.
8175 Big Bend Boulevard
Suite 250
St. Louis, MO 63119

Wonder Studio
12155 Mora Drive, Unit 13
Santa Fe Springs, CA 90670

Yellow M
The Arch, Hawthorn House
Forth Banks
Newcastle Upon Tyne
NE1 3SG ENGLAND